MASTERING **PORTRAIT**

PHOTOGRAPHY

PAUL WILKINSON & SARAH PLATER

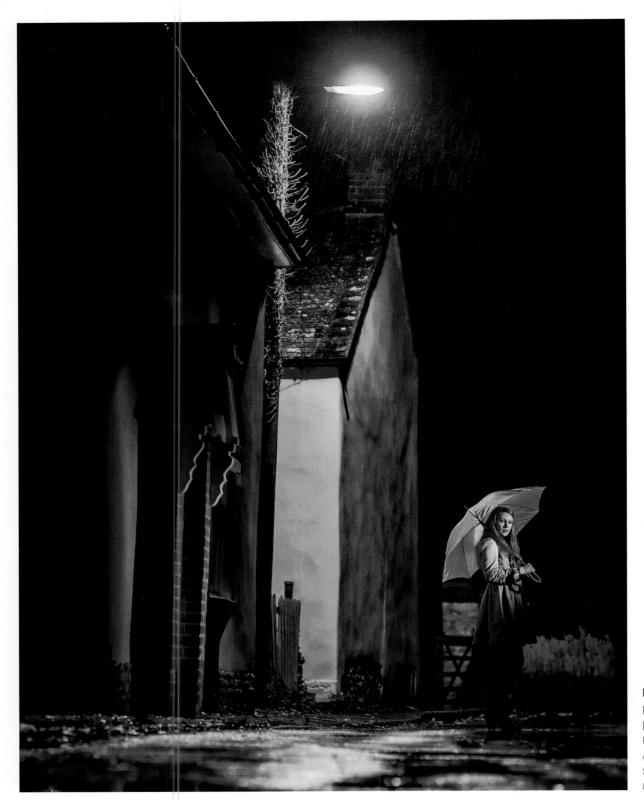

Left: Once you've mastered portrait photography, even the rain and the dark won't prevent you from shooting stunning images.
Focal length: 90mm
Aperture: f/3.3
Shutter speed: 1/30 sec.
ISO: 2200

MASTERING **PORTRAIT**

PHOTOGRAPHY

PAUL WILKINSON & SARAH PLATER

AMMONITE
PRESS

First published 2015 by
Ammonite Press
an imprint of Guild of Master Craftsman Publications Ltd
Castle Place, 166 High Street, Lewes,
East Sussex, BN7 1XU, United Kingdom

Reprinted 2017, 2018

Text © Sarah Plater 2015
Images © Paul Wilkinson 2015 (except where indicated)
Product photography © Canon 10 (top center), 11 (top right), 12 (left),
18 (bottom center); Elinchrom 16–17; Induro 14 (bottom right); Nikon
10 (top left), 12 (bottom right), 64 (left); Olympus 11 (top left); SanDisk
14 (bottom center); Sekonic 18 (bottom left); Sony 11 (top center)

Copyright © in the Work GMC Publications Ltd, 2015

ISBN 978-1-78145-085-7

British Library Cataloging in Publication Data: A catalog record of this
book is available from the British Library.

Editor: Chris Gatcum
Series Editor: Richard Wiles
Designer: Robin Shields

Typeface: Helvetica Neue
Color reproduction by GMC Reprographics
Printed in China

Contents

Introduction

What does it take to become a master of portrait photography? A sensitivity to the nuances of changing light? An intimate knowledge of your camera and lighting equipment? The appreciation that adjusting your subject's head by a mere 1⁄16in. (2mm) can have a huge impact?

All of these are vitally important, but most of all you need a love of being with and around other people. Too often, people buy expensive camera equipment, then stand in the corner and zoom in on the people around them. However, good portraits are *created*, not just captured.

Don't raise the camera to your eye and look for a shot. Instead, begin with the finished photograph in mind. What kind of image are you trying to create? Actively search out the best light for the mood you are aiming for, select a setting within that lit area, and position your subject in a way that flatters them.

Then interact with him or her to generate an expression that will resonate with whoever views the image afterward. If you want the subject to like the photos you take of them, then the whole experience needs to be a positive one; otherwise the images will recall the discomfort felt at the time.

You will need to be likeable and willing to fall in love with your subject for the duration of the shoot. Your enthusiasm needs to become infectious, and your images need to show your emotion, not just your technical skill. When you are making considered decisions, you'll be creating rather than just capturing—and when you can make people look and feel good, you'll be well on your way to mastering the art of portrait photography.

Right: Consider the emotions that you want the image to portray in your photograph. The serenity of this lakeside scene is complemented by the centrally-framed bench, with the off-center family adding a little tension to the composition.

Focal length: 105mm

Aperture: f/2.8

Shutter speed: 1/125 sec.

ISO: 100

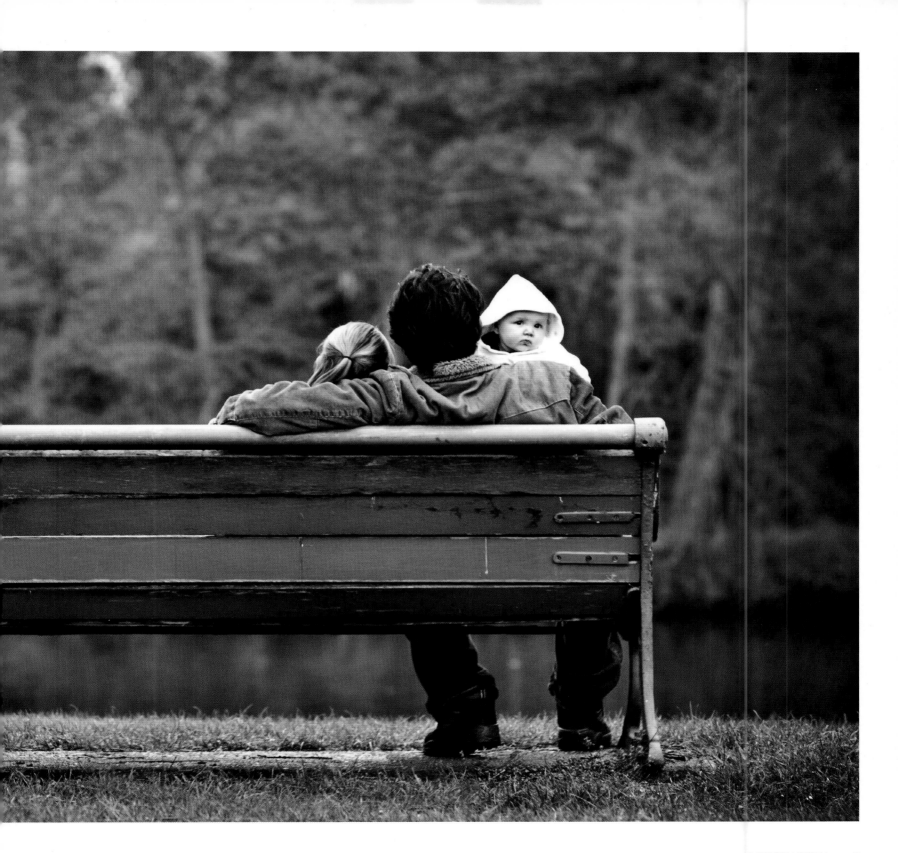

Chapter 1

Equipment

With hundreds of different camera bodies and lenses to choose from—in addition to a limitless number of accessories—it's tough to know where to draw the line when it comes to kit. There's a fine balance between having what you really need and buying equipment that you'll only use once.

If you're looking to earn money from portraiture, then the cost of any equipment needs to be offset by the likely income you can earn by using it. Owning expensive kit won't make you more competent—knowing how to use it and putting in many hours of practice is the only way to master portrait photography.

If you plan to offer studio shoots, then clearly you'll need more equipment than if you were to specialize in natural-light photography. While some accessories can be improvised (using aluminum foil instead of a commercial reflector, for example), you may find the effectiveness, usability, and professionalism of a purpose-made product outweighs any cost savings.

The following pages tell you what to look for when selecting a camera and lens, as well as covering some of the more useful accessories and flash lighting options. However, with all of these items it is a good idea to spend time at a specialist store, handling and testing the different options, so you can be sure you are investing in the right equipment for you.

Right: Investing in the right kit means you'll have maximum control and more options when it comes to creating powerful portraits, no matter what your subject throws at you.

Focal length: 70mm

Aperture: f/6.3

Shutter speed: 1/200 sec.

ISO: 100

Cameras

Whether you choose a camera from Canon, Nikon, Olympus, Panasonic, Pentax, or Sony, once you commit to a particular "system" you are largely tied in to that manufacturer's stock of lenses and accessories. There are adaptors that enable some mixing and matching between certain brands (although not between all brands), and third-party lens manufacturers such as Sigma, Tamron, Tokina, and Zeiss offer a number of compatible lenses, but these are not necessarily available for all systems. So, make your initial decision with the full range in mind, not just a particular camera.

As you are making a long-term commitment to a particular brand of camera system, it is a very good idea to go in store to try them out. Pick up all of the different cameras that fall within your price bracket, note how they feel in your hands, and try taking a few test shots. Choose the one that makes you want to go straight out and shoot. Bear in mind that while prices may be cheaper online, if you buy your kit from a store you will have somewhere you can go if it breaks.

There are two very different camera types for serious portrait photographers to choose from—digital single lens reflex (DSLR) cameras and mirrorless interchangeable lens cameras (MILCs).

DSLR

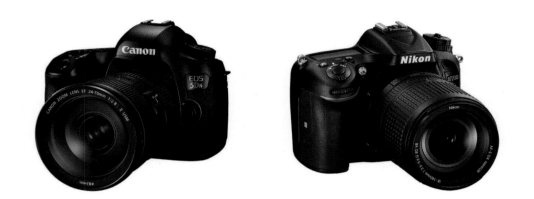

Above: Canon's EOS 5DS (above left) is a pro-level DSLR that utilizes a full-frame sensor, whereas Nikon's D7200 (above right) is a high-end enthusiast camera housing an APS-C sized sensor.

Digital single lens reflex cameras (or DSLRs as they are more commonly known) get their name from the through-the-lens view they provide, with an internal mirror reflecting the scene imaged by the lens up to an eye-level viewfinder (or onto the rear LCD screen). This mirror flips out of the way just before the shutter opens, allowing the light from the scene to reach the camera's sensor.

The mirror mechanism takes up a significant amount of space, meaning that DSLRs are bulkier than other camera types, such as compact cameras and MILCs (see right). However, they are still the camera of choice for the majority of professional portrait photographers, due to their speed, reliability, and durability.

As most DSLRs are based on long-established systems that pre-date digital capture, a huge number of lenses is available, giving a range of options for different shooting situations, lens effects, and price points. They are also compatible with additional accessories that will enhance your portraiture, such as flash units and triggers for studio lights.

DSLRs fall into three categories—entry-level, mid-range, and top-end, with increased build quality and more sophisticated features available at the higher price points. Generally speaking, the more you spend, the higher resolution you will get, as well as ever-increasing ISO ranges that enable low-light photography. Some top-end DSLRs use full-frame sensors, which offer the best image quality—albeit at a premium price.

However, it is important to realize that the camera you choose is only part of the image-quality equation—a top-end camera can easily have its performance curtailed if you fit a low-end lens, while a mid-range camera can excel with the highest quality optics attached. Therefore, whatever your budget, it is a good idea to make sure you've got enough left over for a top-spec lens, rather than investing everything in a camera.

MILC

Sensor Size

Above: The Olympus OM-D EM-5 Mark II (above left) might look like a classic 35mm SLR, but it is in fact a mirrorless digital camera, as is the compact-style Sony Alpha A5100 (above right).

Above: This is the full-frame sensor found in Canon's pro-level EOS 1D X camera. However, most cameras use smaller sensor sizes, such as APS-C or Micro Four Thirds.

Mirrorless interchangeable lens cameras (also known as MILCs or compact system cameras/CSCs) are typically much smaller than DSLRs because they don't use an internal mirror to reflect the scene up into the viewfinder. Instead, the scene is shown on an electronic display on the back of the camera.

The lack of a mirror allows the lens to sit much closer to the sensor, and this means that lenses don't have to be as large as those on DSLRs to let an equivalent amount of light through. With smaller camera bodies and smaller lenses, MILCs are far more portable than most DSLRs, yet they have image sensors of comparable size and image quality to DSLRs.

MILCs are also quieter in operation than DSLRs, as there's no mirror to flip up before a shot is taken. With their more discreet profile this makes them well-suited to street photography or candid portraiture, where the appearance of a more obvious DSLR may attract too much attention.

The downside is that MILCs are a relatively new breed of camera, so current body, lens, and accessory choices are more restricted than for DSLRs. However, if you already have a lot of DSLR lenses, you can get an adaptor that enables you to use them on some types of MILC.

It is also worth noting that the autofocus systems aren't yet as good as those found in DSLRs. Although this is improving with each new model, it can prove frustrating in low-light situations or when your subject is moving.

Pixel count is often considered to be the most important factor when it comes to choosing a digital camera, but the *size* of the sensor is actually of more importance.

A sensor is made up of millions of photosites, each one responsible for gathering the light that will generate a single pixel in the final image. Larger photosites will therefore gather more light, so in general will produce a better image. This means that a larger sensor will typically perform better than a smaller sensor with the same number of pixels, which is why smartphones and compact cameras struggle in low-light situations compared to MILCs and DSLRs.

There are currently three sensor sizes used in MILCs and DSLRs: Micro Four Thirds, APS-C, and full frame. Micro Four Thirds sensors are found in MILCs from Olympus and Panasonic, and measure 17.3 x 13mm, while the slightly larger APS-C-sized sensor (around 23.6 x 15.5mm) is the mainstay for most entry-level and enthusiast DSLRs. Top-end DSLRs use full-frame sensors, which measure 36 x 24mm (the same as a 35mm film frame).

Lenses

Your images will only ever be as good as the lenses you use, so don't blow all your budget on an amazing camera body and end up with a cheap lens. Professional photographers tend to upgrade their camera body every two to five years, but top-quality lenses can last much longer, so consider them a long-term investment: cameras wear out, but lenses don't.

Lenses that are included with entry-level and mid-range camera bodies tend to be lower quality, made from less expensive materials, and with limited aperture ranges. Although they will get you started with a camera they will never give the best results. Instead, get the very best lens you can afford, and you will reap the rewards with superior image quality.

Above: A zoom lens has variable focal lengths, allowing you to adjust the framing of your shot without needing to move closer to or further from your subject.

Focal Length

The focal length of a lens refers to the magnification of a scene that it provides. Wide-angle focal lengths, such as 18mm or 24mm, will enable you to fit more of a scene in, but they are best for group portraits. If you want to fill the frame with a single subject, then you would need to move in very close to him or her. Not only could this feel intimidating, but it will also result in heavily distorted portraits.

Telephoto lenses, with focal lengths of 85mm or longer, have a much narrower angle of view, which enables you to crop in close to one part of a scene or subject. However, this typically means you have to work from a greater distance, so with long telephoto focal lengths this can make it harder to interact with your subject or simply impossible to get the shot you want in a small room.

Despite this, telephoto focal lengths produce far more flattering portraits than wide-angle lenses, and can feel less intimidating as they are used further away from the subject.

A mild telephoto focal length in the region of 85–105mm is often cited as the "ideal" portrait lens, but most professional photographers would typically have a 24–70mm lens for wider angle work and a 70–200mm lens for close-up work. Wedding photographers may also add a 16–35mm zoom for group shots and so they can include more of the venue in shots, and possibly a "fast" prime lens as well.

Crop Factor

Whether you choose a wide-angle lens or a telephoto lens, the actual focal length will appear to be magnified unless you have a camera with a full-frame sensor. This is because smaller sensors effectively "crop" the image projected by the lens (an APS-C sized sensor will appear to extend the focal length by 1.5–1.6x, while a Micro Four Thirds camera will appear to increase it 2x). This means that a 50mm lens would have a focal length of 50mm on a full-frame camera; an effective focal length of 75–80mm on a camera with an APS-C sensor; and an effective focal length of 100mm on a Micro Four Thirds camera.

It is important to note that the actual focal length doesn't change (a 50mm lens is always a 50mm lens), only the *effective* focal length.

Maximum Aperture

A wide aperture will enable you to isolate your subject through blurring the foreground and background. It will also allow more light through the lens, which means you can work in lower light conditions and achieve higher shutter speeds (minimizing camera shake) at lower ISO settings (for optimum quality). For this reason, lenses that offer extremely wide apertures are referred to as "fast lenses."

Professional portrait photographers often take the vast majority of shots at the widest end of the aperture scale—f/1.8, f/2.8, and f/4, for example—yet many entry-level zoom lenses only offer a maximum aperture of f/3.5–5.6, which really limits your options.

Look for a good quality prime lens that opens up to f/1.8, or a zoom lens that offers a fast, constant aperture throughout the focal range.

Zoom vs. Prime Lenses

Zoom lenses offer a range of focal lengths, which means you can adjust the way you frame a shot without physically moving yourself nearer or further away. However, make sure you check the maximum aperture throughout the focal length range of a zoom lens, as some models don't

Above: A prime lens has a fixed focal length, but the image quality will be much better than a zoom lens at a similar price point. The maximum aperture will typically be significantly faster as well.

17mm
This shot was taken with a wide-angle lens. Filling the frame meant getting close to the subject, which has distorted his features.

50mm
Using a mid-range, or "standard" focal length has produced a distortion-free result that reveals some of the subject's surroundings.

85mm
A mild telephoto focal length avoids distortion and crops out unwanted background details—this is the classic focal length for a "portrait" lens.

maintain the same maximum aperture throughout the zoom range. Having a consistent, wide maximum aperture at all focal lengths adds to the cost of a lens, but also makes it more versatile.

Prime lenses have a fixed focal length, which makes it easier to design and less expensive to manufacture. As the optical system only needs to be optimized for a single focal length, a prime lens will deliver superior image quality to a zoom lens at a comparable price point, and may even rival more expensive pro-level zooms. However, you do need

to work harder, as you will have to move yourself or your subject to achieve different crops.

For portrait photography, 50mm, 70mm, 85mm, and 105mm prime lenses are ideal, as they provide a good working distance between you and your subject and avoid the distortion created by a wide-angle lens.

Build Quality

The more you spend on a lens, the better the maximum aperture and focal length range available to you. However, there are additional benefits to high-end lenses, such as improved weather resistance, a more robust build quality, and faster, quieter focusing. The appearance of out-of-focus areas in shots taken with wide apertures—known as "bokeh"—also looks more pleasing in images captured with a high-quality lens.

Accessories

Once you've got your camera and lens choice sorted, there are optional accessories to consider. In addition, if you are shooting professionally, you need to consider having spares of your entire kit. Although this may seem like an unreasonable additional outlay, cameras, lenses, and supplementary kit can occasionally fail, and if you are photographing portraits that can't easily be re-shot, you could be risking your professional reputation if you don't have backups. In addition, you can have different lenses on each camera body, enabling you to switch between lenses more quickly than if you had to turn your camera off, remove one lens, and fit another.

Filters

Having invested in a high-quality lens, many people will attach a filter onto the front of the lens to protect it from scratches—the theory being it is far less expensive to replace a filter than it is to replace the front lens element. Traditionally, the most common filters used for this purpose were UV and skylight filters, but dedicated "protection" filters are now a better option. However, it is worth remembering that a filter affects image quality, so it is worth spending a little more to get a decent filter.

Camera Bags

Camera bags are not just for transporting your kit around in—they protect it too. When working outdoors you will need to be mindful of the risk of condensation and avoid exposing your camera body and lens to extreme changes in temperature, especially when leaving a warm building to go outside in winter. The simplest way to do this is to keep everything inside a good quality bag for long enough that the temperature inside gradually matches that outside.

Memory Cards

Memory cards store your image files as you shoot, and can be taken out of the camera in order to move or copy their contents to a computer. The most common types are Secure Digital (SD) and CompactFlash (CF)—the type you need will depend on which camera body you are using.

Memory cards come in a variety of different capacities and transfer speeds, which determines how many images they can store and how quickly they can read and write data. The simple rule is that larger capacities and faster speeds cost more.

If you are shooting Raw files (which contain unprocessed and uncompressed image data), smaller capacity cards can fill quickly, whereas JPEG files are compressed and require less space. An increasing number of cameras have two memory card slots, enabling you to backup your images as you shoot.

Above: CompactFlash (above left) and Secure Digital (above right) memory cards come in a range of capacities and speeds, depending on your requirements and budget.

Tripods

If you want to shoot in low-light levels with a slow shutter speed, avoiding camera shake, you will benefit from using a tripod. However, tripods take time to set up, are cumbersome to transport around, and don't necessarily allow you to shoot in a spontaneous way. Instead, lean on the back of a chair or against a door-frame to support yourself while shooting, or practice adopting a steadier posture, with your elbows close to your body to minimize camera shake.

Alternatively, you can increase your ISO, set a wider aperture, or use external flash so you can achieve a faster shutter speed—more on all of these options later. Many cameras and lenses also feature integrated image stabilization technology, which can also reduce your need for a tripod.

Above: A tripod, such as this Induro Adventure AKB2, can be invaluable when it comes to holding your camera steady in low-light conditions, or any other time when you want to use a slow shutter speed.

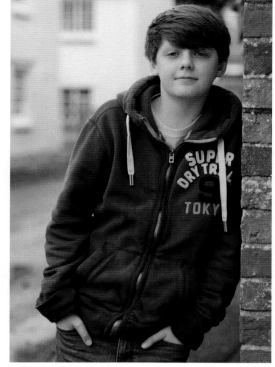

Above: This photograph was taken without a reflector, on an overcast day.

Above: Here, a matt gold reflector was angled toward the subject's right side.

Above: For this shot, a silver reflector was angled toward the subject's left side.

Reflectors

Reflectors are simple, low cost, but effective accessories that help to fill in shadow areas. They come in a variety of sizes, but a reflector with a diameter of around 3ft (1m) would generally be considered the minimum useful size for varied portraiture situations.

There are several types of reflector, including circular, collapsible versions that will usually need someone else to hold them; ones with handgrips that you can hold with one hand while you use your camera with the other hand; and large reflectors with frames that can be used freestanding. These reflectors are also available in a range of color options:

- **White:** Bounces back a subtle light; needs to be used closer to the subject or on brighter days.
- **Silver:** Bounces a stronger light than white, without coloring it. Good if light levels are

lower or if the subject is further away from the reflector. Can be overpowering or make the subject squint if used too close to the subject on a very bright day.
- **Gold:** Bounces a stronger light than white, and adds a warm tint that replicates the "golden hour." Good for warming skin tones on a cloudy day or in shade, but can look overpowering and fake if not used subtly.
- **Hybrids:** Stripes of white and gold or white and silver are combined across the face of the reflector for a more subtle effect than gold or silver alone.
- **Black:** Used to absorb light and create shadows (rather than fill them).

Double-sided reflectors that combine two different colored panels, or reflectors with removable covers that allow three or four color

options (plus, sometimes, a diffusion panel) offer increased flexibility, while still offering portability.

When you are using a reflector, it needs to be angled so that it bounces the light back onto your subject's face. The closer it is to your subject, and the stronger the ambient light levels, the stronger the effect it will have.

Diffusers

Diffusers come in similar sizes and shapes to reflectors, but are made of a thinner material that is designed to soften the light as it passes through it, rather than block and reflect it. Diffusers are positioned between the subject and light source, and are typically used when the light would otherwise be harsh and direct.

Lighting

Photography isn't a cheap pursuit and it's easy to spend a huge amount of money on equipment that will end up being largely unused. Studio lights definitely fall into this category, so before getting out your wallet, think about what you want to achieve with the kit.

If you're going to set up a permanent home studio, it perhaps makes sense to get proper studio lights, but if you want more flexibility with regards to your location, it's probably better to get a few battery powered flashes instead. You can use them in a similar way to studio lights, but they are far more portable.

Studio Lights

Studio flash kits range in price and specification, but they all share one thing in common: the ability to produce a burst of flash at a pre-determined power level. However, you'll get more control, better build quality, and additional features if you opt for higher-end versions.

There are two types of studio flash, but the most common type for a home studio are

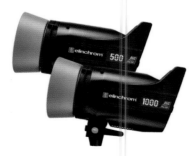

Above: These pro-level Elinchrom studio flash units come in different power options—the faster and more powerful versions cost a little more.

"monoblocs." These come as single units that plug directly into an electrical outlet. All of the controls for the flash are built into the flash head, and are adjusted using buttons, dials, or touch controls on the rear of the unit.

The alternative flash type—which tends to be seen more in commercial studios—uses independent flash heads that plug into a power pack. Multiple flashes can be plugged into a single pack, and the power it generates can be distributed to each flash using controls on the power pack. The advantage with this type of setup is that the flash heads are relatively simple and inexpensive, so should one break mid-shoot, you can simply plug a new flash into the pack and carry on shooting.

In both cases, studio flash usually has both a flash tube (that generates the flash) and a modeling light, which is a continuous, lower intensity bulb that stays on throughout the shoot. This can help you decide where to position your flash heads relative to your subject, as you will get an idea of how the light will fall on their face and body. Modeling lights also provide enough light to allow the camera to focus accurately, but not so much light that the subject's pupils shrink in response. Enlarged pupils are an unconscious sign that someone is attracted to you, so photographing a subject whose pupils are widened results in a more appealing final image.

A lower cost alternative to studio flash is continuous lighting that uses daylight-balanced fluorescent bulbs. As you can see how the lighting will look, they remove a lot of guesswork, and also mean you can use your camera's regular exposure metering systems. However, fluorescent bulbs lack the power output of flash, restricting you to higher ISOs, wider apertures, and slower shutter speeds.

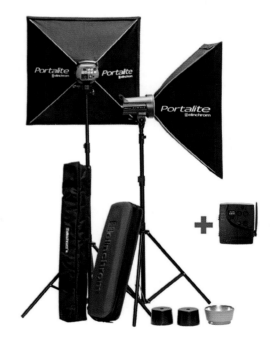

Above: This studio lighting kit packs down into carry cases, making it idea for location shoots. The set comes with two softboxes, two stands, and a wireless transmitter, which is everything you need to get started with studio portraits.

Lighting Accessories

If you buy a lighting "kit" it will typically include stands for the lights and one or more modifier attachments, such as umbrellas or softboxes. These light modifiers attach to the front of the flash and subtly alter the quality of light, so choose a kit with the right accessory for your purpose, or be prepared to buy extra attachments.

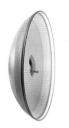

Above: A beauty dish is ideal for making the subject's skin sparkle in close-up portraits, due to its unique blend of soft and hard lighting.

Beauty dish: These are commonly used for close-up portraits as they have a unique lighting effect that can show off makeup really well and make skin sparkle. However, if your subject has anything less than flawless skin and makeup, a beauty dish will highlight those imperfections.

Honeycomb grid: A grid ensures that the light from the flash doesn't spread. Keeping it in a narrow, directional beam makes the light strongest at its center and weaker at the edges, allowing you to light a specific area of the shot in a more subtle way than is achievable with a snoot.

Softbox: These are the most popular accessory for portrait photography, as they produce a soft, diffused light that is very flattering. A softbox fits over the front of a flash, with the light passing through one or more layers of diffusion material before it reaches the subject. Softboxes can be square, rectangular, or octagonal (known as an "octabox") and come in a wide range of sizes—the larger the softbox, the softer the light will be.

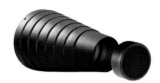

Above: The long, conical object at the left is a snoot, which focuses the light into a small, hard beam. The accessory near its tip is a honeycomb grid that only allows light to pass through in a straight line.

Snoot: A snoot is a conical attachment that narrows the light from the flash, producing a small beam of hard, directional light that is similar to a spotlight. Snoots are best suited to rim-lighting or used as a hair light.

Spill kill: These simple reflector dishes concentrate the light into a narrow beam, minimizing how much gets "spilt" outside of that beam. They are ideal for lighting backgrounds and hair, or used as a rim light, but are quite harsh and unflattering for faces.

Umbrella: There are two versions of umbrella: translucent ones that act as a diffuser that you shoot through, aiming the flash toward the subject; and reflective umbrellas where the flash is aimed away from the subject, into the umbrella, and bounced back onto them from a reflective white- or silver-lined surface. As with reflectors, white produces a softer light, while silver has a more powerful, but harsher quality.

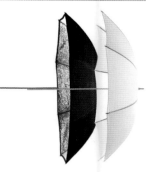

Above: The umbrella at the left is used with the flash pointing away from the subject—the silver lining reflects the light from the flash back onto the subject. The white umbrella at the right is used with the flash head facing toward the subject—the light is diffused as it passes through the translucent umbrella.

Wireless Triggers

Rather than having cables connecting your camera to your flash heads, a wireless trigger system will give you more freedom of movement and far fewer tripping hazards. Infrared triggers require the receivers attached to the flashes to have line of sight to the trigger (which is usually mounted in the camera's hotshoe).

Alternatively, you can use radio triggers, which use radio waves to trigger the flash. These don't necessarily require line of sight (they can even work through walls), but do require a clear channel so the signal isn't obstructed.

Flash Meters

When using studio flash, the camera cannot determine the exposure for you, as the lighting will be different when the shot is taken. Therefore, you will need to use Manual mode for studio photography and you will also need to use a flash meter to determine the exposure. Although it appears complex, using a flash meter is actually very straightforward—you set your chosen ISO on the meter and ask your subject to hold the device in front of their chin while you trigger the flash. The flash meter will show which combination of shutter speed and aperture will give the correct exposure. If you want to use a different aperture setting, you can change the f/stop on the flash meter and it will adjust the shutter speed accordingly.

You can then transfer the exposure settings (aperture, shutter speed, and ISO) to the camera and you should get a correct exposure straight away. Unless you change the power setting of the flash(es) or the distance between the subject and the lights, you'll only need to take a light reading once, as the exposure is based solely on the flash-to-subject distance, rather than the camera-to-subject distance.

Flash meters can also be used to read the ambient light in any situation, not just when you are using flash. They are often more reliable than your camera's built-in metering, as a flash meter measures the light falling onto the subject, rather than the light being reflected from it. This means a flash meter will not be fooled by high-contrast scenes, those with uneven lighting, or scenes that are overly bright or dark.

Above: Sekonic's Flashmate L-308S is an entry-level flash meter that can still give both ambient and flash exposure readings, in ultra-precise $^1/_{10}$-stop increments.

Portable Flash

A battery powered hotshoe flash offers more powerful and flexible lighting than built-in, on-camera flash. If you're willing to use the flash in manual mode, you won't need to spend much money at all, but if you want the camera to set the flash exposure you will need to invest in a dedicated flash that is compatible with your camera model. In both instances, the more you spend, the more features and power you will get.

If you are planning to use portable flashes as an alternative to studio lighting while on location, you may want to invest in more than one, so you can mimic multiple light studio setups. If you're going to use the flashes off camera you'll also need stands for them and wireless transmitters/receivers to trigger them remotely. It's also worth investing in some light modifiers, such as mini softboxes or umbrellas, to improve the quality of the light that falls on your subject, and colored gels so you can balance the color temperature of the flash with the ambient light (flashes emit daylight-balanced light).

Above: High-end battery powered flashes, such as Canon's Speedlite 580EX II, are remarkably versatile, especially when multiple off-camera flashes can be controlled wirelessly by the camera.

Backgrounds

What do you want to be visible behind your subject? If you're shooting on location, you may want to have the environment around you visible, but for indoor shoots you might prefer a cleaner background, such as a plain white, black, or colored backdrop. You can buy fabric or paper rolls that are made specifically for photography use; the size you'll require depends on whether you want to be able to capture full-length shots as well as close ups, and how many people you want to photograph at any one time.

Right: Paper background rolls are available in myriad colors, while fabric backdrops come in both plain and patterned finishes. Despite the many options, plain black and plain white are most commonly used for studio shots.

Focal length: 70mm

Aperture: f/8

Shutter speed: 1/180 sec.

ISO: 100

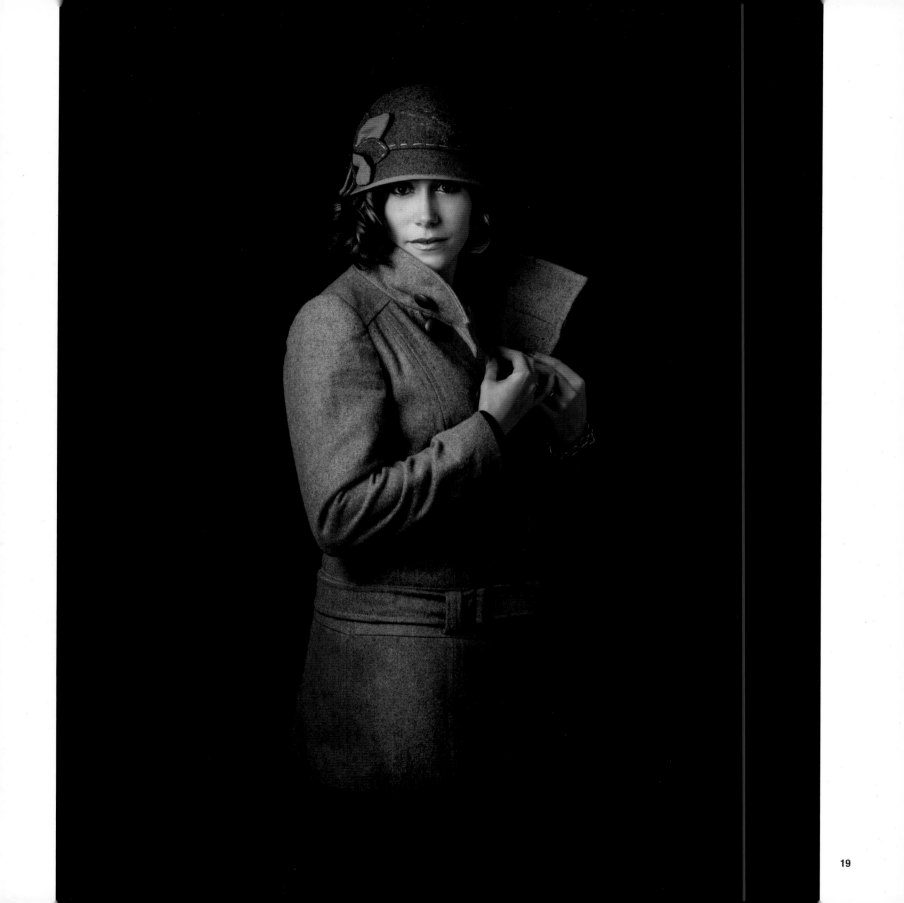

Chapter 2
Technical Skills

Even after you've selected a model and a location there are hundreds of choices to make when taking a portrait. Yet while this may seem daunting, it enables a creative difference between images taken by two photographers, even if they are photographing the same person, in the same location, with the same camera kit.

One of the first things you need is an appreciation of the technical capabilities and limitations of your camera. This will enable you to start predicting how the camera will record different scenes, and how you can adjust its settings to achieve a specific outcome.

As an extension of this, you may want to start exploring your camera's Manual mode. Although it will slow you down at first, this is the best way to understand how the aperture, shutter speed, and ISO combine to create the final exposure. These key technical skills are explored in this chapter and with sufficient practice it will quickly become second nature. Soon you will be able to accurately guess which settings will allow you to achieve your desired result in a range of situations.

Right: The subject is silhouetted, the background blurred, and the sparks from the tool captured as white pinpricks and wriggly light trails. Each of these elements is a result of the technical choices made by the photographer when deciding which camera settings to use.
Focal length: 165mm
Aperture: f/4
Shutter speed: 1/1000 sec.
ISO: 1100

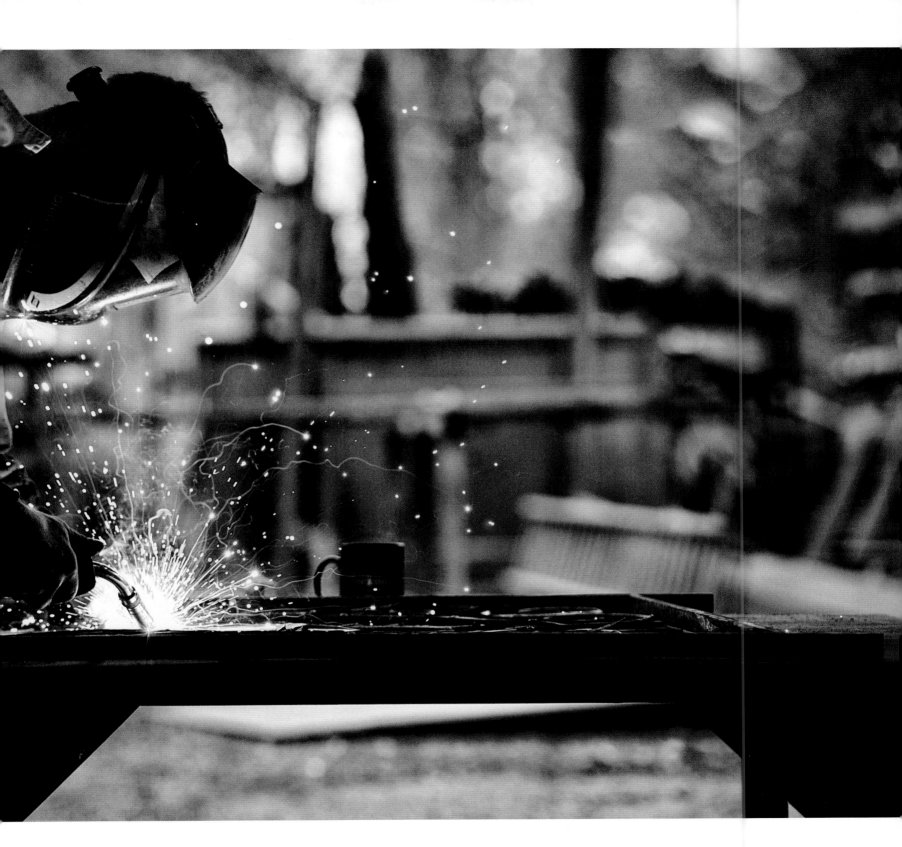

Exposure

Above & Right: This shot and its histogram show a scene that has been underexposed, with insufficient light contributing to the final exposure. Accordingly, the histogram is shifted toward the left side, indicating lots of shadow areas.

Above & Right: Here the scene is overexposed. The histogram is shifted toward the right side of the graph, with some of the pixels stacked against the edge. This indicates there are areas of pure white in the image, where detail has been lost completely.

Exposure is the technical term for the creation of an image, and a photograph can be deemed underexposed (too dark), correctly exposed, or overexposed (too light). However, this is something of a subjective judgement. As photography is a creative art, a "correctly exposed" photograph should be seen as the exposure that is as the photographer intended (which could be lighter or darker, depending on the desired outcome).

Exposure Essentials

An exposure is created through the combined effects of the aperture, shutter speed, and ISO, which respectively control how much light is allowed through the camera lens, how long the light strikes the sensor for, and how much light is needed to start with.

The way in which these controls interact will create a brighter or darker image, and your task as the photographer is to balance these three elements so that the correct amount of light contributes toward each exposure you make, in the way that you intended.

In a scene where there is less light available— indoors or at dusk, for example—you can manipulate the camera settings to maximize the amount of light contributing to the exposure, so that the image isn't underexposed. Conversely, on a very bright day, you can adjust these settings to minimize the amount of light contributing toward the exposure so it doesn't become overexposed. In both cases, the final image should look as *you* planned it to.

Often the photographer's intention is to capture an image that reflects how the scene appeared to the human eye, but there is a fundamental difference between the way in which our eyes and a camera work. Our eyes automatically adjust to changing light levels, whereas cameras are programed to set an exposure that will render an average midtone correctly in the ambient light. While most cameras will often make a very good job of this, they can struggle in certain situations, such as when there is bright light behind your subject, or when a scene has a high level of contrast.

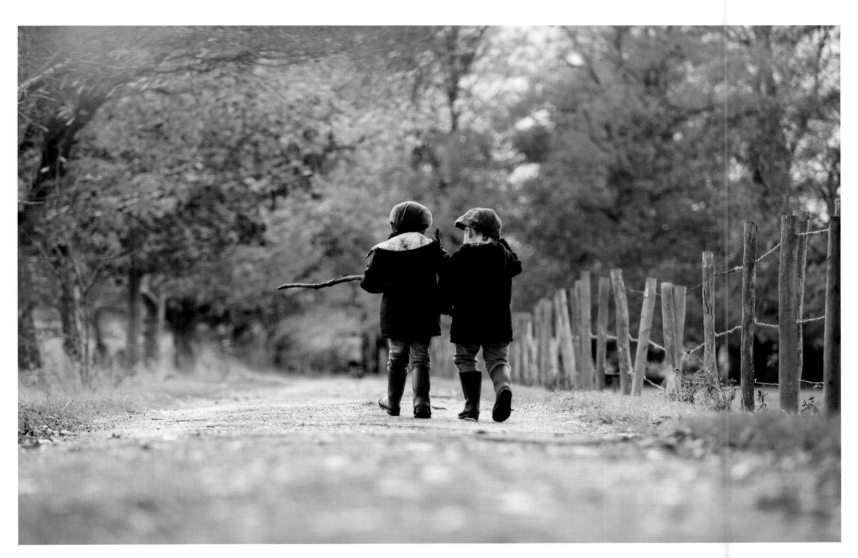

Above & Right: When the scene is exposed correctly, the histogram is fairly evenly spread across the graph, indicating that this scene has a range of tones in it from dark to light. The histogram isn't stacked at either side, which indicates that no detail has been lost in either the shadow or highlight areas.

Focal length: 200mm

Aperture: f/4.8

Shutter speed: 1/500 sec.

ISO: 800

Histograms

A histogram is a graph that you can display either on the back of your camera or in image-editing software. The graph shows the spread of tones in an image, from pure black (indicated at the left of the graph) to pure white (shown at the right of the graph). Consequently, an image with a lot of light tones will have a histogram that peaks toward the right side of the graph, whereas a darker-toned image will have a histogram that is shifted to the left. An image with a wide range of tones will have a histogram that is more evenly distributed across the graph.

There isn't a correct shape to look out for, but you can use the histogram to help you judge whether the spread of pixels looks right for the particular scene you are photographing—if you are photographing a predominantly dark subject, but the histogram is shifted to the right, this is almost certainly a sign that the image is overexposed.

If there are pixels stacked at either edge of the graph, then this warns you that you are likely to have lost image detail in that area, which is referred to as "clipping." This means that lighter-toned areas of the image may appear pure white and/or darker-toned areas may appear pure black, depending on which end of the histogram is clipped. This occurs when the exposure is

Right & Below: The pixels on this histogram are grouped toward the left side, but this doesn't mean that the exposure is incorrect. Because it is a "low-key" shot, with lots of shadow areas, the histogram is simply indicating that the pixels in the image are mainly darker toned.

Focal length: 92mm

Aperture: f/6.3

Shutter speed: 1/100 sec.

ISO: 100.

significantly brighter or darker than required, or when the scene has a very high level of contrast that the camera simply cannot deal with in a single shot (see Dynamic Range, right). Many cameras will also show clipped highlights as flashing areas on the image preview when you review the image.

Clipping can cause problems when images are printed, as it affects the way the ink is laid down—no ink will be used in clipped highlight areas, for example, allowing the paper to show through. Even if you intentionally want a shot to contain areas without detail in the darkest shadows or brightest highlights, for printing purposes it is worth tweaking the image so that the histogram is just a touch away from either extreme.

Above & Right: In this shot, clipping has occurred, with lost detail in the brightest areas of the scene. This is indicated in blue on the second shot, and also by the pixels stacked at the right edge of the histogram. However, in this instance the clipping is intentional—the aim was to create a pure white background.

Focal length: 160mm

Aperture: f/8

Shutter speed: 1/180 sec.

ISO: 100

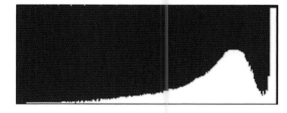

Dynamic Range

The dynamic range of a camera is the range from light to dark that it can record in a single exposure. This is typically measured in "stops," with most current DSLRs possessing a dynamic range of 10–14 stops.

The scene you are photographing also has a dynamic range, which is again a measure of the lightest-to-darkest tones, usually given in stops. If the dynamic range of the scene is lower than that of the camera, then you can record all of the detail in the scene—from the darkest shadow to the brightest highlight—in a single exposure.

However, a backlit or high-contrast scene may have a dynamic range that exceeds that of the camera. In this situation you will only be able to capture a limited portion of the visible detail, so clipping is inevitable—some areas of the image will be recorded as pure white or black, depending on your exposure settings.

In this instance you have two options—accept that you will have to compromise on image detail at one end of the tonal range, or take a number of exposures that cover the full dynamic range of the scene and combine them in postproduction.

Aperture

The aperture is the opening in the lens that allows light to pass through to reach the camera's sensor. The size of the aperture can be changed, just as the pupil in your eye shrinks in harsh sunlight and expands in the dark, so a wider aperture can be used to let more light in (causing a brighter exposure), while a smaller aperture restricts the amount of light (for a darker exposure).

The size of the aperture is given as an "f/stop," which is the focal length of the lens divided by the

Above Left: In this portrait, a small aperture has been used, giving a deep depth of field. This has resulted in a portrait where the background details compete with the subject's face for attention.

Focal length: 105mm

Aperture: f/11

Shutter speed: 1/20 sec.

ISO: 1100

Above: As the background doesn't add anything to the image narrative, the portrait is stronger when it is blurred out. Here, the background is out of focus enough to add interest, without distracting from the subject.

Focal length: 105mm

Aperture: f/2.4

Shutter speed: 1/500 sec.

ISO: 1100

diameter of the lens opening. In this way, a 50mm focal length with a 12.5mm opening would be indicated by an aperture setting of f/4, while setting f/8 on the same lens would indicate an opening of 6.25mm. As this demonstrates, the lower the f-number, the wider the lens opening (aperture), so a setting such as f/1.4 or f/2.8 will allow significantly more light to pass through the lens than a setting such as f/16 or f/22.

However, increasing the size of the aperture to allow more light into the camera has a side effect—less of that light will be focused. This means that areas in front of and behind the point of focus appear more out of focus the further they are away from that point. The amount of the image that is in focus is referred to as "the depth of field," with wide aperture settings (f/1.4 or f/2.8, for example) delivering a very shallow depth of field. This effect is commonly used in portrait photography to draw the viewer's attention to a key part of the image (usually the subject's eyes), while allowing the foreground and background to fall out of focus.

Above Right & Right: When shooting with a wide aperture, the depth of field becomes very shallow, making accurate focusing essential. In the first shot (above right), the subject's eye furthest from the camera is in focus, which looks unusual. In the second shot (right), the closest eye is sharp, making for a stronger portrait.

Focal length: 195mm

Aperture: f/2.8

Shutter speed: 1/250 sec.

ISO: 200

Bokeh

Bokeh is a Japanese word that translates most closely as "blur" and is used when discussing the esthetic quality of out-of-focus areas of photographs. Although a subjective judgement, "bad" bokeh tends to refer to out-of-focus objects in the background that have harsh outlines, or when blurred points of light are captured as edged polygons rather than smooth circles. "Good" bokeh is when the background is blurred so it is smooth, creamy, and complementary to the overall image, rather than an unwanted distraction. If, for example, you are photographing someone at dusk, and there are colored lights in the background, using a good quality prime lens at its widest aperture will ensure the lights become beautiful, soft circles of color glowing behind your subject.

Right: Out-of-focus lights behind the subject add striking background interest to this portrait. The points of light have become blurred circles with smooth edges, adding an edgy fashion feel to the shot.

Focal length: 110mm

Aperture: f/3.5

Shutter speed: 1/160 sec.

ISO: 1250

Shutter Speed

If the aperture is like the pupil in a human eye, the camera's shutter is like an eyelid—light can only enter while it is open. The length of time that the shutter is open for, allowing light to fall on to the camera's sensor, is the shutter speed, which is typically measured in fractions of a second. "Fast" shutter speeds range from 1/250 sec., and faster, while "slow" shutter speeds are those lasting 1/15 sec. or longer. The typical shutter speed range on a DSLR extends from 1/2000 sec. down to 30 seconds, with longer exposure times possible if you use the camera's Bulb (B) mode.

Slow Shutter Speeds

Extending the shutter speed means that light is allowed to reach the sensor for longer, enabling brighter exposures, even in darker environments. A slower shutter speed also enables motion to be recorded as blurred elements in a scene. This is because anything that moves during the time the shutter is open will be recorded in multiple places in the frame.

Avoiding Camera Shake

An unwanted side effect when using slow shutter speeds is camera shake. This happens when you are handholding the camera and your own movements—such as breathing and other tiny, natural body movements—cause the whole image to be blurred. In all instances there will be a minimum "safe" shutter speed, beyond which shake is likely, but this depends on a number of things. The first is your ability to hold steady—some people can still all motion easily, while others naturally tremble more.

Focal length also has an impact on camera shake, and the longer the focal length, the more apparent any camera shake will be. The general

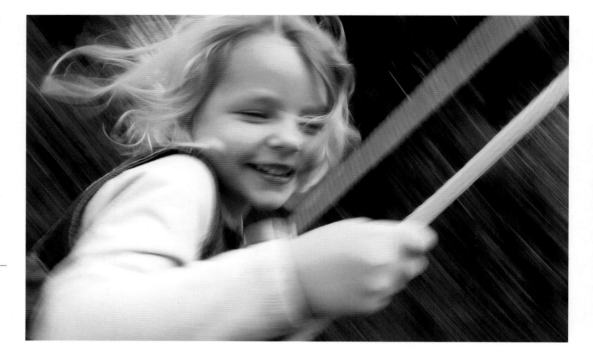

guideline here is to use the "reciprocal rule," which dictates that the shutter speed should be equal to or higher than the focal length of your lens. For instance, if you are using an 85mm lens, your shutter speed should be 1/85 sec. or faster in order to avoid camera shake. Test yourself by taking shots at different shutter speeds and noting when camera shake starts to affect your images. If your camera or lens has image stabilization, activating this will typically allow you to extend your "safe" shutter speed by 3 or 4 stops.

You can also eliminate the risk of camera shake by using a tripod and a remote release, but tripods can be very limiting in portrait photography. Instead, you could use a wider aperture and/or increase the ISO so you can use a faster shutter speed. Alternatively, you can try to steady yourself by leaning against a wall or door frame, or supporting your camera on the back of a chair. Even adjusting your stance to a more stable one can be enough to prevent camera shake.

Above: A slow shutter speed can help to capture a sense of movement. In this shot, the blur helps to convey the look and feel of the world as seen from a swing, as well as the sheer joy of flying through the air!

Focal length: 20mm

Aperture: f/22

Shutter speed: 1/15 sec.

ISO: 200

Fast Shutter Speeds

In brighter environments, or when you want to freeze motion, a faster shutter speed is needed. If you wanted to use a wide aperture on a bright day, for example, you would need to combine it with a fast shutter speed to avoid the image becoming overexposed. Equally, if you want to photograph a moving subject without any motion blur, a fast shutter speed will be required.

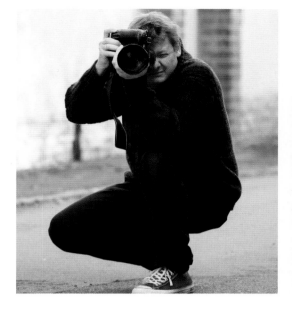

Above: Changing your posture can help minimize camera shake when shooting at slower shutter speeds. Here, the photographer's left arm is steadied on his knee. This will minimize movement in a crouched position, helping to maintain image sharpness.

Setting the Shutter Speed

Select Shutter Priority on your camera's mode dial; on most cameras this is marked as "S," although Canon labels it "Tv" (for Time value). Turn the main control dial to adjust the shutter speed, noting that it will usually be displayed as a full number, rather than a fraction (so a shutter speed of 1/100 sec. will show as "100," while a 1/2 sec. shutter speed will be displayed as "2").

Each full adjustment up or down the scale (and adjustment of 1 "stop") will halve or double the length of time the shutter is open for, which will also halve or double the amount of light that reaches the sensor. However, most cameras allow shutter speed adjustments to be made in ½- or ⅓-stop increments for greater precision.

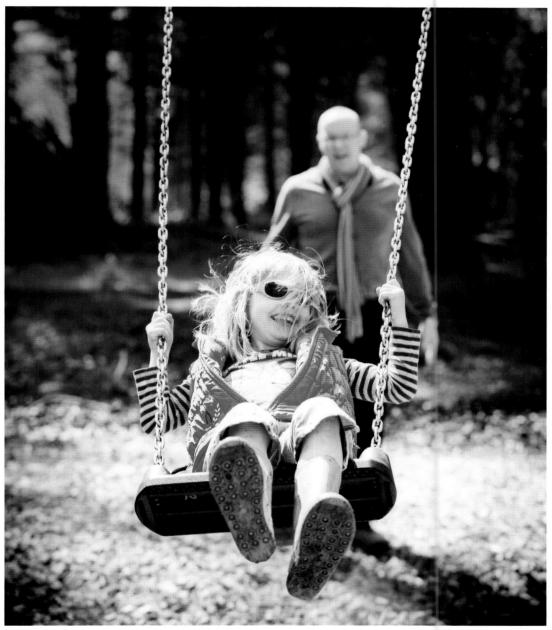

Above: Another portrait of a child on a swing, but this time the motion has been frozen through the use of a faster shutter speed. To ensure enough light reached the sensor during this brief exposure, a wide aperture was needed. This has resulted in a shallow depth of field, so while the girl is sharply focused, her father is blurred in the background.

Focal length: 80mm

Aperture: f/4

Shutter speed: 1/1250 sec.

ISO: 320

ISO

ISO was originally used to indicate the sensitivity of film; ISO 100 film is less sensitive, so ideal for use in brighter situations, whereas ISO 400 film is more sensitive and therefore better for indoor shots, for example. There is a trade-off for using film that is more sensitive, though—as sensitivity increases, so too does "grain," which is the inherent light-sensitive part of the emulsion.

The ISO setting on your digital camera plays a similar role, in that it effectively determines how sensitive the camera's sensor is to light. However, rather than changing the physical characteristics of the sensor (which is simply impossible), it does this by adjusting the amplification of the signal generated from light reaching the sensor—a higher ISO setting means greater amplification.

Image Noise

Just as grain increases with film speed, so ramping up a digital camera's ISO creates certain artifacts. In this instance, the side effect is digital "noise," which you can think of as the visual equivalent of playing an old recording at a high volume—as the volume increases, any background hiss eventually becomes audible.

In a digital photograph, noise is seen as colored pixels in areas that should just be one even tone (chroma noise) or an overall mottled texture (luminosity noise). In both cases it does not have the same quality as film grain, and beyond a certain point can start to obliterate image detail.

Noise is present in all electronic devices that transmit signals, but thankfully it is becoming less of a concern in digital photography as sensor designs and in-camera processing improves. Only a few years ago, any digital photograph taken at ISO 800 or above would have been negatively affected by the presence of noise, but with many of the latest cameras it is now possible to photograph at ISO 3200 without any problems.

Setting the ISO

On most DSLRs, there is an ISO button that you hold down while rotating the main control dial, allowing you to choose the ISO best suited to your shooting conditions. The current setting will be visible on the main control panel while the ISO button is pressed. Typical ISO settings start from 100 and then double (200, 400, 800, 1600, 3200, 6400, and so on), although most cameras offer intermediate settings as well. The lower the number, the less sensitive the sensor is to light. Each time you halve or double the ISO setting, you halve or double the sensitivity—as with shutter speed and aperture, this is a difference of 1 stop.

To fully understand how ISO affects exposure, take a series of shots in different light levels at each setting. Study your images afterward to find

Above: If you are photographing a brightly lit scene, as was the case here, a lower ISO setting will restrict the sensitivity of the camera's sensor to the light. This, in turn, will deliver the maximum image quality.

Focal length: 200mm

Aperture: f/4

Shutter speed: 1/350 sec.

ISO: 200

out at which setting noise becomes visible on your DSLR (particularly checking darker areas where it tends to be most evident). If you have a recent DSLR and/or one with a large sensor you are likely to be pleasantly surprised by how high the ISO can be set before you start to see a detrimental effect on image quality.

Left & Above: When shooting indoors, or when the light levels are low, you will often need to increase the ISO. At extremely high ISO settings, your images will become adversely affected by "noise," which appears as a coarse texture across your image.

Focal length: 98mm

Aperture: f/3.3

Shutter speed: 1/350 sec.

ISO: 9050

Metering Modes

Unless your camera is set to Manual (M) mode, it will measure the amount of light reflected from the scene you want to photograph and use built-in algorithms to decide how best to set the aperture, shutter speed, and/or ISO.

However, it's important to understand that the camera doesn't know what exactly you are trying to capture, so by default it will choose exposure settings that would result in the tones in the image averaging out to a mid-gray tone. For example, if you were shooting portraits on a bright, snowy day, with pure white scenes behind your subject, the camera would expose the scene to render those white tones as mid-gray, resulting in an underexposed image. Conversely, if you were photographing a dark-skinned subject wearing dark clothes, against a dark background, the camera would bring all those heavy tones to mid-gray, leaving you with an overexposed shot.

There are several ways in which you can overcome this, and adjusting the exposure metering mode will change which part of the image frame the camera takes its exposure reading from. This is particularly useful when photographing a scene that is backlit or high contrast, as you can choose a metering mode that will exclude areas that might "fool" the camera. Here's what the different modes mean:

Multi-zone metering: This option is the default metering mode on most cameras, although it is known by a variety of names: Canon calls it Evaluative, Nikon calls it Matrix, and Sony goes with Multi-segment, for example. Multi-

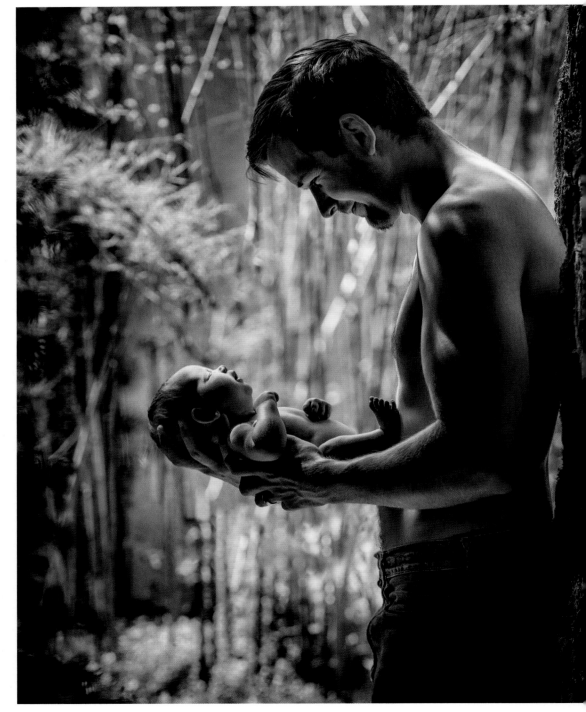

Right: Metering systems can be fooled by backlit scenes. In this instance, spot metering is ideal, as the subject isn't central or taking up the bulk of the frame.

Focal length: 98mm

Aperture: f/4.8

Shutter speed: 1/180 sec.

ISO: 200

zone metering takes light readings from multiple areas across the frame and then averages these readings out to determine the overall exposure. Some systems will also take the focus point into account, and bias the exposure toward that area. Although multi-zone metering works well with most low-contrast scenes, it can let you down when there are extremes of light and dark tones. Using exposure compensation (see page 39) is a quick and easy way of compensating for over- or underexposure when using this mode.

Center-weighted metering: In this mode, the camera meters from a large proportion of the frame, with a bias toward rendering the central tones as an average mid-gray. This mode works well when your subject is in the middle of the viewfinder, and doesn't take into account which area of the image is in focus.

Spot metering: This mode takes a light reading from a small area of the frame—typically as little as 2% of the center of the frame. This is ideal for high-contrast scenes, as you can exclude any overly bright or dark areas from the meter reading, but you need to make sure that the reading is taken from a midtone.

Some cameras allow you to link the spot meter to the active focus point, allowing you to more easily target a midtone area. If your camera doesn't allow this (and the area at the center of the frame isn't a midtone), use your camera's exposure lock, as outlined on the following page.

Partial metering: This mode is similar to spot metering, but it measures the light from a slightly larger central area (typically 10% of the frame).

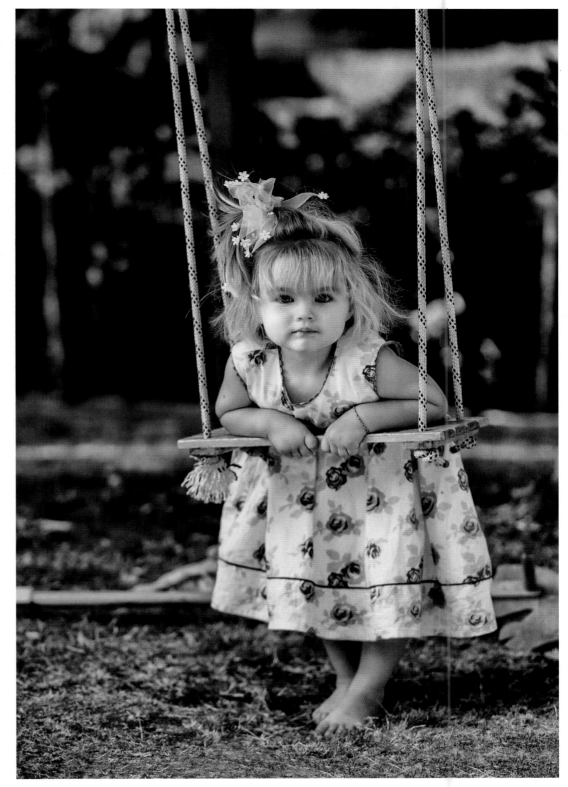

Right: Center-weighted or partial metering would work here, as the subject is in the middle of the frame. Multi-zone metering could be fooled into overexposing the scene by the dark background.

Focal length: 170mm

Aperture: f/4

Shutter speed: 1/250 sec.

ISO: 320

Exposure Lock

Regardless of the metering mode you use, it's important to remember that the camera is looking to set the exposure for a midtone. This means that you need to meter from a midtone area (or an area that would average out to a midtone).

This is particularly pertinent when it comes to using spot or partial metering, as the central metering area may not sit neatly over a midtone. If this happens, you may need to frame the shot differently at first, to make sure a midtone area is at the center of the frame when the camera takes its meter reading.

To do this, frame your shot so the metering area sits over a midtone and press the shutter-release button down halfway. The exposure settings will be locked until the shutter-release button is either released or pressed down fully, which means you can keep it held halfway, reframe your shot, and then push it down fully to make your exposure.

The downside to this is that most cameras will lock the focus as well as the exposure when you press the shutter-release button down halfway. Instead of using the shutter-release button to lock the exposure, look for a button marked "AE-L" on the back of your camera. This stands for Automatic Exposure Lock, which will allow you to set—and lock—the exposure before reframing and focusing your shot.

Right: For off-center subjects like this, use your camera's exposure lock to get a more accurate light reading. Turn the camera so the subject is at the center of the frame, then press and hold the shutter-release button down halfway to set and lock the exposure. Reframe your shot before pressing the shutter-release button down fully.

Focal length: 116mm

Aperture: f/4

Shutter speed: 1/200 sec.

ISO: 640

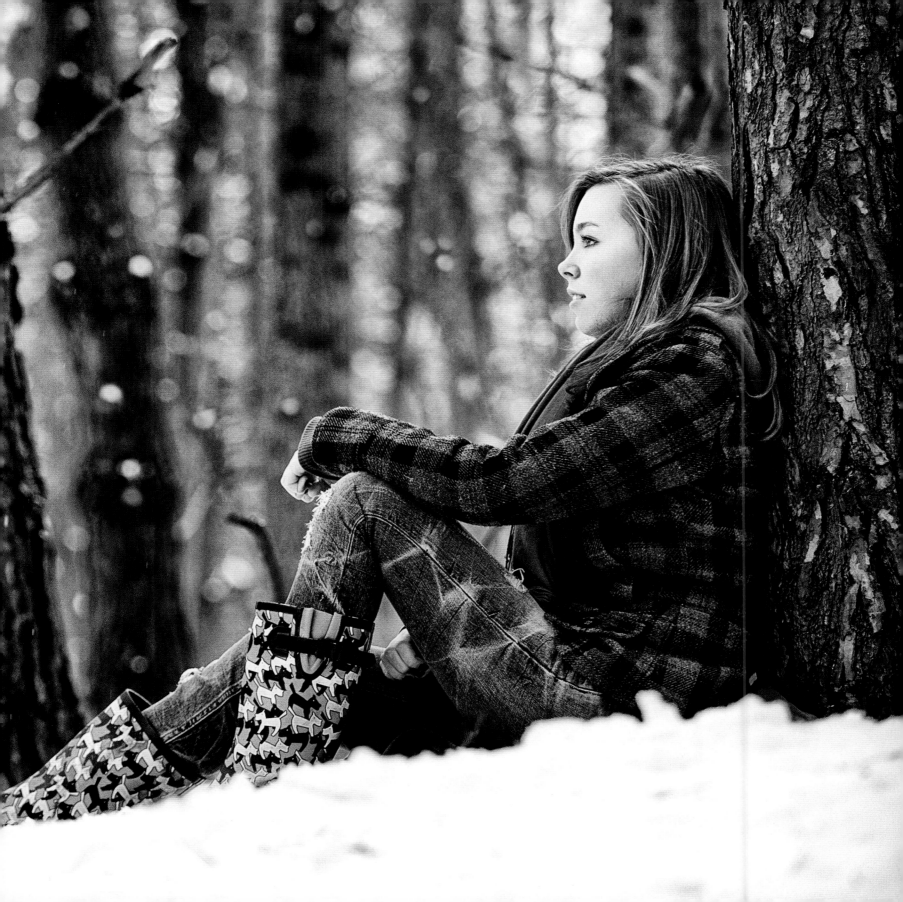

Shooting Modes

The range of modes and settings on a camera can seem daunting at first. The best (and quickest) way to become a confident photographer is to experiment with your camera in every shooting mode, so you fully understand how ISO, aperture, and shutter speed interlink. It is often better to do this exercise without having another person involved, so you don't have to worry about your subject getting bored or uncomfortable. Self-portraits, still-life subjects, or landscape shots are preferable as you explore your camera's different shooting modes:

1 **Program:** In this mode, you set the ISO and the camera chooses the aperture and shutter speed. This is typically done with the aim of delivering a shutter speed that would be "safe" to handhold. This mode is quick and easiest to get started shooting with, but it leaves all of the creative exposure decisions to the camera. Even the most expensive camera has no idea what your intentions are, so you risk limiting yourself to decidedly average images—the camera is unlikely to set the widest or smallest aperture, for example, or an exceptionally fast or slow shutter speed.

2 **Aperture Priority:** This is the mode to use when depth of field is the most important consideration, as you choose the aperture (and ISO) and the camera sets the shutter speed. If you want a blurred background to your portrait, for example, choose a low ISO setting and dial in a wide aperture

However, remember that your camera doesn't know what kind of portrait you are trying to create. With a high-contrast scene, or one that contains extremes of light and dark, the final result may not always be what you were hoping for.

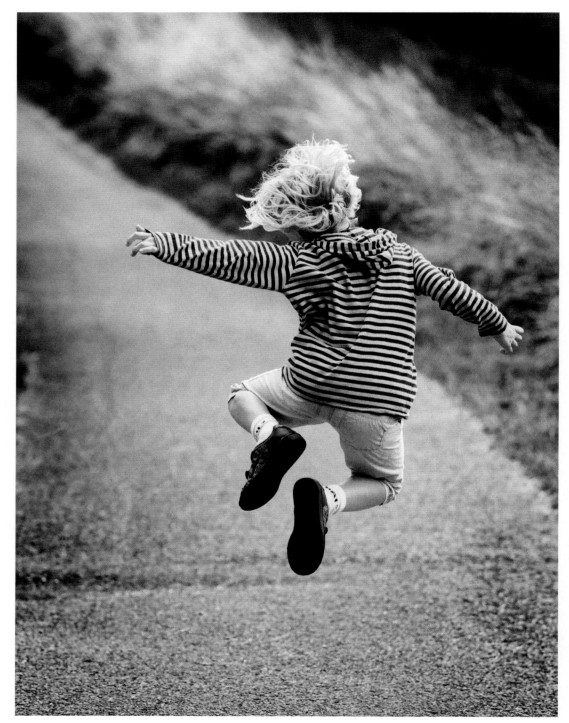

Left: Manual mode puts you in full control of the aperture, the shutter speed and the ISO, enabling you to capture your images exactly as you intended. Here, this meant determining how movement was captured (shutter speed), and the depth of field (aperture).

Focal length: 200mm

Aperture: f/5

Shutter speed: 1/1600 sec.

ISO: 500

3 **Shutter Priority:** This mode will help you control how motion is recorded; whether you want to freeze it or include it as a blur. Choose an ISO then dial in the shutter speed you want to use, bearing in mind the risk of camera shake if you're handholding the camera. The camera will select a suitable aperture, but be aware that this is not always possible—if you set an extremely fast or slow shutter speed, there may not be a suitable aperture setting on the lens.

4 **Manual:** In Manual mode you have full control of your exposure—you need to select the ISO, aperture, and shutter speed that you think are most appropriate to the image you are trying to achieve.

Most cameras have some form of exposure indicator scale displayed inside the viewfinder or on the rear LCD screen, which indicates how bright or dark the exposure will be using the current settings. With practice, you will find you can start to predict which settings will work in different situations.

Once you've nailed the exposure settings for a particular shot, you will usually only need to adjust the exposure settings again if the light changes or if you want to vary the outcome. This means you can focus on the composition and interacting with your subject.

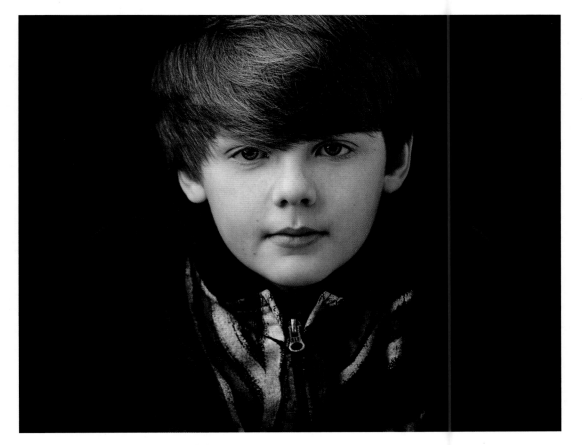

EXPOSURE COMPENSATION

When you use a shooting mode other than Manual, you can use exposure compensation to quickly increase or decrease the brightness of the exposure, either for creative effect or to adjust for an overly bright or dark subject.

To use exposure compensation, hold down the button marked +/- and rotate the camera's main dial. If the scene is overexposed, dial in negative exposure compensation to darken it; to counter underexposure, dial in positive compensation.

Above: Most automatic or semi-automatic shooting modes would overexpose a shot like this, in an attempt to compensate for the dominant dark tones. Applying positive exposure compensation before you shoot will quickly fix this, though.

Focal length: 165mm

Aperture: f/4.8

Shutter speed: 1/180 sec.

ISO: 200

Focusing

In the majority of portraits, the subject's eyes are the main focus of the shot, so it's important to ensure they are sharply focused, especially when using a wide aperture. By default, your camera's autofocus system will usually focus on whatever is at the center of the frame and/or closest to the camera. Consequently, if your subject is positioned off-center or behind foreground elements, you may find that the default focus settings mean you end up with a blurred subject. Even when your subject is in the middle of the frame, you may still end up with their nose or ears as the sharpest point, rather than their eyes.

To avoid this, you need to manually select which part of the frame the camera focuses on. A DSLR will have anything from a handful of focus points up to 50 of them—with your eye to the viewfinder you can use arrow keys on the back of the camera to select the one that covers the area of the frame where your subject's eye is.

Alternatively, you can select the central focus point, position the camera so this point is on your subject's nearest eye, press the shutter-release button down halfway to set the focus, and then keep the button half depressed while you reframe your shot as intended. Once you are in the habit of quickly recomposing after focusing, this method can be much quicker than manually selecting a focus point each time. Another benefit is that the central focus points are usually more responsive and accurate than those toward the outer edges of the frame, making it quicker and easier to get an accurate focus lock, especially when the light levels are low.

However, it's important to remember that some metering modes are biased toward the area of the frame that's in focus (and may even be linked to the focus point in the case of spot metering). If this is the case with your camera, use Automatic Exposure Lock (a button marked AE-L) if you want to meter from a different part of the scene to your selected focus point.

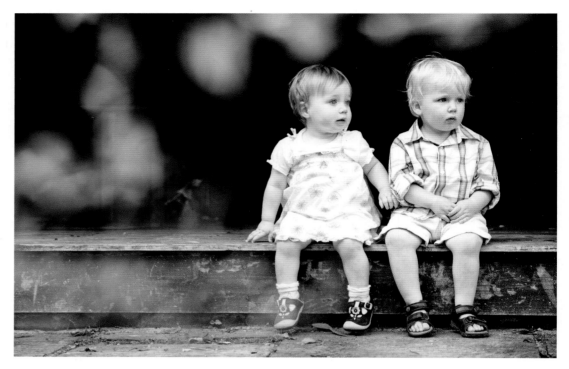

Depth of Field

Differential focusing is the creative use of focus to intentionally blur the main or secondary subject of your portrait. For instance, you may want the background blurred behind your subject to provide separation and stop it becoming a distraction, or you may want just the children to be sharp in a group portrait, while their parents are out of focus behind them. Alternatively, you may want to focus on some foreground foliage, allowing a couple to become a blurred silhouette behind it.

However, shooting with a minimal depth of field makes accurate focusing essential—any slight movement of the subject or camera after focusing could mean the subject's eye isn't tack-sharp anymore. This will be compounded if you're using a long focal length lens and/or are working relatively close to your subject.

Above: In shots like this, the foreground elements are intentionally blurred to add interest and create a partial frame around the subject. Sometimes this can confuse autofocus systems, so use manual focus or focus on the subjects with them in the center of the viewfinder before reframing the shot.

Focal length: 116mm

Aperture: f/4.5

Shutter speed: 1/250 sec.

ISO: 250

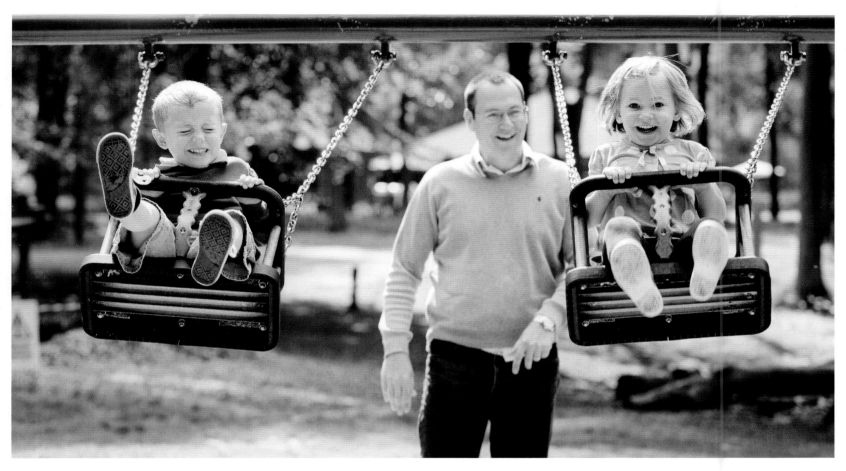

Manual Focus

Sometimes the camera's autofocus can whir back and forth, "hunting" for something to focus on. This can be caused by low light levels, low contrast in a scene, or due to obstacles in the foreground (a wire fence in front of your subject, for example).

In these situations, you may find it quicker and easier to switch to manual focus, by flicking the relevant switch on or near the lens. When you are ready to take your shot, look through the viewfinder and turn the focusing ring on the lens until your subject's eye looks sharp.

Moving Subjects

If you are photographing a child running toward you, the time between the camera focusing and the shot being taken might be sufficiently long that the child is out of focus when the exposure is made.

There are two ways to counter this. The first is to pre-focus on an object that is the same distance from the camera as the child will be when you want to take the shot. The second option is to use your camera's continuous focus setting, so the camera tracks the subject's movement and continually refocuses until the shot is taken.

Above: When photographing a moving subject, pre-focus on a point that is at the same distance as the subject will be; you can do this by pushing the shutter-release button down halfway and holding it. When the subject is in position, push the shutter-release button down fully.

Focal length: 80mm

Aperture: f/4

Shutter speed: 1/400 sec.

ISO: 200

Chapter 3
Lighting

If you want to master portrait photography, you need to be aware that light is key to taking a shot from average to amazing. In fact, it's the foremost consideration in portrait photography: its quantity determines the exposure settings, its quality determines how flattering it is, and its direction determines how highlight and shadow areas appear on the subject's face and body.

Every day we encounter light of different colors and intensities, yet we rarely notice that it's changed at all, thanks to the ability of our eyes to instantly adapt. However, your camera can't adapt so easily, which means the exact nature of the light matters more. If the camera settings don't take that into account, then your photographs can just look "wrong," or at least lack the atmosphere that encouraged you to reach for your camera in the first place.

This chapter will show you how to start noticing the changing light around you, and describe what to look for when lighting a portrait.

Right: The low-key lighting sets the mood for this mysterious and somber portrait. Tightly controlled studio lights were positioned either side of the subject to reveal detail in his face and clothes, and separate his outline from the dark background.

Focal length: 50mm

Aperture: f/4.8

Shutter speed: 1/250 sec.

ISO: 100

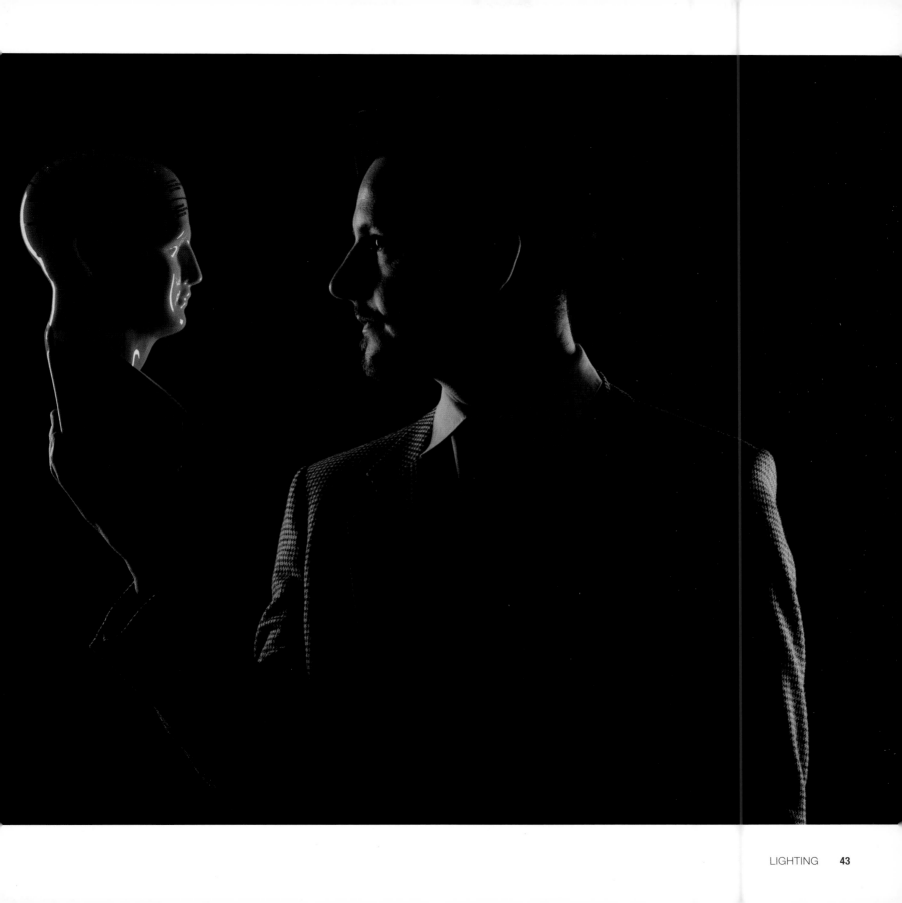

The Role of Light

Striking photographs—the kind that stop you in your tracks—usually owe much of their impact to the use of lighting. It could be the mood conveyed by atmospheric sun flares, or the way in which the subject's eyes seem to sparkle from the studio flash; either way it's the photographer's ability to notice and manipulate the light that is key.

Above all other elements—composition, camera settings, and camera equipment included—the lighting will determine whether a shot is pretty standard or perfectly stunning. For example, you can photograph someone with model looks, but if the noon sun is causing them to squint and casts dark shadows in their eye sockets and under their nose, they will look mediocre at best; moving them to a shaded area or using a diffuser would quickly remedy the problem.

When working with artificial lighting, the quality of the light can be vastly improved by using readily available accessories to soften it. Careful positioning of the light source will also ensure that any shadows cast are flattering, helping to shape the subject's face and give the photograph a greater sense of depth.

To master the art of lighting you need to get into the habit of noticing its effects. Consciously force yourself to evaluate the light around you, until you automatically start to notice when it changes. For one day, you could set an alarm on your phone to ring every 30 minutes and use that as a reminder to look around and notice the light, wherever you may be. Ask yourself where the main source of light is? How strong is it? Is it harsh and

Right: The softest light is often found just under a doorframe or archway, where the light is diffused and takes on a wonderful quality.

Focal length: 105mm

Aperture: f/4

Shutter speed: 1/125 sec.

ISO: 800

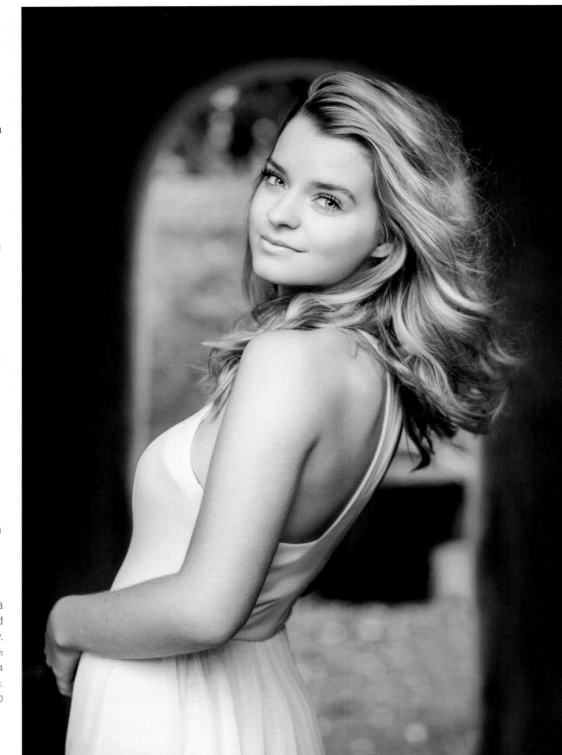

directional, or soft and diffused? What color is it? Study the way that the light falls on the faces of people nearby, or ask a friend to pose for you. At which angle is the light most flattering? Which sources of light are least and most appealing? How does daylight differ in its qualities from morning to afternoon, and from afternoon to evening? How does this change during the seasons?

In general, there are three elements to consider when judging light:

- Its strength (affected by the distance between the light source and your subject, and also your exposure settings).
- Its direction (the angling and positioning of the light relative to your subject).
- Its quality (whether the light is hard or soft).

Strength

Light loses its strength quickly, the further the source is from the subject. For broad light sources, such as large windows and softboxes, doubling the distance between the light source and the subject will halve the strength of that light. For point light sources (such as flash bulbs and the sun), the Inverse Square Law applies, which states that light falls off in inverse proportion to the square of the distance traveled.

This means that if your subject is initially 1 meter (3ft) from a light source and you move them to a distance of 2 meters (6ft), the light will be a quarter of its original strength (and not, as you might assume, **half** as strong). If you then move your subject 3 meters (9ft) from the light source,

Above: The light from the window falls off quickly here, so the room appears very dark in comparison to the subject. This allows the background to create a subtle sense of place that doesn't steal attention from the main subject.

Focal length: 50mm

Aperture: f/3.2

Shutter speed: 1/50 sec.

ISO: 320

its strength will be one ninth of what it was in the first instance. The simple way to work this out is to multiply the distance (in meters) by itself and put the resulting figure as the denominator (the bottom number in a fraction), with the numerator (top number) as 1. For example, at a distance of 4 meters the strength would be 4 x 4 (16), so $\frac{1}{16}$.

In this way, a dark background can be made to appear pure black if it's far enough away from the light source—the light's fall off will mean it is simply underexposed in relation to the subject. Sometimes, you may want this—if you want to minimize the visibility of background clutter, for example—but other times you may want to include elements of the room as well. The trick is to reposition the subject, so they are the same distance from the light source as other elements in the room that you wish to be exposed correctly.

Direction

The angle at which light falls on to your subject will affect the amount and placement of any shadows and catchlights (the reflection of the light source in the subject's eyes). Some shadows are flattering, such as those that help to slim the subject and give the image a sense of depth, but others are unflattering—shadows that make the subject's eyes appear sunken or highlight imperfections, for example. "Narrow lighting" occurs when the side of your subject's face that is furthest from the camera is lit by your light source, causing the near side to be more shaded. This has a slimming effect, as the visible side of the face appears narrower than it really is due to those shadows.

The opposite effect occurs when the side of the face closest to the camera is illuminated, making it appear wider. This is known as "broad lighting."

When using natural light, you will need to reposition your subject in order to change how the light falls upon him or her, whereas you can

Above Right & Right: When shooting in direct sunlight you can only change your position and that of your subject, not the light source! Here, just a slight change in the subject's pose has dramatically altered the size and position of the shadows on her face—the eyes appear less sunken and the nose shadow is smaller in the lower shot.

Focal length: 200mm

Aperture: f/4.0

Shutter speed: 1/1000 sec.

ISO: 100

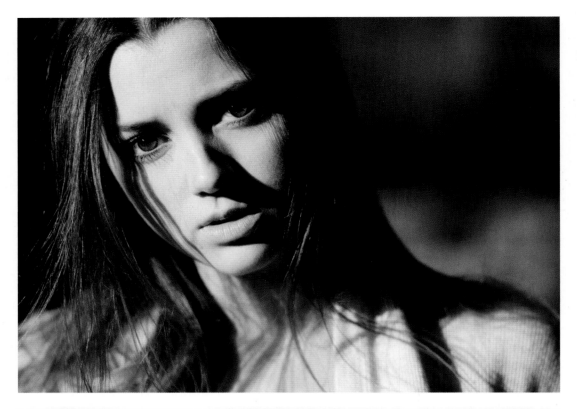

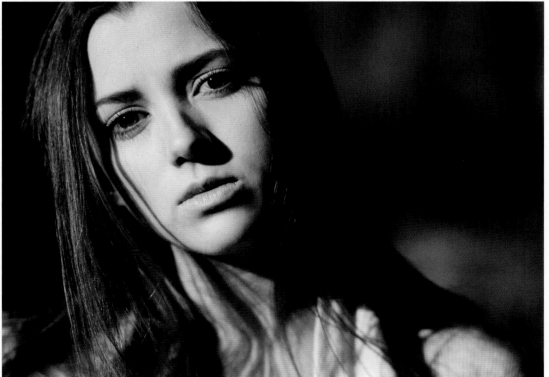

move artificial lights around your subject to change the direction of the light. You can also use lighting aids such as reflectors to fill in shadows and bounce light, while black-colored "reflectors" can be employed to absorb light and create shadows.

Quality

Photographers often speak about the "quality of light," by which they usually mean whether it is hard or soft. Hard lighting is directional, creating high-contrast extremes of light areas and shadows—examples include the midday sun and spotlights. This is good for low-key portraits with prominent shadows.

Soft lighting is less directional, hitting the subject from multiple directions as it is bounced and diffused. It is more even and creates a lower contrast result—examples include natural light on an overcast day or a flash fitted with a softbox.

As a general rule, the smaller and/or more distant the light source, the harsher and less flattering it becomes. Large, close-by light sources (such as a big window on a bright, but cloudy, day or studio flash fired through a large big softbox) is softer and generally more flattering.

Above Right: There were windows along the full length of this room, and the soft, diffused light wraps around the subject beautifully, leaving gentle shadows on his face on the side furthest from the light source.

Focal length: 105mm

Aperture: f/2

Shutter speed: 1/350 sec.

ISO: 200

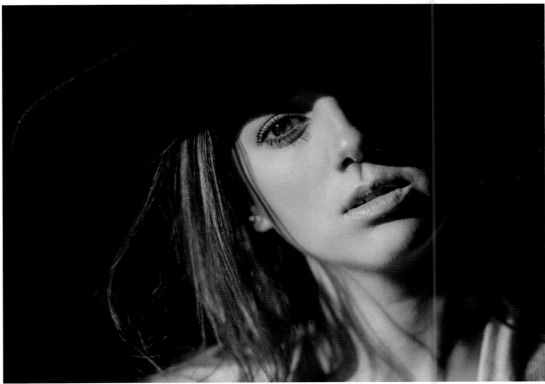

Right: During the middle of the day, sunlight can be incredibly hard and directional, which makes portraiture challenging, but not impossible. Here, the addition of a floppy hat has created some intriguing shadows and framed the subject's right eye.

Focal length: 200mm

Aperture: f/2.8

Shutter speed: 1/1500 sec.

ISO: 100

The Color of Light

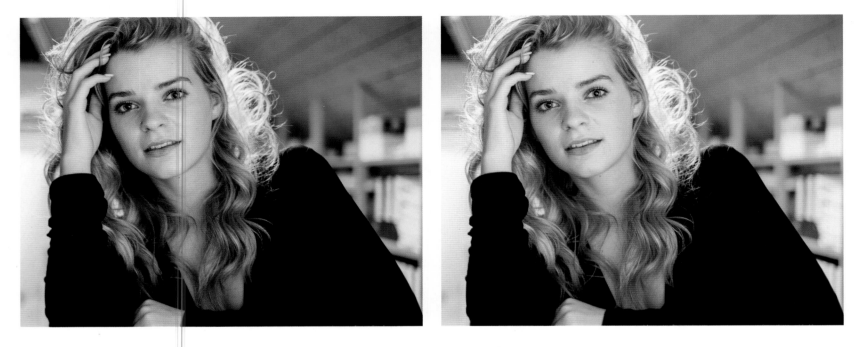

Our eyes automatically adjust to different lighting conditions as we move from place to place, so we don't tend to notice the subtle color tints it carries. For example, the light from a candle has a warm red/orange color cast, whereas an energy-saving bulb emits light with a cool blue/green tinge. Natural light also changes, depending on the time of day—midday sunlight is a clear white, for example, whereas open shade has a blue tint. While we may not necessarily notice these changes, these variations are far more obvious to the camera, requiring adjustments to the white balance setting to compensate for them. The aim of changing the white balance is to make whites appear as they would under the tint-free light of the midday sun, which will keep skintones accurate in portrait photographs.

Often, the camera's automatic white balance (WB) setting will do a good job of measuring the "temperature" of the light and adjusting it accordingly. If, however, your images appear off-color, you may want to manually select a white balance mode appropriate to your lighting situation. This is as simple as holding down the WB button and rotating the dial through the choices—tungsten, fluorescent, daylight, cloudy, shade, flash, and so on—to match the lighting condition you are shooting under.

For a more accurate reading you can use your camera's custom WB function and position a piece of white card in front of the camera, under the lighting conditions you want the reading for. Fill the viewfinder with the white card and take a shot. The camera will calculate the WB setting needed to ensure the white card appears neutral and will use that setting until you take another custom WB reading or change the WB mode.

If you are shooting in Raw format, you can change the white balance setting when you convert your images, making it slightly less critical to get it right in camera. In your Raw conversion software you will typically need to select the white balance tool and click on an area of the photo that should be neutral (an area that should be gray is

Above Left & Above: This was a grab shot taken under a mix of cool-toned fluorescent lights (behind the subject), warm-toned LED lights (on the subject's face), and cool-toned light from two computer screens (at the left of the subject). The first image (above left) shows the white balance set to accurately render the warmer lighting, while the second image (above) prioritizes the cooler light sources. White balance is more of an art than a science, and it's up to the photographer to choose how he or she wants the image to feel: cool or warm.

Focal length: 35mm

Aperture: f/1.4

Shutter speed: 1/30 sec.

ISO: 800

often a better option than white). The software will then make the color adjustments needed to neutralize the target area.

In some editing programs this can be done in batches, enabling you to select all of the images taken under the same lighting conditions before you use the white balance tool to change them all at the same time.

To make the process easier, you can shoot a gray card under the same lighting conditions as your subject and use this to set the white balance—an array of white balance cards are available in specialist camera stores and online.

However, you don't always need to set a technically correct white balance, as an "incorrect" setting can be used for creative effect. For example, if you chose the cloudy WB setting on a clear day it would add a slight warmth to the tones of your portraits, while setting the WB to incandescent (tungsten) on a clear day will introduce a strong blue tone.

Right: In this shot, the light under the arches has a warmer color temperature than the daylight coming in from the street. This is most likely because the marble walls and pillars have reflected and colored it slightly.

Focal length: 86mm

Aperture: f/4

Shutter speed: 1/125 sec.

ISO: 160

Natural Light

Natural light is freely available, requires little or no specialist kit to use, and comes in enough different forms to keep your portraits looking varied for many years to come. In fact, many professional photographers use natural light exclusively.

Of course, this comes with many challenges, with the weather, intensity of the light, and time of day being just a few of the variables to consider.

To start with, you'll need sufficient light on your subject's face to create an exposure, but not so much that they end up squinting. You'll also need to protect your kit—and your subject—from extreme conditions, and you will need to be ready to react as the light changes, sometimes on a minute-by-minute basis.

Although you'll never be fully in control of natural light, there are ways you can make the most of what's available: you can position your subject to get the benefits of shade, for example, time your shoot so you benefit from the golden hour (see pages 60–61) or use tools such as diffusers and reflectors.

However, having limitations and challenges to overcome can force you to be creative. Read the advice on the following pages then go out and get experience in every type of lighting situation—soon you'll be able to handle anything that nature throws in your direction.

Left: You'll often need to move a subject to make the best of the light available to you. For this shot (taken for a commercial client), the light patterns caused by the window blinds add interest in the form of diagonal lines that play over the furniture and some of the subject's clothes.

Focal length: 105mm

Aperture: f/2

Shutter speed: 1/180 sec.

ISO: 100

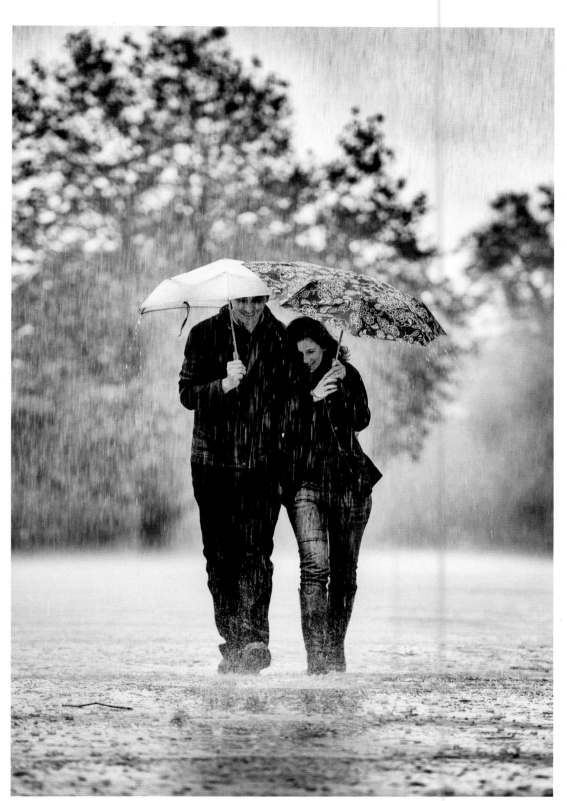

Right: Changeable weather can create some major challenges when it comes to using natural light outdoors, but it can also result in some unique images if your subjects don't mind braving the elements!

Focal length: 185mm

Aperture: f/4

Shutter speed: 1/125 sec.

ISO: 200

Window Light

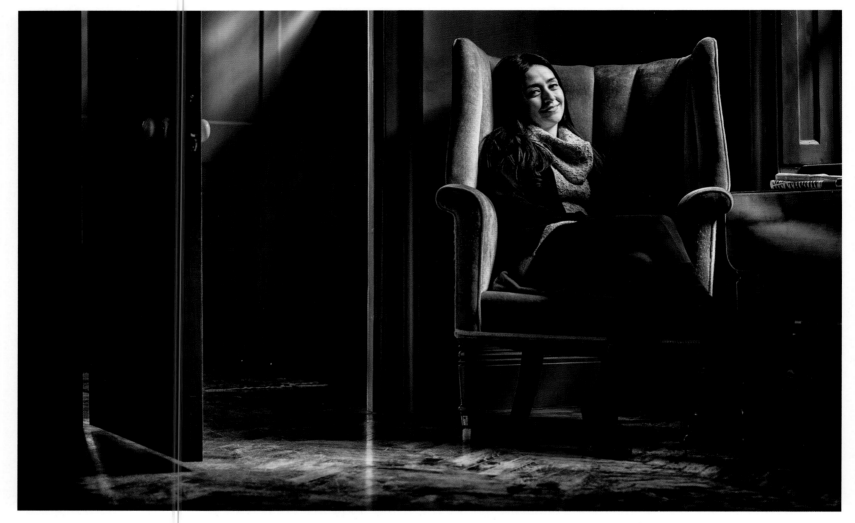

Window light gives you all the benefits of using natural light, but without having to worry about the weather. There are two main restrictions, though.

The first is seasonal: some rooms, particularly with small windows facing away from the equator, may not get enough light in the winter months to make indoor portraiture feasible.

The second challenge relates to the time of day: regardless of where you are in the world, you will need to time your shoot for when the sun is strong enough to light the room sufficiently.

Direct & Indirect Window Light

If you have strong, direct sunlight streaming into the room, this can cause similar problems to shooting outdoors without shade—your subject may be forced to squint due to the glare, and there will be high levels of contrast in the image. To resolve this, either hang a thin, white bedsheet across the window to diffuse the light (or use a commercial diffusion panel), or angle your subject to make the shadows more flattering.

In the northern hemisphere, a north-facing window will always mean you are working with indirect light, which naturally has a softer, more diffused quality to it. However, this also means it is a weaker light source. In the southern hemisphere, the opposite is true.

In general, larger-sized rooms with big, floor-to-ceiling windows (or glass doors) and pale, plain walls are best for window-lit portraiture.

Left: Direct window light can be particularly effective if it's late in the day, when the light becomes softer, or if your subject is angled to the light effectively, as is the case here. The shadows on the right side of the subject's face form a pleasing triangle of light on her cheek, a lighting pattern known as "Rembrandt lighting."

Focal length: 700mm

Aperture: f/4

Shutter speed: 1/125 sec.

ISO: 800

Positioning your Subject

The distance between your subject and the window affects the strength of the light that falls on them: the closer the subject is to the window, the more intense the light will be. However, the light will fall off faster too, leaving the background looking dark and underexposed. Sometimes this may be desirable—especially if the background is cluttered or will otherwise distract from your subject—but sometimes you may want to show the subject in their environment instead.

To achieve this, move your subject further away from the window, and compensate for the reduced light strength by increasing the ISO, widening the aperture, or decreasing the shutter speed. Remember that any object or background element that you want to be exposed correctly needs to be the same distance from the light source as your subject.

The angle of your subject relative to the window will determine the extent and position of any shadows that fall on their face. For flattering shadows that slim your subject's face, position them at 45-degrees to the window; to remove facial shadows completely, have them look toward the window. Also bear in mind that "narrow lighting," where the near side of the face is in shadow, is more flattering than "broad lighting."

Using a Reflector

If you want to lighten any shadows, position a reflector opposite the light source and angle it toward the area you want to brighten. Alternatively, position your subject close to pale-colored walls, which will naturally bounce light toward him or her.

To deepen shadows you can use a black "reflector" or position very dark fabric on the appropriate side of your subject. Either of these will create a barrier that stops any reflected light from reaching that area of your subject.

Above: The gradual shadows across the near side of the subject's face flatter her and add depth to the image. The exposure is set to expose the skin correctly, and as the subject is close to the light source (the window) the background has become much darker in comparison.

Focal length: 105mm

Aperture: f/2.4

Shutter speed: 1/180 sec.

ISO: 800

Direct Sunlight

It's a common misconception that good weather results in good portraits—direct sunlight actually presents the most difficult challenge to the photographer out of all natural lighting situations. Aside from during the golden hour (see pages 60–61), the sun is a harsh point of light that makes subjects squint their eyes and throws ugly, unflattering shadows around the contours of their face, highlighting any imperfections. It's also tricky to expose correctly, because of the high levels of contrast it produces.

Even if you position your subject so the sun is behind them, you risk unwanted lens flare and you would still need to overcome the exposure challenge, otherwise your backlit subject's face will be underexposed. You can alleviate this a little by using a reflector in front of your subject to bounce some light back on to their face, however, even a reflector's glare can be blinding, again causing your subject to close their eyes. Instead, angle the reflector so it pushes light toward the ground in front of your subject. This will result in a small amount being reflected from the floor back onto your subject's face (the color and texture of the ground will determine how much).

Sometimes there's a need to capture a portrait in a large open area with little or no shade when the sun is fierce, and there is no option other than having your subject face toward the sun. If you don't want your subject to be squinting, you could have them wear sunglasses—if it suits the mood and intentions of the kind of image you want to capture—or you could ask them to close their eyes fully and look toward the light, as if they are basking in its warm glow. Alternatively, you could have them look away from the camera, so the squint is not obvious and it's not so important to have flattering light across their face. Or, you could use a diffuser, so your subject is shaded from the direct light, while the background behind them is still bathed in sunlight—there are plenty of options to help you.

Above: With the sun in the background, these subjects have been intentionally underexposed to create a silhouette against the dusk sky.

Focal length: 195mm

Aperture: f/4

Shutter speed: 1/2500 sec.

ISO: 320

Diffusers

If you want to take outdoor portraits at locations that typically don't have any shade available—such as beaches and fields—then a diffuser is a worthwhile investment. Opaque fabric is stretched across a frame, and this is positioned between your subject and the sun. As with reflectors, diffusers come in a range of shapes and sizes, but unless you opt for one that has a handgrip or can be freestanding, you will need someone to assist you by holding it in place.

The more expensive versions have different weights of fabric, which block the light to varying degrees, giving you very precise control over the level of diffusion. As a general guide, you should get one that is at least 60cm (2ft) in diameter (assuming it's round), and always check your viewfinder to make sure that the edges of the diffuser aren't visible in the frame, either directly, or by way of its outline appearing as a shadowed shape. Bear in mind that using a diffuser may result in your background becoming overexposed—you will be exposing for your subject's face, in the shade of the diffuser, while the background may still have the full glare of the sun falling on it.

Above: The sunglasses worn by the subject here prevent her from squinting her eyes, enabling a successful portrait in harsh, direct sunlight. Her angle to the sun allows the shadows to fall on the side of her face closest to the camera, flattering her and adding depth.

Focal length: 120mm

Aperture: f/4.8

Shutter speed: 1/1000 sec.

ISO: 100

Above: This was taken just a few seconds after the sunglasses shot (above left), with a large diffuser panel placed between the subject and the light source. The diffuser has softened the light, which has prevented the subject from squinting.

Focal length: 125mm

Aperture: f/4.8

Shutter speed: 1/250 sec.

ISO: 100

Shade

On bright, sunny days, when you want to avoid dark shadows and squinting eyes in your portraits, the best thing you can do is head for the shade. You can find shaded light under trees, around buildings, by angling your subject so their face is in the shade, or even by asking your subject to wear a hat if it suits the final shot.

One of the most consistently flattering places to shade a subject for a portrait is just inside a doorway entrance to a building, with yourself positioned outside, shooting back in. When the subject is standing far enough inside that no direct light falls on their face (or just inside the edges of a north-facing doorway in the northern hemisphere or a south-facing doorway in the southern hemisphere), they will be lit purely by reflected light, bouncing back onto them from all sides of the doorframe.

If no doorways are available, look for top shade instead. This could be under the overhang of a building, or beneath the branches of a leafy tree. Top shade blocks the direct rays of sun, which means your subject will be surrounded by softer, reflected light. This will result in lower contrast across the scene and smoother-looking skin on your subject. However, be sure to avoid having dappled sunlight creeping onto your subject's face, as it will result in blown highlights (dappled sunlight looks great as out-of-focus highlights in the background of your shot, though).

Right: Taken under the shade provided by a doorway, the light is flattering and the shadows soft. Be aware that moving your subject deeper into the shade will change the direction of the light source from overhead to front on. For this shot I wanted overhead lighting and a dark background, so kept the subject close to the entrance.

Focal length: 105mm

Aperture: f/2.4

Shutter speed: 1/250 sec.

ISO: 200

Be aware that colored surfaces reflect colored light, so if you shade your subject by positioning them next to a bright red wall, the reflected light will carry a red tint. Equally, a subject standing on grass underneath a tree will be lit by subtly green-tinted light. To overcome this, move your subject further away from the reflecting surface, or adjust the color balance in postproduction. Concrete floors reflect a lot of neutral-colored light, so are ideal in this situation, especially for close-ups where the background isn't visible.

One problem with shaded light is that it can sometimes look too flat or "muddy." To rectify this, use a reflector to bounce more light onto your subject's face and fill in any slight shadows. For close-ups, ask your subject to hold the reflector for you—angle it toward his or her face, adjusting its position until the light appears to gently glow from your subject's skin. You could also use fill-in flash for a similar result, and this will also add catchlights to your subject's eyes.

If the area behind your subject is also in shade, then the background will appear dark and potentially unexposed, due to the way that light falls off. Conversely, if you have an unshaded area in the background, it will be lighter, and potentially overexposed. In both scenarios, prioritize the exposure for your subject's face, but be aware that the level of lighting in the background will affect the final look and feel of your portrait.

Once the sun drops below the horizon, there's a brief amount of time when any area will be shaded, but the ambient light level is still sufficiently high. This is the perfect time to shoot in open spaces that may not have been possible earlier in the day, while the sun was visible.

Left: This shot was taken in a patch of shade in a street on a bright, sunny day. All of the light falling on the subject's face is reflected from the walls, road, and path around her. The sun is actually behind the subject, as evidenced by the glinting leaves at the top right of the frame.

Focal length: 200mm

Aperture: f/5

Shutter speed: 1/200 sec.

ISO: 250

Overcast

On overcast days, clouds act like a giant diffuser in the sky, softening the light from the sun before it reaches the earth. This reduces contrast levels, making it easier to expose a shot without blowing highlights and losing detail in shadow areas.

When the cloud cover is very thick, the light levels may be so impaired that you need to raise your ISO or widen your aperture to compensate. Cloudy but bright days are the easiest to work with, as there is still plenty of light available, although if the clouds are too thin you may need to look for shade to soften the light further.

On days with lots of small, individual clouds, the light will keep changing as they pass in front of the sun then move away again. Care needs to be taken in these conditions—if you're shooting in Manual mode you will need to constantly watch the changing light levels and time your shots to coincide with the appropriate level of cloud cover.

Although light on a cloudy day is significantly less directional than on a clear day, there will still be some direction to it. Look up to the sky and note where the lightest patch is, as this is where the majority of the light will come from. For a flattering portrait, angle your subject with their face toward the brightest part of the sky and take your shot from above their eye level, at an angle of roughly 45 degrees.

If the cloud cover is thick, or the light on your subject looks overly flat, boost it by using a reflector; a white reflector will provide a subtle boost, a silver one will give a stronger effect, and a gold one will have a strong effect as well as adding a warm color tint. Alternatively, use fill-in flash to lighten any shadows and add catchlights to your subject's eyes.

TIPS

- If the cloud cover is thick, raise the ISO to compensate for the lower levels of sunlight penetrating through. Alternatively, widen your aperture or decrease your shutter speed for the same effect.
- Note the rough position of the sun behind the clouds—although the light will be diffused, it will still have a direction.
- Position your subject relative to the direction of the light in the same way as you would if using studio lighting.
- If needed, angle a reflector up toward your subject's face to brighten up highlight areas and lift any heavy shadows in their eye sockets. This will help to stop the light from appearing too flat. Alternatively, use a black reflector to add more shadows. In both instances, the increased contrast will add depth to your portrait.
- Use off-camera flash as a secondary light source, either lighting up a dark, dull background or angled toward your subject from behind to add a rim light that mimics the softer but more atmospheric light of the sun when it's nearer the horizon late in the afternoon.

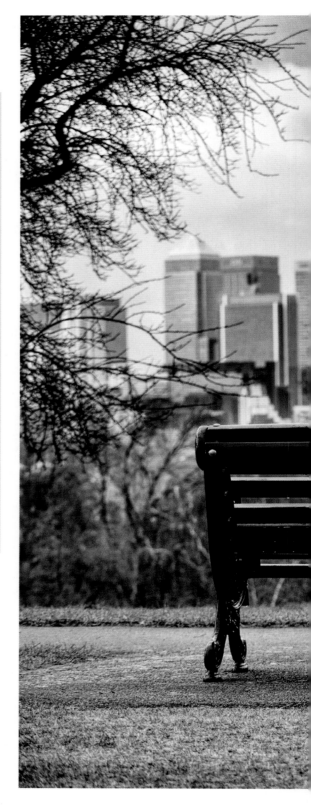

Right: The overcast sky provided a softer light for this unusual family portrait. Although the strength of the sun is much reduced, the light still has directional qualities to it, as you can see from the shadow under the bench.

Focal length: 82mm

Aperture: f/6.3

Shutter speed: 1/400 sec.

ISO: 800

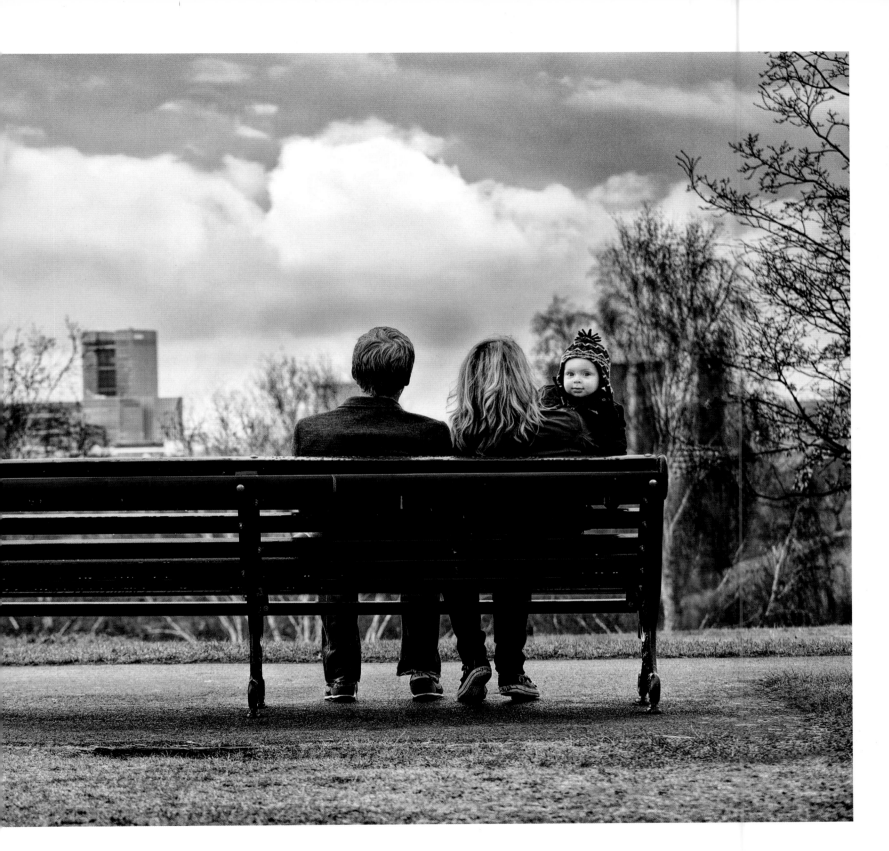

Golden Hour

The "golden hour"—also referred to as the "magic hour"—occurs just after sunrise and just before sunset, when the sun is about 10 degrees above the horizon.

It is the one time of day that direct sunlight is soft enough to use in portraiture without making your subject squint. In addition, it adds plenty of atmosphere to your shots, with a warm, golden tinge to the light.

Confusingly, this period of beautifully soft sunlight doesn't necessarily last an hour; its duration depends on both the season, and your distance from the equator. Closer to the equator, the sun rises above 10 degrees very rapidly, so the golden hour may only last a few minutes. On the other hand, if you are nearer the poles, it can last all day at certain times of the year.

To take the guesswork out of it, there are smartphone apps and web sites that accurately calculate the exact time this period of magical lighting will occur for your location. Of course, if the sky is too cloudy it won't happen at all.

Above: The golden hour light was coming from the wrong angle to include the tree in this shot. However, rather than change the composition, I used a large reflector to bounce the setting sun's light back onto my subjects' faces.

Focal length: 300mm

Aperture: f/3.2

Shutter speed: 1/200 sec.

ISO: 320

The "magic" light occurs because when the sun is lower in the sky, its light passes through more of the atmosphere before reaching earth. This reduces its intensity and filters out a lot of the blue end of the spectrum, making it appear orange-red.

At this time of day, you can shoot without a diffuser, as the light is not harsh and directional. This softer light also means there will be less contrast between the highlight and shadow areas of your scene, making it easier to set an exposure without losing any detail.

As well as using the low sun to illuminate your subject, you could also position him or her so that they are rim-lit by the sun behind them, giving the edges of their hair a halo of gold. Alternatively, you could include the sun in the image, spilling an atmospheric flare across your image. However, when you include the light source in your shots, shadows will typically become a muddy gray-brown instead of black, so you may want or need to bring them back to black during postproduction.

Above: Late on a summer's evening, the light was coming through a clearing in the trees almost horizontally, and was weak enough that the subject could look toward it without squinting. This shot wouldn't have worked if the wind was blowing in the opposite direction, as the subject's hair would have been flying over her face, rather than off it.

Focal length: 105mm

Aperture: f/3.2

Shutter speed: 1/100 sec.

ISO: 160

Portable Flash

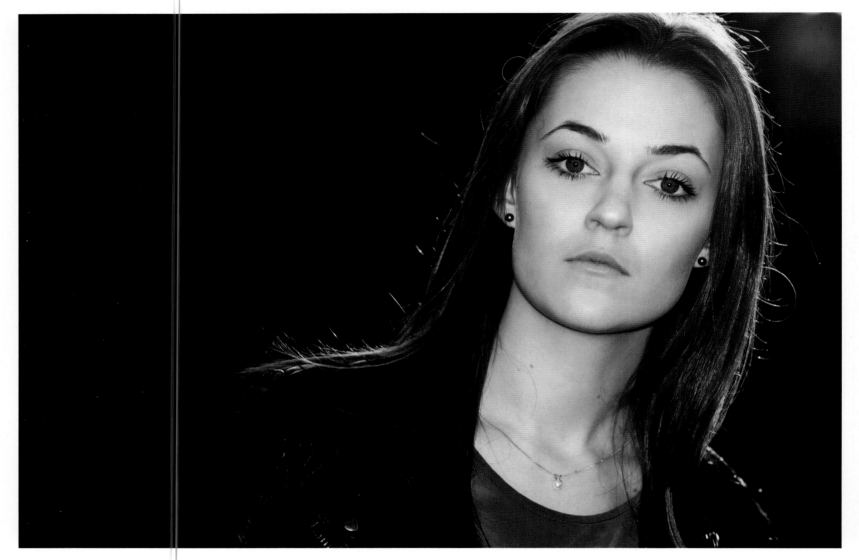

On-camera Flash

While natural light is variable and impossible to control, artificial light provides a consistent and adjustable light source, which immediately gives it a certain appeal—with flash you don't have to wait for the right time of day, or for the weather to clear.

Entry- and enthusiast-level DSLRs usually include an on-camera flash that pops up on demand, or automatically in some shooting modes when you encounter low-light conditions. Out of necessity, the flash is physically positioned close to the lens, which causes several problems, including "red eye" and harsh, flat lighting. The flash emitted also tends to overpower the ambient light, resulting in an obvious "lit by flash" appearance. In addition, any reflective surfaces in your scene that are parallel to the camera will end up recorded as areas of white glare.

Although there are some famous professional photographers (such as Juergen Teller) who have developed a unique style using on-camera flash, these images are notable for how unflattering they

are. The appeal of the shots is that the subjects don't appear to be photographed professionally, giving the viewer a feeling of a private image taken by a close friend—the "snapshot esthetic."

For the majority of photographers, however, the main priority of a portrait is to flatter the subject, which is much more easily achieved with off-camera flash, or by increasing the ISO, extending the shutter speed, and/or using a wider aperture. Alternatively, you could experiment with other light sources, such as a street light or a table lamp.

Opposite: The pinprick of light in the subject's eyes reveals that on-camera flash was used to light her face, with the evening sun providing rim lighting on her hair. The background was underexposed to make it appear completely dark.

Focal length: 135mm

Aperture: f/4.8

Shutter speed: 1/320 sec.

ISO: 71

Above Left & Above: Taken within seconds of each other, these shots demonstrate how different the same scene can look when lit with flash (above left) as opposed to ambient light (above).

With flash:

Focal length: 120mm

Aperture: f/4

Shutter speed: 1/180 sec.

ISO: 71

Without flash:

Focal length: 120mm

Aperture: f/4

Shutter speed: 1/30 sec.

ISO: 71

External Flash Units

External flashes offer many advantages over fixed on-camera flash. For a start, their larger size means they can pack in more power, while providing accessible options to adjust and control that power. Their adjustable heads also mean that the light can be bounced easily off walls, ceilings, and other surfaces, rather than firing directly at your subjects.

Some have built-in or add-on diffusers, which soften and spread the light, and small white pop-up cards that reflect catch-lights into your subject's eyes, even when the flash is angled upward or to one side. You can also buy mini softboxes and umbrellas for your external flashes, enabling you to recreate flattering studio-style lighting on location, while still being much more portable.

Above: Nikon's Speedlight SB-910 is a high-end external flash with a bounce-and-tilt head that can swivel up and around to change the direction of the light and bounce it off the ceiling or a wall.

Flash Modes

Modern flashes offer numerous modes and features—the most common are outlined here:

Through-the-lens (TTL) auto mode: The camera uses through-the-lens flash metering to judge how much flash is required to make a correct exposure. If necessary, you can use flash exposure compensation to quickly increase or decrease the power of the flash.

Red-eye reduction: Red eye is caused by light from the flash reflecting off the inside of the subject's eyeball. This most commonly happens in low-light situations, as this is where you are most likely to use flash and people's pupils are naturally wider to allow more light in. When red-eye reduction is activated, the camera fires a rapid burst of low-power flashes to shrink the subject's pupils before the exposure is made.

Slow sync: Uses a slower shutter speed to capture the ambient background light in addition to the flash-lit subject, making this a good choice for twilight and evening portraits. However, you need to watch out for camera shake and be aware that the default setting will see the flash fire at the start of the exposure. This means that if your subject subsequently moves, their position at the start of the exposure will be frozen by the flash, with their later movements recorded as blurred trails in front of them. This can look odd, as you would expect the movement trails to show the earlier movement, with the final position of the subject captured most prominently by the flash.

Second/rear-curtain sync: Uses a slower shutter speed to capture ambient light, but also addresses the movement trail issue mentioned above, as the flash is fired at the end of the exposure instead of at the beginning. The name comes from the physical process that takes place during an exposure—a "curtain" draws back to allow light to reach the sensor, then a second follows it to block out the light again. In this mode, the flash fires just before the second curtain moves into place.

Flash off: In automatic exposure modes, the camera will default to using flash whenever the light levels are low. Selecting this mode disables this function.

Zooming the Flash

Many advanced flash units use the focal length information from the lens to concentrate the beam of light before firing. This minimizes the wasted light that would be spread over a wider scene when a longer focal length is used, and gives the flash a longer reach. This also makes the light more controllable when bouncing it, as setting the flash to its longest zoom setting will ensure it becomes a narrow tunnel of light, rather than an arc, reducing the amount that spills elsewhere.

Off-camera Flash

Cable connectors and wireless trigger systems mean that you can just as easily use your flashes completely off-camera, even using multiple flash units at once, increasing the number of effects you can use them for. If you slide a wireless trigger into the hotshoe of your camera, rather than a flash, it will fire the flash remotely using radio or infrared signals. This can often be used in conjunction with TTL metering, so you can create incredibly sophisticated off-camera lighting setups.

Your positioning and choice of power settings for the flash units will determine how flattering the light is. Whether you are relying on a single flash or have several that you can position around your subject, you can use the same principles as those set out for studio flash in the pages that follow, recreating similar effects on location.

Right: Here, the subject has been lit by two off-camera flashes. The first lights his face, while the second—positioned behind him—creates a slight "rim light" and lights the smoke, creating a transparent, atmospheric effect. The shutter speed was set to allow the lights on the building behind to show through and create a more interesting backdrop.

Focal length: 150mm
Aperture: f/4
Shutter speed: 1/45 sec.
ISO: 200

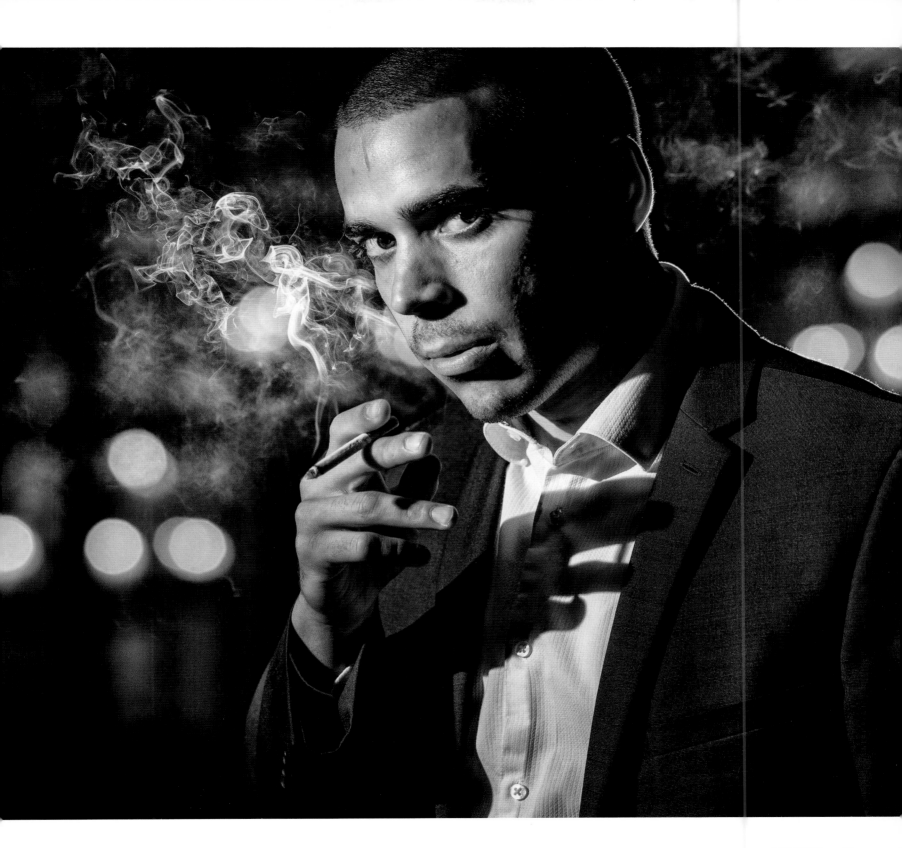

For example, you can use a large, white, matt surface (such as a room divider or neutrally painted wall) to replicate the effect of a giant studio softbox. Simply position your subject as you would if the surface was a softbox in a studio (at a 45-degree angle, or behind the camera, for example), then fire the flash toward that surface, using the maximum zoom setting on the flash to minimize spillage. If you are using a wall behind the camera, be aware that the shape of your body will block light, so allow some distance between yourself and the subject to avoid shadowing them.

If you have a second flash, you can aim it at the same surface to double the flash output. Alternatively, you could use it as a fill light, set at a lower power setting and aimed toward the shadowed side of your subject, or angle it toward your subject's hair to add depth and texture to the image.

You could also choose to position it behind your subject, pointing toward their back to add a rim light that will lift and separate them from their background. This is particularly effective on very overcast days, when the background and subject are both under similar lighting conditions.

When using multiple flash units, take test shots to see the effect produced by each one individually so you can check and balance their eventual effect on the final image.

Right: The principles of studio lighting have been applied to this location shot. Underexposing the background has resulted in a dark, moody sky, while two off-camera flashes have been used to light the subjects.

Focal length: 110mm

Aperture: f/6.3

Shutter speed: 1/160 sec.

ISO: 200

Manual Flash

As with camera settings, leaving your flash in an automatic mode means you lose out on creative control. Although TTL flash metering gets it right most of the time, it can fail in backlit situations, when the scene is highly reflective, or when the backgrounds are very light or very dark. If you don't know your kit well, you won't know how to correct its output in these situations, which is risky. Instead, spend time experimenting with your flash until you can accurately predict what settings will create the desired effect in different situations.

Flash Sync

Be aware that you will need to use a shutter speed that falls within the camera's flash sync range. Depending on the make of your DSLR, the top shutter speed available to you will be 1/200–1/250 sec.—anything faster and your image will have a black band across it, where no detail is recorded. This is because the second shutter curtain, which closes to end the exposure, is already in motion when the flash fires, so is physically preventing the light from reaching the sensor at that point in the frame.

However, a shutter speed of 1/200 sec. can be too slow, especially if you want to use flash to fill-in shadows on a bright day. To remedy this, some flashes offer a high speed sync (HSS) mode, in which the flash is fired repeatedly as the shutter curtains move across the sensor, enabling you to use faster shutter speeds and wider apertures than you would be able to use normally. To avoid overpowering the scene—particularly when using a wide aperture—simply turn the power of the flash down using the manual settings or the flash compensation control.

Flash Power & Range

All flashes have a guide number (GN) to indicate its maximum power when used at its narrowest setting. For comparison purposes, GNs state the distance that the light from a flash will reach when using ISO 100.

To determine the maximum distance (in meters) the flash can reach—when fired directly toward the subject—you simply divide the GN by the aperture you want to use. For example, a GN of 40, divided by an aperture of f/4, means you can be up to 10 meters (33ft) away. Change the aperture to f/8, however, and you would need to be no more than 5 meters (16ft) away.

However, these calculations are complicated by the fact that most of the time you will be taking advantage of a flash's adjustable head to fire the flash indirectly at your subject or reducing its output by adding a diffuser to make the light more

Above: Using off-camera flash provides you with numerous creative options—this image was created on a sunny afternoon, in a shaded alley, for example. The flash was balanced on the wall facing the subject, so it created a pool of light on her. Underexposing the ambient light has given the image an almost nocturnal feel.

Focal length: 122mm

Aperture: f/4.8

Shutter speed: 1/750 sec.

ISO: 280

flattering. When used in this way, flashes will only be effective across fairly limited distances.

Note also that when using your flash gun at its maximum power setting, it will take longer to "recycle" (which means it will take longer for it to become ready to fire the flash again). It will also use the batteries up more quickly.

Studio Flash

Learning to use studio lighting is great training for shooting on location with portable flash—you simply visualize where you would place the lights in a studio and find ways to replicate that with whatever light you have available to you.

It's easy to get started, with basic studio kits now readily available and affordable. However, what's more difficult is learning how to control and modify your light sources to create the kind of shots you envisage—it can take years of practice to fully master. Don't be put off though, as you can get professional quality shots fairly quickly.

Positioning your Lights

There are several traditional ways of lighting a portrait. Not all of these lighting styles will be possible on all types of face, as different bone structures may block or allow too much light to reach the shadowed side of the face, but it's worth practicing all of them. That way, you will be able to quickly and easily light a subject according to any of them—and start to experiment and tweak them.

In general, portrait lighting is either broad or narrow (see page 46). Unless your subject has a very thin face, it's most likely that they will prefer portraits of themselves that employ narrow lighting, as illustrated on the page opposite.

Above: Artificial lighting enables a degree of control and consistency that isn't achievable with natural light.

Focal length: 340mm

Aperture: f/16

Shutter speed: 1/125 sec.

ISO: 50

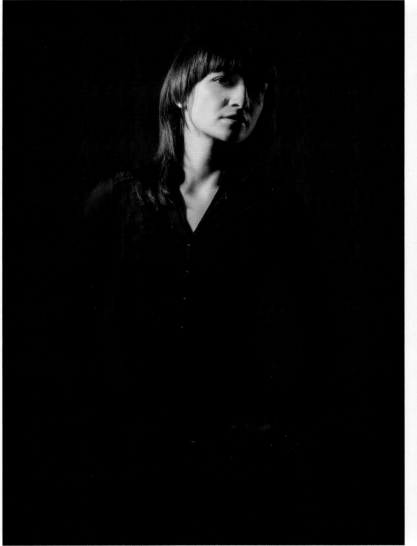

Above: Broad lighting occurs when the side of the subject's face closest to the camera is lighter than the far side. This makes the face appear wider and is less flattering on the majority of subjects.

Focal length: 85mm

Aperture: f/19

Shutter speed: 1/180 sec.

ISO: 50

Above: Narrow lighting occurs when the near side of the subject's face is more shadowed than the far side. It is very flattering on most subjects, as it gives the appearance of a slimmer face.

Focal length: 85mm

Aperture: f/19

Shutter speed: 1/180 sec.

ISO: 50

Traditional Lighting Styles

As shown here, there are five distinct traditional portrait lighting styles. All of these styles can be achieved using a single light, but you can also experiment with a reflector to lift the shadows or use additional lights as fill lights, to light the subject's hair, or to lift the background.

In all scenarios, the main light should always be set or positioned so that its output is stronger than the fill light, otherwise there will be no shadows, causing your portraits to appear flat. As a starting point, set the fill light to about half the strength of your main light.

When you're comfortable with selecting a lighting style and adjusting it where necessary to flatter your subject, start experimenting with shooting at the edge of the light source, rather than at its strongest point. At the edges, you'll find the light has an indescribable quality that will take your portraits to the next level.

BUTTERFLY LIGHTING:
Great for older subjects, as it disguises wrinkles better than the other lighting styles, and for subjects with high cheekbones, as these will be enhanced further. Position your main light directly in front of your subject, but behind and above the camera position, angled down toward your subject. Optionally, use a second light below the camera position to fill in shadows, or use a reflector (the subject can hold the reflector on their lap if you're creating a close-up shot). The name for this style comes from the shape of the shadow that forms under the subject's nose, and the gentle shadows on the subject's cheeks.

LOOP LIGHTING:
For this style, the nose throws gentle shadows to one side and its base, where it creates a "loop" shape. The shadow of the nose shouldn't touch that of the cheek, otherwise it becomes Rembrandt lighting (see right). To achieve loop lighting, your main light should be slightly above the subject's eye level and at an angle of about 45 degrees to one side. It's particularly flattering for people with rounder faces.

REMBRANDT LIGHTING:

Named after the painter, because his portraits commonly utilized this lighting style. The main light needs to be further around the subject's side than in loop lighting, but not so far it becomes split lighting. There should be a patch of light hitting the far cheek, forming a triangle shape, and a catchlight in both eyes.

PROFILE LIGHTING:

With the subject's nose 90 degrees from the camera, and the main light about 110 degrees from the camera position, this style is perfect for showing off a beautiful profile. You can add a fill light on the side of the subject closest to the camera; an angle of about 30 degrees from the subject's line of sight is ideal.

SPLIT LIGHTING:

Equal halves of the face are lit and shadowed respectively on a subject who is facing directly toward the camera. This is a dramatic lighting style that tends to be used more on men than women, as it's atmospheric and moody rather than flattering. To achieve it, position the main light at 90 degrees to your subject—the subject's eye on the opposite side should just be picking up the light. If light is falling on the far cheek, try moving the light a little further back around the subject.

High Key & Low Key

Bright portraits with few or no shadows are classified as "high key." Without the sense of depth that shadows provide, high-key portrait lighting can appear a little flat, but it is the easiest type of lighting to work with when you have a group of people or fidgety kids, as changes in the position of the subjects relative to the light source don't matter so much. If you use the previously outlined lighting styles on a bright or white background, and/or supplement the main light with strong fill-in lighting, the end result is likely to be high key.

Conversely, portraits with lots of dark tones and shadows are considered "low key." They are more atmospheric and have a sense of depth and shape that can be missing from high-key portraits. In the right place, shadows also help to slim a subject, so it's a good lighting choice if you want to flatter your subject. If you create portraits on a dark or black background, use only a single light and/or use a fill-in light at a very weak setting, the end result is likely to be low key.

A good, balanced portfolio of portraits should have a mix of both of these lighting types.

Right: This image features lots of bright tones and highlights, so would be classified as "high key." The symmetrical composition and pale top worn by the subject adds to the shot's simplicity and ethereal feel.

Focal length: 140mm

Aperture: f/5.6

Shutter speed: 1/180 sec.

ISO: 50

Opposite: This is a low-key image as it contains mainly dark tones and shadows. The softness of the light comes from working with the light emitted at the edge of the softbox, where it begins to feather. This shot uses loop lighting, a form of narrow lighting that brings out the structure in the cheek bones.

Focal length: 195mm

Aperture: f/9

Shutter speed: 1/125 sec.

ISO: 50

Chapter 4
Locations

Your subject may claim they have nothing good enough to wear, but after reading this chapter you can never again claim you have nowhere good enough to shoot.

Almost everywhere has potential: although it's all too easy to spot the problems with a location—cables overhead, the trash near the curb, a street sign, and so on—most barriers can be overcome with a change of angle or crop. However, lighting almost always comes before location in terms of choosing where and when to shoot— as long as the lighting is good, there's usually a way to make the location work.

The only time the background is more important is when it adds a significant narrative to the shot, as with an environmental portrait, for example. Either way, you can use accessories such as reflectors and diffusers to help soften and bounce the light as needed.

Whether you want to bring attention to the background, use it to add interest to the portrait, or keep it as plain as possible to make sure the focus is on your subject, in this chapter you'll see what to look for, and how you can get the best out of indoor, studio, and outdoor locations.

Right: Finding locations for portraits is all about noticing potential. This side street in a typical English village ticked lots of boxes for a great background: texture, interest, patterns, complementary colors, and a great device for framing the subject.

Focal length: 70mm
Aperture: f/4
Shutter speed: 1/90 sec.
ISO: 200

Getting The Most From Any Location

For some portraits you may want all the focus to be on your subject, with a clean, monotone background behind them. However, for other shots the background can play a key part in adding context, interest, or narrative. The kind of things you will need to look for in a background will therefore depend on your shot.

If you want to imply a relationship between your subject and the background, you will have more considerations to make, as the location will provide context and a sense of place.

If you don't need to create a relationship between your subject and the background, the criteria are usually more straightforward: the usual

Above: Here, the background tells us something about the subject's attitude to following rules, providing the viewer with more information than just what the subject looks like.

Focal length: 70mm

Aperture: f/3.2

Shutter speed: 1/60 sec.

ISO: 160

aim is to create interest and texture behind your subject, in a location where there is sufficient lighting to make an exposure.

In either case, remember you are using the location to provide a backdrop to your portrait; you are not there to photograph the location itself. It's easy to visually lose a subject inside a complicated environment, so keeping the shot simple is usually far more effective.

Location Scouting

When you are looking for locations, you need to bear in mind that you will require different qualities than if you were attempting to capture a landscape photograph; the prettiest backgrounds don't necessarily make the *best* backgrounds for portraits. For example, a rusted metal shack or peeled paint on a wooden door blurred in the background can add interest, while a derelict yard could add edgy contrast to a fashion shoot.

In fact, you often don't need to go far at all to find a great background for your portrait; what's more important is developing the ability to spot opportunities in the locations available to you, rather than focusing on the problems. For example, it would be easy to dismiss a parking lot as not having any potential, but even somewhere that seems as unpromising as this could offer you a range of options:

- You could position your subject against a car and include part of its bodywork to add abstract color to the shot.

- You could stand your subject between two cars and include both of them in the shot, implying a relationship between them and your subject.

- You could shoot from a low angle so only the sky is visible behind your subject.

- You could ask your subject to crouch down and crop the image in close so the surface of the parking lot is visible as an out-of-focus texture.

- You could include a feature of the parking lot, such as a graffiti-covered wall or signage, behind your subject.

Above: Photographing nervous subjects in a familiar location will help reduce any nerves. A favorite location can also add meaning and narrative to an image that a studio shot would lack.

Focal length: 50mm

Aperture: f/2.8

Shutter speed: 1/100 sec.

ISO: 2500

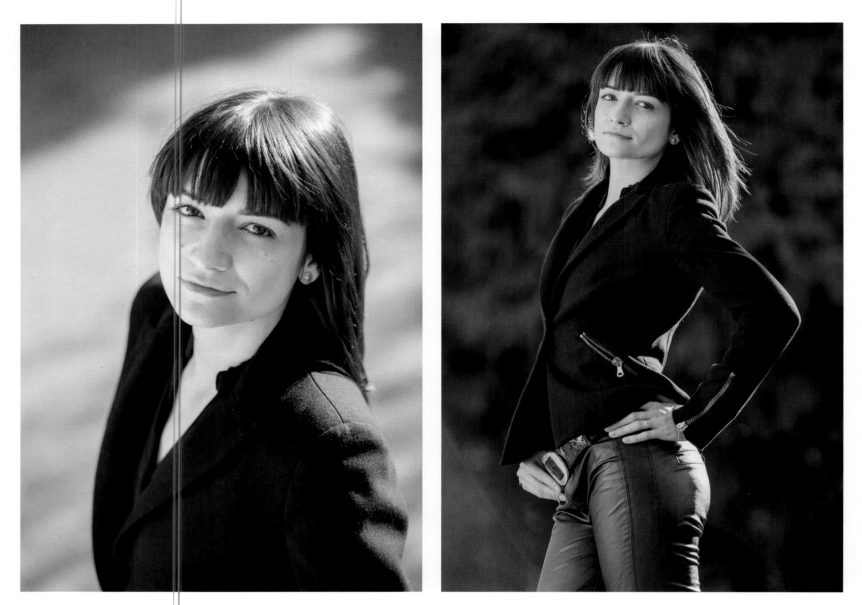

Angle

Simply changing the height at which you are shooting from can create two or three completely different images from the same background. Similarly, circling around your subject will change which part of the background is visible behind them. By constantly moving, you will be able to achieve a varied set of images from a single place.

Changing your angle will also enable you to use elements in your location as compositional devices—by shooting through a gap to frame your subject, for example, or by positioning yourself so that the bricks in a wall become a series of leading lines pointing toward your subject. Quickly changing your angle so that you are parallel to the wall for your next shot will give a totally different feel to the image.

Different angles can also imply different balances of power: shooting from above your subject's eye-line suggests vulnerability, whereas shooting from lower down suggests the subject is confident, or even arrogant (although changes to the pose can partially or wholly mitigate this effect).

However, be aware that changing your angle may also affect how the light falls on the subject. In general, you should prioritize getting the light quality right, unless the background adds narrative elements that are more important than the lighting.

Far Left & Left: These two shots were taken moments apart in the same location, showing just how much impact a change of angle can have. In the first shot (far left), the viewer looks down on the subject, with the ground visible behind her. In the second (left), a lower angle reveals a leafy green background, rim-lit hair, and gives the subject a sense of confidence and power.

Far Left	Left
Focal length: 145mm	Focal length: 150mm
Aperture: f/4	Aperture: f/3.3
Shutter speed: 1/350 sec.	Shutter speed: 1/350 sec.
ISO: 100	ISO: 150

Crop

Changing your crop—by moving closer to your subject or zooming in—can drastically change how much of the background is included in each portrait. Aim for variety, by including a range of crops in each location that you visit. Try to remember to change your angle as well as your crop, by constantly moving around your subject.

Foreground Interest

Although we're largely looking at the role a location plays in providing a background for your portrait, elements can also be used in front of your subject to achieve the same purpose and add an inner frame to the shot. For example, you could use architectural elements to frame your subject or shoot through out-of-focus foliage. You could even hold loose foliage in front of the lens when nature doesn't supply the foreground you want!

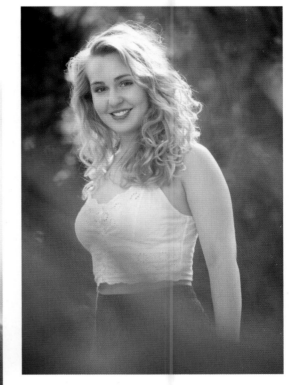

Above Left & Above Right: Two very different shots, taken within seconds of each other, show how changing your crop and angle can help you to get more out of a single location.

Above Left	Above Right
Focal length: 155mm	Focal length: 150mm
Aperture: f/4	Aperture: f/4
Shutter speed: 1/250 sec.	Shutter speed: 1/250 sec.
ISO: 100	ISO: 100

Above: Foreground elements in front of your subject can add a sense of an intimate moment that has been "caught," rather than staged. Here, the greenery also provides a partial frame along the bottom edge of the image, softening the appearance of the crop into the subject's lower body.

Focal length: 200mm

Aperture: f/3.3

Shutter speed: 1/350 sec.

ISO: 400

Indoor Portraits

Sometimes the weather dictates that an indoor location has to be used for a shot; other times, you may want to start off at a subject's house as they will feel most relaxed there. For shots of newborns, you will need the consistently warm temperature that only an indoor location can provide.

People can be self-conscious about their homes, and critical of their potential as the location for a shoot. However, a blank, neutral wall and sufficient natural light are enough to get started with. Clutter tends to be one of the biggest

challenges for home portraits, but can usually be overcome with a quick tidy up, by rearranging furniture, or by choosing your angle selectively. Ask to be shown through any and all parts of the location that can be used for the portraits, so you can assess their potential. Use this as an opportunity to get to know your subject better, and notice what type of photos they are currently displaying, if any.

If you are photographing portraits for a customer who wants to display the final images

Above: White rooms are ideal for portraits, as the light is bounced around, making it softer and more flattering. Look for architectural elements that provide a frame within a frame, such as the textured wooden door used here.

Focal length: 50mm

Aperture: f/4

Shutter speed: 1/180 sec.

ISO: 1100

in their house, taking the images in the same room that they will be displayed in ensures that the shots will complement the decor. Alternatively, you could use colors in the shot that match those in the room the photos will be displayed in, or ask your subjects to wear certain colors that will work well.

Large windows and glass doors provide the easiest sources of indoor light, particularly in the winter months when the sun is weaker. Shots of newborns can work particularly well on white sheets in the master bedroom, as these rooms typically have the biggest windows.

For lifestyle portraits of teens and adults, living rooms tend to have the best supply of natural light.

Position your subject at the edge of the light, as this will prevent it from wrapping around them, yet also produce the softest lighting effect.

However, even a small window can work—if you get the light to fall on the subject's face, the rest of the room will become relatively dark, helping to disguise any imperfections in the location.

The light in the entrance of a home is almost always excellent—position your subject far enough back so that no direct sunlight reaches them; reflected light will bounce off the doorframe and walls to create a flattering portrait. Without additional light in the background, the hallway can easily be underexposed, hiding any clutter.

Above: Large windows at either side of the subject provided the soft light for this indoor shot, while using a wide aperture blurred out background distractions.
Focal length: 175mm
Aperture: f/4
Shutter speed: 1/100 sec.
ISO: 800

Of course, there are many other indoor locations where you may want to capture portraits, and the same principles apply—just be aware of any additional clutter that needs to be avoided (or edited out during postproduction).

Studio Portraits

Studio spaces give you maximum control over the lighting, as all natural light is usually blocked out entirely, so the only light falling on your subject is from artificial lighting. Learning where to place studio lights in a way that will flatter your subject is great preparation for location shoots as well, as you will know where the light needs to be relative to your subject, and you can aim to replicate the effect with whatever is available to you.

Although it's possible to get shots in a space measuring as little as 2 x 2m (6 x 6ft), it will certainly limit your options. Where possible, use the largest space available to you, as this will allow more distance between the subject, background, and camera. You will also need to be aware of the height of the studio's ceiling, especially if you want to fit a softbox above your subject to light their hair.

Equally important are power outlets for your lighting equipment, and neutrally toned walls that won't bounce colored light onto your subject. It would be easiest to control the light in a studio with black walls and ceiling, but this can make the room depressing for your subject to walk in to; ideally you want it to be a nice place to be, so your subject can relax more easily.

Right: Studio shots help to ensure the focus is kept on the subject. The muted colors and simplicity of this image allow the subject's grace and poise to be the center of attention.

Focal length: 50mm

Aperture: f/2

Shutter speed: 1/160 sec.

ISO: 100

You can use the studio walls as a background if they are clean and blank, or buy fabric or paper rolls purpose-made for portraits. Whichever you choose to use, make sure the surface has a matt finish, otherwise glare from the studio lights will be reflected back into the camera. Separate the subject from the background so that creases and imperfections in the wall, fabric, or paper can be hidden through the use of a wide aperture.

Backgrounds can be either white, black, gray, or colored, but the position of your lights will also affect how the color of the background is recorded; a white background will appear gray if it's underexposed, for example. You can also buy patterned studio backgrounds that are designed to replicate the interest and texture provided by some outdoor locations, although you need to accept that they often look a little fake in the final image!

Studio shots tend to place all the emphasis on the subject. This can be limiting, as there is no relationship between the subject and the background, so you'll need to work harder to make your portraits interesting.

Right: You don't need a lot of space or equipment to take bust shots like this one, just two lights and a background. Choose background colors that complement (but don't detract from) the subject.

Focal length: 125mm

Aperture: f/13

Shutter speed: 1/200 sec.

ISO: 100

Natural Locations

Natural locations include parks, woodlands, forests, beaches, meadows, and fields. The latter three often lack shade, so are better suited for overcast days, while the first three provide plenty of places under trees with which to shade your subject on bright days. Natural environments tend to be less busy than urban spaces and are safer for children to move around in, making them (and their parents) feel more relaxed.

The majority of private gardens don't tend to have sufficient shade for portraiture on bright days, and can have limited space for children to move around in. Equally, your choice of angle will be limited as you try to avoid getting any outbuildings or the house itself in the background of the shot. It is far better to head to larger natural environments, so you can keep moving along. This will prevent your subject(s) from getting bored, and enable you to react spontaneously to potential locations as you encounter them.

Don't necessarily look for things that would make a good landscape shot, though—some of the best backgrounds are textures, colors, and open spaces that add interest but don't distract from your subject.

Footpaths can be ideal for taking a family on a walk as you shoot portraits. Look for tunnels of trees that can provide shade and background interest. Wooden fences can become lead-in lines, while gates and stiles can help you position groups, with each subject posed slightly differently on the far side, leaning over the barrier. Lie on the floor for some shots to change what's visible behind your subject or crouch in the verge to add foreground interest.

Shooting on a beach or in snow provides a challenge, as there is a vast expanse of pale-colored ground bouncing light in multiple directions. This can help to avoid shadows on the face, but the glare can be powerful—in this situation, consider using a diffuser to take the edge off the light.

Above: These bluebells give the portrait a sense of time and place, as well as acting as a colorful backdrop to the main subject. Note how the child has been placed so the low sun rim lights her hair and adds atmosphere to the shot.
Focal length: 105mm
Aperture: f/4.5
Shutter speed: 1/200 sec.
ISO: 500

However, on the beach, endless sand can result in a boring background, so look for other elements to provide a sense of place and interest, such as sand dunes twisting into the distance or rows of colorful deck chairs and beach huts behind your subject. Some beaches have piers or jetties, with ironwork beneath them offering an opportunity for a different type of shot.

As you tend to have more open space in natural environments, you can often include the sky as a backdrop. If you time your shoot as the weather turns from fair to foul you can get dark, rolling clouds in the background that add atmosphere, or shoot at the golden hour (see pages 60–61) for gentle sunlight with a warm glow.

In all instances, it's important to protect your kit from the elements—sand, water, and extremes of temperature can all put your camera equipment at risk. You can buy protective covers to protect your camera from rain and sand, and always avoid changing lenses when there's a risk of particles entering the camera body—step back inside a building before switching them. When going outside on a cold day, keep your camera in its bag for at least 20 minutes to allow the air inside to cool gradually, otherwise you risk getting condensation inside the lens.

Right: Natural environments offer a safe space for children to move around in, as well as an esthetically pleasing background. Nature also offers plenty of compositional devices, such as the line of trees in this shot, which draws the viewer's eye into the frame.

Focal length: 200mm

Aperture: f/3.5

Shutter speed: 1/320 sec.

ISO: 500

Buildings & Urban Locations

The majority of people live in or near a city, which means plenty of opportunities for urban portraiture are virtually on your doorstep. Built-up locations give portraits an edgier look than those shot in natural locations, and are particularly ideal for teen shoots, or portraits with a fashion feel.

If you want to include or exclude other people in your portrait, consider your timing. Some urban locations are heavily congested during the working week, but if you come at the weekend, you can often have them to yourself. In busy locations, experiment with having your subject remain still, then using a slower shutter speed so that passers-by are rendered as blurred motion.

Your timing will also affect the lighting available to you. Shadows and overhangs from buildings will provide flattering top-shade on a bright, sunny day, but can affect your ability to make use of the golden hour as the sun drops near to the horizon.

Instead of seeing a building as a whole entity, mentally break it down into potential backgrounds it could provide. A set of stairs could be used for seating your subject, with the other steps contributing to horizontal or diagonal background lines; an archway could frame your subject; and a brick wall could provide a patterned backdrop or lead-in lines. Look for shapes, colors, and lights that will become interesting, abstract backgrounds once blurred.

Right: Crowds are always going to present a challenge in popular, tourist locations. Selectively choosing the time of day can help you avoid the worst congestion, but you may need to consider other ways of setting your subjects apart, from the crowd. Here, the subjects are closest to the camera, sharp, and central, which makes them the clear focus of the shot.

Focal length: 170mm

Aperture: f/5

Shutter speed: 1/400 sec.

ISO: 100

Above: A textured brick wall adds an edgy background to this portrait, complementing the young men's relaxed, cool, and confident poses.

Focal length: 92mm

Aperture: f/5.6

Shutter speed: 1/125 sec.

ISO: 280

Don't overcomplicate the background by trying to include too much in one shot—just pick out one or two elements from the scene. You should also be aware of any trees, signposts, and other urban clutter in the background that can easily appear to be growing out of your subject's head. Often, a slight change of angle is all that's needed to prevent this.

Entrances to subways or pathways under bridges can provide incredibly flattering light—position your subject a few feet inside so there's no direct light on their face.

Sometimes you may want to neutralize the background so you have some shots with all the focus on the subject—bridges and walls can help you to do this. Ask your subject to safely lean over the side of a bridge at its apex and shoot along the railing or wall to get a pleasing depth of effect, with blur beyond and in front of your subject. With only the sky visible behind your subject there will be no background distractions, while the reflected light from the water will help fill in any shadows.

As dusk draws in, cities are transformed, giving you the opportunity to use light trails from cars, street lighting, and displays in commercial windows as a backdrop to your portrait, although you may need to use flash to expose your subject correctly. Look for doorways that provide a visual boundary between two different types of light; for example have your subject lit by the warm, tungsten light in a building's doorway, with the blue light of dusk visible outside.

Left: Urban locations offer some great opportunities for including texture and dereliction behind your subject and adding intrigue to your portraits. Here, a connection is implied between the subject and her background, which arouses the viewer's curiosity.

Focal length: 105mm

Aperture: f/5

Shutter speed: 1/320 sec.

ISO: 160

Environmental Portraits

Environmental portraits tell us more about the subject than just what they look like. Rather than being blurred or abstracted, the location is clear, helping to give the portrait context and narrative. Choosing the specific place will depend on the intended use of the shot and the story you want to convey about the person—it could be the subject's home, their workplace, or a place of leisure. The subject's gaze and expression will also depend on your intentions for the shot. You may want him or her to be absorbed in a task, interacting with another person, or looking toward the camera. Ideally, take a range of shots, so you have more options later on.

Take time to get to know your subject, so you can create a portrait that best reflects their character and personality. Ask to be shown all the potential spaces that could be used for the portrait, and find out what an average day looks like for them. The subject may overlook a detail or room that would make a great shot, simply because they see these things everyday and no longer notice them.

Unlike candid or reportage photography, there is normally an element of posing in an environmental portrait, albeit in a way that fits the context of the image. There may also be a relevant uniform, prop,

Right: This shot wouldn't have the same impact if it had been taken in a studio, as it would be completely out of context. Instead, the goal in the background, trimmed grass, and atmospheric sky create a visual narrative around the subject and his soccer ball.

Focal length: 82mm

Aperture: f/10

Shutter speed: 1/160 sec.

ISO: 100

or accessory that will add to the image's impact, such as a chef's hat or a relevant tool that the subject is holding, for example. However, as with other types of portrait locations, the main focus of the shot should still be the person, so be careful not to let the surroundings dominate.

Where you position your subject in the location will depend on which details you want to include in the image and how you plan to light it. You might move the subject to a patch of light, for example, or use the white walls of a room to bounce light from a flash.

Above: The chef's stance and expression suggest a level of authority in this environmental portrait. Note the muted color palette, and the way in which the subject is framed by the elements in the location—the background lines draw the viewer's eye to his face.

Focal length: 30mm

Aperture: f/5.6

Shutter speed: 1/180 sec.

ISO: 400

Chapter 5
Composition

A photograph's composition is the sum of how you place all the parts within it: it's the use of the edges of the frame, the use of shapes within the frame, the prominence of any foreground/background details, the position of the subject within the frame, and even the shape of the frame itself.

As with a successful exposure, a successful composition is one that creates the effect intended by the photographer, whether that's a sense of space, pleasing esthetics, and visual harmony, or the polar opposite.

It is also important to consider how the portrait will be used and seen: will it be displayed as a large print on a wall, or as a tiny part of a web page? Where do you want the viewer's eye to go to first? What path do you want their eye to take within the frame?

There are many guidelines and "rules" for portrait photographs, which are generally intended to create attractive compositions. However, depending on your desired intention, you may want to achieve something else entirely. In addition, relentlessly applying these rules will result in rigidly composed photographs that quickly become repetitive. Instead, you should look to develop your own style, as this is what will set you apart from other photographers. With this in mind, it is a good idea to learn the rules, but don't be afraid to break them.

Right: The rules of composition can help ensure that your subject is optimally placed in the frame, but rigidly following them will limit your creativity. Learn them and use them as optional tools instead.
Focal length: 105mm
Aperture: f/3.3
Shutter speed: 1/350 sec.
ISO: 400

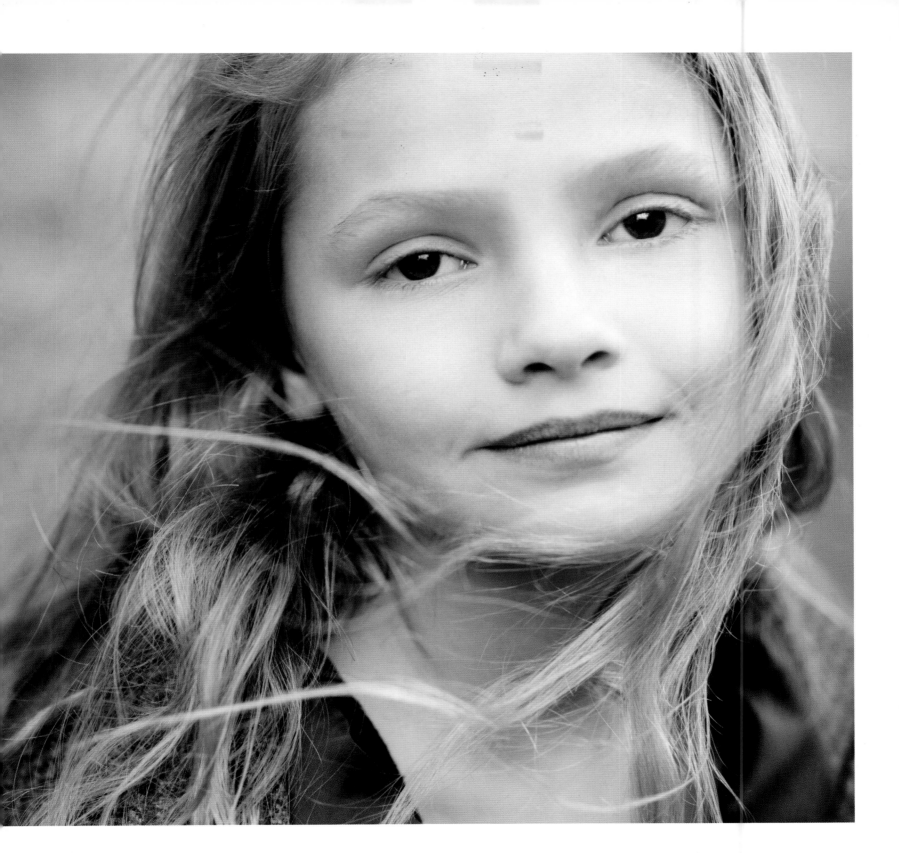

Use & Scale

Usage

The destination for your image will—to a certain extent—determine the best composition. For example, if the subject wants to use the shot as their profile picture on a social media web site, you may need to provide a square crop. At the same time, a full-length shot with lots of space around the subject will have detail that is too small to see once the image is in a small box online; a close crop would be much more usable.

However, if the image is for a large frame on the wall, a close crop may be overkill, as you would need to stand too far back to take in the subject's full features. In this instance, a portrait that includes a lot of background detail could work well, as the smaller the subject is in the frame, the larger the print will need to be to have the same impact.

Alternatively, if you're looking to build a web site, a lot of page templates aimed at the photography market feature a large, landscape frame for a powerful first impression—if all your shots are portrait, you'll struggle to find one suitable to use.

Finally, if you plan to fill a photobook with the images you take, you will find many of the templates available feature a range of landscape, portrait, and square apertures for images, so having a variety of formats in your set will be key. Similarly, if you are hoping to take images that may be used by a newspaper or magazine, then providing them with a portrait version as well as a landscape one will boost your chances of having something that fits the space they need to fill.

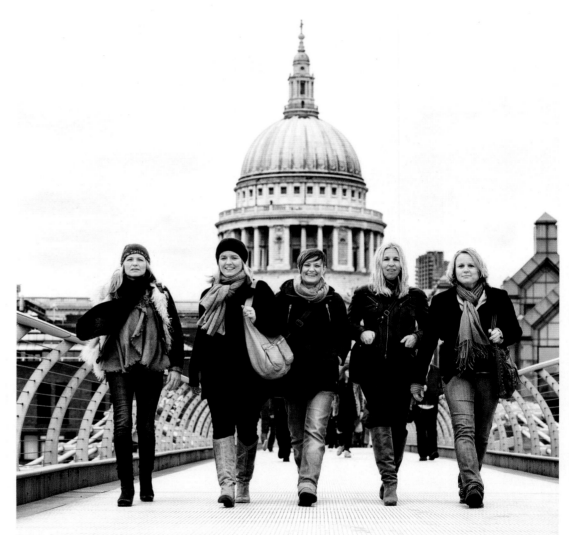

Right: A very close crop might be too overpowering for a large wall print, whereas a distant shot won't work at a tiny print size, or on social media. The detail in this scene would be lost if displayed as a small print.

Focal length: 70mm

Aperture: f/5

Shutter speed: 1/400 sec.

ISO: 400

Scaling

If you are taking photographs for wall displays, you need to be aware of underscaling—one of the most common failings when people choose a print size. This happens because people don't tend to use a reference point, but guess at which dimensions to buy while the print or frame is immediately in front of them. If you hold a piece of A3- or tabloid-sized paper near your face, it seems huge, but hold it up to a wall and it can quickly appear lost. Visit interior design shows or new showhomes and you will quickly see what sizes complement different spaces—and they tend to be much larger than most people naturally go for!

As a photographer, part of your job is to introduce the concepts of usage and scale to your clients, so that prints and frames complement the space they will be displayed in. Hold a print up in the space the client is considering displaying it in, so they can make an informed decision. If you intend to make money from selling prints, then bigger is definitely better for you as well, as you can make more money from them! The alternative is to cluster multiple, smaller framed images together for a similar effect.

It's therefore good practice to consider the end use of the image, and, where possible, take both portrait and landscape versions of each shot, as this will give you the most opportunities later on.

Above Right: Before picking up your camera, consider how and where the final shot will be used and be prepared to educate your customers about scale. A tiny, three-quarter length portrait will look lost printed at a small size and displayed in a big space, as here.

Right: An alternative to a very large wall print is a cluster of mid-size ones, displayed together in matching frames. These can show a series of images that help to tell more of a story, or provide space for individual shots of members of a family or group.

Formats

The vast majority of cameras provide a rectangular image frame, but many have options for different shapes as well. Image-editing software also allows you to use other formats, including square and panoramic shapes.

Different formats lend themselves to different scenes and compositions—practice capturing the same portrait using a range of different formats to

see which you prefer and why. Over time, you will soon be able to judge which format will work best for a particular photograph, even before you have lifted the camera to your eye.

Above: One image; four formats. Postproduction enables you to make decisions about composition after the image has been captured, so long as you leave sufficient space around your subject. Which of these shots do you think works best?

Focal length: 98mm

Aperture: f/4

Shutter speed: 1/100 sec.

ISO: 200

Portrait or Landscape?

Despite the latter's name, both portrait and landscape formats can be used in portraiture. In fact, some portrait photographers use the landscape format almost exclusively. Sometimes this is based on personal preference, but landscape shots can also offer some marketing advantages—they display better on digital media and on some screens, where the viewing area is better suited to landscape format images.

Take a look through your recent images. Do you naturally incline toward portrait or landscape format, or does your work have a fairly even mix of both? Your choices may depend on your subject matter, or you may wish to develop a distinctive style by predominantly featuring one format.

Square Format

The square format is ideal for emphasizing visual balance and symmetry by placing your subject in the center of the frame. Alternatively, for a more arresting portrait you could position your subject off-center or with an extreme crop.

To achieve a square format shot, shoot a portrait or landscape photography loosely, with plenty of space around your subject. Then, carefully crop your shot in postproduction.

Panoramic Format

The panoramic format takes longer for our eye to travel across and absorb the whole scene. Consequently, it's harder to take in everything at once—particularly if the image is large—but this can work to your advantage.

Some cameras offer a built-in panoramic option (typically a 16:9 widescreen format), or you can take several shots and stitch them together in your editing software. Alternatively, if your camera offers high enough resolution, you could simply crop a regular shot into a panoramic format.

Montages

Montages enable you to tell a story through a series of photographs. The word "story" doesn't imply a detailed plot here, but rather a journey or experience brought to life through its visual details. The relationship of the different images may be clear, with each of them featuring the same colors, subjects, or lighting conditions, for example, or the relationship could be implied simply by the grouping of a selection of images for the montage. The story's narrative could be as simple as "our day at the beach," "our child's first year," or "a fashion shoot in the factory."

Montages also allow space for shots that might otherwise not be considered standalone display material, but which add depth to the photographic story, such as close-ups of seashells, a tiny newborn fist, or a macro shot of a heel amongst rubble. They could include images that are not portraits, strictly speaking, but these shots provide space for creativity and variation that can give the viewers a visual rest between images that may otherwise be too similar.

Two popular configurations are triptychs—three images presented side by side—and montages of nine images, often arranged in a 3 x 3 grid. However, there are limitless variations, including the choice of the width of borders and gaps between images (if any), and whether the image formats within the montage are the same (all portrait format, for example) or mixed.

Rule of Thirds

The rule of thirds provides a guide as to the most impactful place within the frame to place key elements. Imagine two horizontal lines that split the image into thirds, crossed by two vertical, equidistant lines that split the image into thirds the other way. Placing an image component along one of these lines or—even more powerfully—on one of the four intersection points where the lines meet—contributes to a strong composition.

For close-up portraits, aim to get the nearest eye on one of the top two intersection points. For three-quarter or full-length shots, the subject's face should be on one of these top two points, regardless of whether you are shooting portrait or landscape format. In either case, make sure that the focus point is also on the area that falls on the intersection, so this part of the image is sharpest.

The rule of thirds is particularly useful if you take a landscape format shot according to the rule, and then decide later that a portrait format crop would work better. The subject is likely to still be placed on one of the key areas of the frame when the rule is applied to the new, portrait-format version.

Left & Above: The thirds lines and their four intersections are the areas of an image that you would place key elements on if you were composing using the rule of thirds. Here, the subject's eyes are placed on the top two intersections, creating a powerful composition.

Focal length: 200mm

Aperture: f/4

Shutter speed: 1/200 sec.

ISO: 200

Golden Spiral

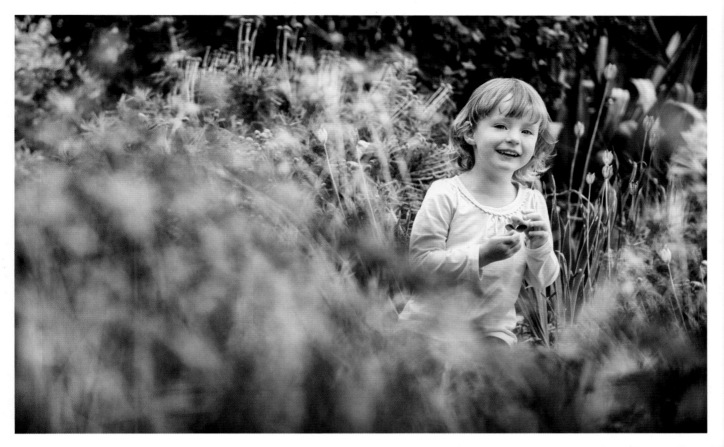

Like the rule of thirds, the golden spiral is a guideline for positioning elements of the image within naturally powerful areas of the frame. It is an ancient design principle which states that the ratio of 1:1.618 is the most visually pleasing. This particular ratio has been found to appear repeatedly in nature (such as in the shape of a snail's shell) and is one that humans are drawn to.

It can be used to divide the image frame into a series of smaller and smaller rectangles. A line is then curved from the outer corner of the first rectangle, through the corners of the second largest, through to the next, and so on, until you have a spiral flowing through the whole image.

This ratio can also be used to create a guideline grid, which looks very similar to the rule of thirds,

albeit with a slightly different placement of the lines and intersections resulting in a smaller central box.

In fact, it is possible that the rule of thirds is a simplified version of the golden ratio, although the latter is supposedly more refined and historically proven to be superior.

Above: This shot shows the golden spiral in action, with the placement of the young girl's face at the exact center of the spiral.

Focal length: 190mm

Aperture: f/4

Shutter speed: 1/160 sec.

ISO: 200

Angle & Viewpoint

Positioning your subject in a location is only one part of the puzzle—even in a studio environment, you need to consider where you will be positioned, as the photographer, and whether you will be holding the camera level or angled toward your subject. The simple choice of whether you stand or crouch can have a huge impact on the composition and connotations of the final shot. If you always take every photograph at the same angle, you will be missing out on a world of creativity. Instead, consider and experiment with a range of different angles for each shot. With experience, you will instinctively know where to position yourself to achieve the result you are after.

Perception of Power

Changing your viewpoint affects the balance of power between the viewer and the subject. If the image is taken from a low viewpoint, angled up toward the subject, this imbues the subject with a sense of strength, confidence, power, and even arrogance. Conversely, taking an image from a high viewpoint and angling the camera down toward the subject results in associations of vulnerability, weakness, and lack of power. To exaggerate this effect, stand on a chair or use steps to make your high-angle shots more extreme, while raising your subject or shooting from ground level will give you options for low-angle shots (watch out for double chins and unappealing nostrils!). A shot taken at the subject's eye-level has a neutral effect on the viewer's perception of the subject's power.

Angling the Camera

As well as holding the camera in a portrait and a landscape orientation, you can also tilt it midway between the two. Angling your camera so that neither edge of the frame is parallel to the horizon

Above & Above Right: Photographing from above the subject's eye level gives the feeling of looking down on the subject, with connotations of submissiveness and lack of power implied on the subject. Shooting from the same height as the subject's eye level removes the power imbalance between viewer and subject, but here has meant that the logo on the subject's top is now sharp, due to it being on the same plane as the subject's face.

Above

Focal length: 98mm
Aperture: f/4
Shutter speed: 1/350 sec.
ISO: 560

Above Right

Focal length: 135mm
Aperture: f/3.3
Shutter speed: 1/750 sec.
ISO: 560

can add a sense of drama and energy to a shot that might otherwise appear mundane or too static. It can also sometimes improve compositions that aren't working well in either a portrait or landscape orientation.

Using the camera like this also gives you a longer axis to shoot along, so may enable you to fit in more than you could otherwise with a portrait or

landscape, especially where you are struggling to fit in the elements of your subject that you want to include in the frame.

When adding a diagonal tilt, it should be significant enough that it doesn't look accidental, as a shot just a few degrees off level will feel like a mistake to the viewer. It is also a good idea to use this technique sparingly—a whole set of images

taken at extreme angles quickly becomes tiring for the viewer and will reduce the photographs' impact. Also consider how the images will be used or displayed—if in doubt, take additional shots in portrait and/or landscape formats too.

Above: Tilting your camera when taking a shot can add energy to a composition and enable you to better fill the frame. Ensure the tilt is significant, though, otherwise it can just look like an accident.

Focal length: 200mm

Aperture: f/5

Shutter speed: 1/400 sec.

ISO: 250

Above: Photographing your subject from a 45-degree angle above their eye level guarantees a flattering shot for the vast majority of people, as it focuses attention on the eyes, which are at their widest.

Focal length: 200mm

Aperture: f/3.3

Shutter speed: 1/90 sec.

ISO: 400

Flattering your Subject

Often, your aim is to show your subject at their very best. One angle that works for almost everyone is to shoot from about 45-degrees above their eye level, with their body facing slightly away from the camera and their face turned back toward

the lens. In general, bigger eyes are considered more beautiful and when we look up, our eyes are opened to their fullest, creating the illusion that they are bigger. In addition, it's common for people to consider their eyes to be their most attractive

feature. This angle—combined with a wide aperture—places all the attention on the subject's eyes, while body parts they may not be so keen on are either out of the shot completely, blurred in the background, or just not the focus of the image.

Crop

A crop is the removal of unwanted elements from the frame in order to improve the composition or increase the focus on other parts of the scene—a close-up shot involves a conscious decision to exclude the rest of the subject's body, in order to focus on their eyes, for example. Conversely, you may want to show the full body of your subject by selecting a wider crop, perhaps showing some of their environment as well. Tightly cropped portraits tend to have more impact on smaller screens, such as smart phones and tablets, as a lot of detail is lost when viewing photographs at this small scale.

Ways to Crop

You can crop into a scene by physically moving closer to your subject, zooming in with your lens, or by trimming the edges of an image in postproduction. However, try to avoid getting into the habit of consistently delaying your cropping choices until postproduction, as cropping an image reduces its resolution. Instead, aim to get as much right in-camera as possible, as this will save time later on and push you to create images, not just take them. Cropping in postproduction should be viewed as an additional opportunity, not a default option.

Where to Crop

When cropping into a subject's body, do it confidently or not at all—a bit of a foot cut off or the very top of a head sliced into will appear accidental, drawing attention to the crop rather than the subject. Equally, crop above or below the subject's joints, rather than on them—a crop through the ankle, knee, or elbow looks odd.

Cropping into a subject's hairline can really strengthen a composition, as it tends to place the eyes on one of the lines of the rule of thirds.

However, be careful with crops into the top of the heads of people with thin hair (as it makes them look completely bald) or those with no hair at all (as it can look unflattering). You should also avoid cropping into a subject's chin, unless you are taking an extreme close up—losing this element of a person's face tends to weaken the composition.

Elements that are touching or are very close to the edge of the frame can cause visual tension and appear accidental. They draw attention to the edge of the frame and detract from the main subject. Crop them out completely or allow sufficient room around them so they don't draw undue attention.

Variety is key when it comes to cropping. Having a variety of full-length, three-quarter length, bust shots (upper torso and head visible), and close-ups will help ensure your final set of images looks as varied as possible.

Above: Crop shots can cut into the subject's hairline, but should never cut into their chin. This type of shot enables you to place one of your subject's eyes on one of the rule of thirds line intersections, creating a strong composition.

Focal length: 160mm

Aperture: f/3.3

Shutter speed: 1/180 sec.

ISO: 200

Above: Bust shots cut into the subject's torso, but include the full head and hair of the subject. They are more formal and traditional than crop shots.

Focal length: 150mm

Aperture: f/3.3

Shutter speed: 1/180 sec.

ISO: 200

Above: Three-quarter-length portraits crop into the subject mid thigh. They include the subject's head (without cutting into it), torso, and hands.

Focal length: 112mm

Aperture: f/4

Shutter speed: 1/125 sec.

ISO: 200

Above: Full-length portraits include the subject's entire body. Normally, there should be an even or greater amount of image space between the top of the subject's head and the top edge of the frame as there is below their feet.

Focal length: 175mm

Aperture: f/3.3

Shutter speed: 1/180 sec.

ISO: 200

Aspect Ratios

The shape of the images your camera produces will depend on its aspect ratio. This is the measure of the width and height of the image frame expressed as a ratio. The most common digital camera aspect ratios are 3:2 and 4:3.

When taking photographs that you intend to print, bear in mind that standard print sizes won't necessarily correspond to your camera's aspect ratio. In this case, your image may be cropped to match the print size, which can result in details positioned close to the edge of the frame being cut off, or unintended adjustments being made to the overall composition. If print crops might be an issue, shoot "loose," with slightly more space on both edges of the image frame. Then, when you take the shot into your editing software, you can crop it to the precise aspect ratio you need for printing, actively choosing where the crop occurs.

Visual Balance

Visual Weight

Every element in a photograph has a "visual weight" attached to it. A harmonious composition is one in which these elements are arranged in such a way that there seems to be an overall visual balance.

Elements that are high contrast, large, dark in color, placed on one of the key sections of the frame according to the rule of thirds or golden ratio, or that we know are physically heavy have increased visual weight. Those that are low contrast, small, light in color, placed randomly in the frame, or that are known to be light have less visual weight.

Subject Placement

A perfectly centered subject will quickly draw the eye to the middle of the frame and hold it there. This type of composition can be effective if you want to emphasize a subject's symmetry and visual balance. However, it can lessen the interest of other types of portrait, with the viewer immediately moving on to more interesting stimuli.

Off-center subjects inherently carry more interest, particularly in landscape format images, but they need to be placed carefully in the frame. The rule of thirds and golden ratio offer a potential solution for off-center positioning, or you could balance an off-center subject with other elements in the frame or leave some "negative" space (see pages 106–107).

Reading Directions

In cultures where text is read from left to right, be aware that a background element such as a tree or streetlight that is positioned at the left side of the frame can act as a visual "block," slowing the eye's progress across the image. The same element at the right side of the frame can act as a stabilizer, keeping the viewer's eye from leaving the image. In cultures where text is read from right to left, the opposite is true.

Above Left & Above: The position of vertical elements can affect the success of a composition. Objects at the left side will block the path of the eye, while objects at the right will hold the viewer's eyes within the composition for longer.

Focal length: 86mm

Aperture: f/5

Shutter speed: 1/320 sec.

ISO: 250

Left: A perfectly centered subject creates a strong, symmetrical image that keeps the viewer's attention firmly on the subject's eyes. The looping curl to one side of this model's face adds interest to the shot.

Focal length: 145mm

Aperture: f/11

Shutter speed: 1/180 sec.

ISO: 100

Space

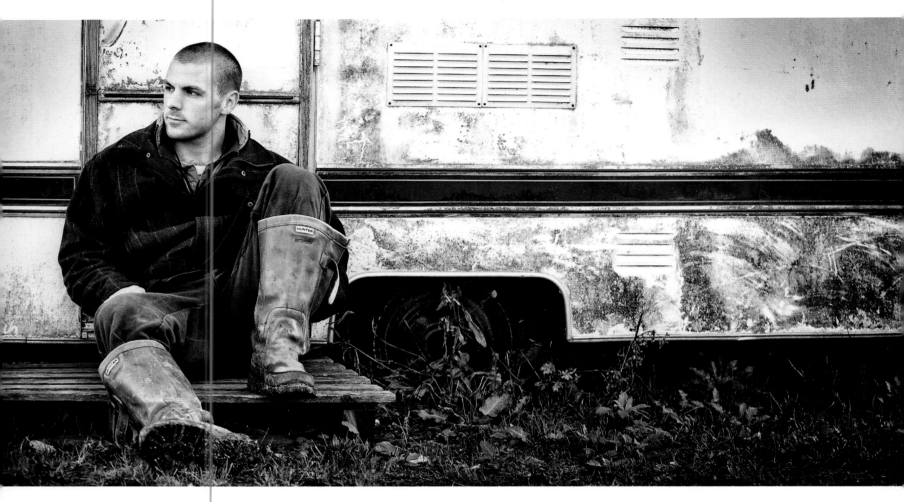

While filling the frame with your subject can lead to a high-impact portrait—particularly if the final image will be used at a small scale—using this technique all the time leads to a selection of images that are repetitive. As with many of the rules of composition, when your images are viewed as a set, variety becomes key.

Leaving some space around your subject will enable you to include background or environmental details. Sometimes you may want a simple background that keeps the focus on the subject, but adds more interest than a plain white or black studio background. Everyday locations—such as

flaking paint on an old wall or rusty garage doors—can become attractive areas of texture or color when used as out-of-focus backgrounds behind your subject, yet they are not so visually strong or distracting that they pull the viewer's eye away from the subject. In this instance, the "empty" area around your subject is known as "negative space."

Other times you may want to include environmental details that provide an additional narrative to the "story" of the image.

Either way, by *not* filling the frame, you give yourself additional compositional options, such as positioning your subject to one side, and

Above: Having your subject look out of the frame adds tension, as the viewer's gaze follows that of the subject. Harmonious composition is about keeping the eye within the image, so breaking the nose room "rule" should only be done if you want to create a sense of unease in the viewer.

Focal length: 82mm

Aperture: f/4

Shutter speed: 1/160 sec.

ISO: 500

making them small in the frame—perhaps to imply isolation or vulnerability. Additionally, your shots will have a wider range of commercial opportunities, as negative space provides an area for graphic designers to position text without it crashing into the subject, making your images potentially more appealing for editorial usage.

"Nose Room"

The viewer's eye tends to follow the gaze of the subject in an image. So, if your subject is looking off-camera to the edge of the image, the viewer's eyes will follow. To keep the viewer's gaze within the portrait, allow sufficient space around your subject, particularly in the direction they are looking (this is known as "nose room"). The same is true of a moving subject—allow sufficient space in the frame in the direction of the subject's movements for a more harmonious composition. Having a subject crashing toward the edge of the image creates tension for the viewer, and brings unwanted attention to the frame itself.

Visual Flow

In cultures where text is read from left to right, the eye tends to also travel across images in this direction. Therefore, a portrait where a small child is running across the frame from left to right reflects this visual flow, and will appear more harmonious. In contrast, a model placed at the right side of the frame, looking toward the left, subtly disrupts this flow, and may appear more challenging, strong, and/or rebellious as a result.

Above Right & Right: The direction of movement in an image can determine how successful the composition feels. Left-to-right motion feels more harmonious than right-to-left motion in cultures where text is read left to right.

Focal length: 66mm

Aperture: f/22

Shutter speed: 1/15 sec.

ISO: 100

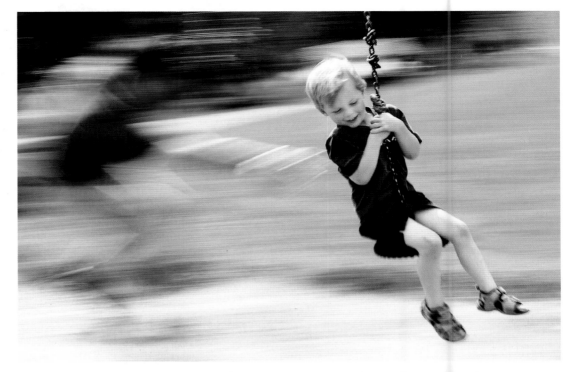

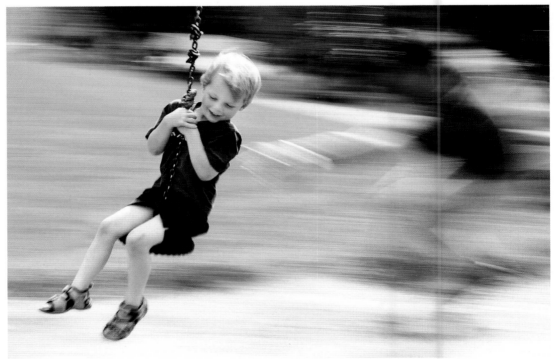

Eye Contact

Having the subject look straight down the lens gives a feeling of direct eye contact when the image is later viewed. As in real life, eye contact is arresting—it captures your attention and is a form of communication in itself. However, it also demands more of the viewer, so a whole set of images containing eye contact can become tiring and repetitive.

There are two alternatives to through-the-lens eye contact; a subject looking off-camera, but at something within the frame, and a subject looking off-camera at something outside of the frame.

When the subject is looking at something within the frame, such as an object or another person, it's as though the photographer has captured a private moment candidly, rather than a posed shot. It can enable more of a storytelling approach than with direct eye contact, as the viewer tries to determine the relationship between the subject and the thing they are looking at. The expression of the subject forms part of the story—is it a look of love, of fear, or intrigue?

When the subject is looking at something outside of the frame, this provides an unanswered

Above: The level of eye contact can vary, even within a single image when there is more than one subject. Here, the man's attention appears to be completely on his partner, while only she is aware of the camera.

Focal length: 110mm

Aperture: f/4

Shutter speed: 1/60 sec.

ISO: 400

puzzle for the viewer—what are they looking at? Again, the expression of the subject is key; if they look tense, the viewer will believe that they are anxious about the thing they are looking at,

Above: This shot of world-famous architect Peter Aldington OBE has the subject's gaze looking slightly off-camera, at something the viewer can't see. This creates intrigue, as the viewer tries to guess what the subject is looking at.

Focal length: 105mm

Aperture: f/4.8

Shutter speed: 1/125 sec.

ISO: 50

Above: A downward gaze implies shyness and modesty. This young boy was very active, but when the photographer suddenly said, "Look at that toy car down there," the boy glanced down. The result appears calm and serene, but in reality it was a hasty "grab shot."

Focal length: 62mm

Aperture: f/10

Shutter speed: 1/125 sec.

ISO: 200

whereas a serene expression or a smile tells the viewer that the subject feels positive about it. If the subject is looking toward the floor, this can imply shyness and modesty, which is why it's a commonly used setup for bridal portraits.

When viewing an image, our gaze follows that of the subject, so be aware that if the subject is looking out of the frame, then our eyes are pulled toward that point, creating visual tension. Harmonious compositions usually aim to keep the

eye within the image, so leave space at the side of the image your subject is looking toward.

Lead-in Lines

Lead-in lines are strong compositional elements that guide the viewer's eyes around an image, and draw their focus toward the subject. For example, in a shot of a subject walking along a winding path, inclusion of the path in the foreground will create a lead-in line. Equally, two rows of converging trees either side of your subject create lead-in lines that draw the viewer's eye to a vanishing point behind the subject. By giving the eye a clear path to travel through the photograph, lead-in lines help to make an image more visually appealing.

When the aperture is opened wide in order to blur the secondary elements of the image, lead-in lines can also add a powerful sense of depth, particularly where they are partially or fully blurred and the subject is sharp. This is because they clearly illustrate that the elements of the image are at different distances to each other, evidenced by the shallow depth of focus.

Lead-in lines can be formed by natural or manmade elements and are not all that hard to find if you look around you, think creatively, and are prepared to change your shooting angle. Even a wall can become a lead-in line when you shoot along it (not parallel to it), with the rows of bricks drawing the eye toward the subject. Repeated elements in a row can form an implied line, such as a sequence of equally spaced trees or rocks.

Even in full-frame portraits, the subject's body can be positioned to create lead-in lines, by placing limbs in a way that will encourage the viewer's eye to travel along them toward the subject's face.

Diagonal lead-in lines add a sense of energy to compositions, so look for ways to add these to your portraits, starting them at one of the frame's corners for maximum impact.

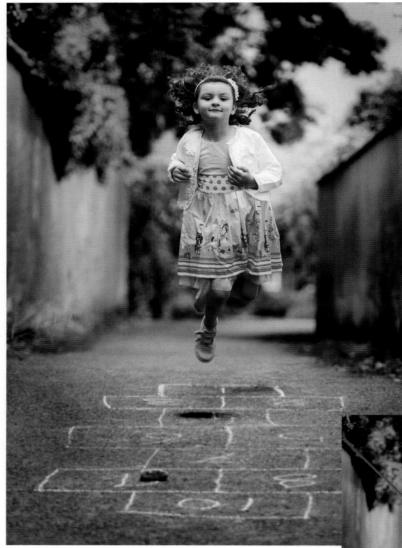

Above: This image is full of lead-in lines that draw the viewer's eye to the young girl at the center. Look around you for opportunities to strengthen your composition by simply changing your angle or position.

Focal length: 165mm

Aperture: f/3.3

Shutter speed: 1/750 sec.

ISO: 200

Background Patterns

Textured backgrounds, or those with repeating elements, can often create patterns that are ideal for adding low-key interest behind a subject. For example, the horizontal lines of a brick wall or the vertical lines of wooden planks on an old barn could both make great backgrounds.

Horizontal lines tend to suit a landscape format image the best, while vertical lines appear to be more powerful in a portrait image, as the lines echo the longest edge of the frame.

However, patterns or background lines that are set at an angle can add energy to a composition. Where the lines naturally form a vertical or horizontal plane, simply tilting the camera can change them into a high-energy diagonals. Angle your camera so that the lines run corner to corner rather than edge to edge for the most powerful effect. This is easily overdone, though, so it is worth experimenting with lesser tilts (and don't feature too many unusual tilts in the same set of images).

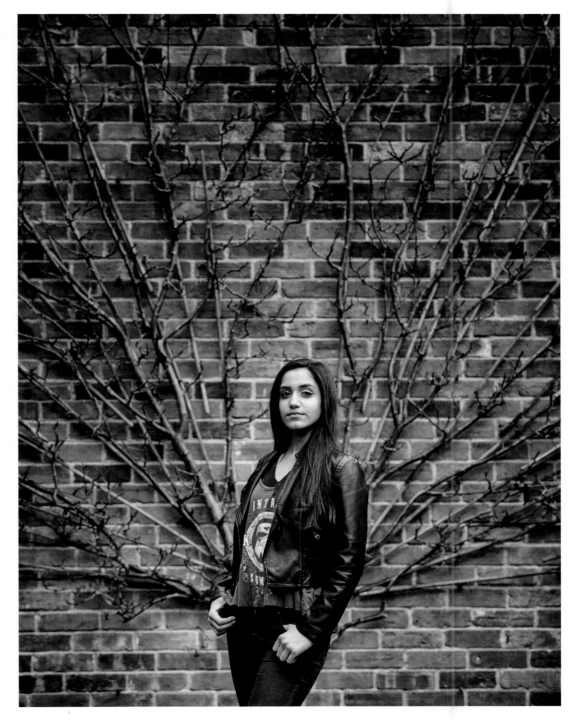

Right: The branches of this tree provide both lead-in lines and a striking fan pattern that contrasts with the horizontal lines of the bricks behind the subject. This adds both interest and energy to the composition.

Focal length: 95mm

Aperture: f/4

Shutter speed: 1/180 sec.

ISO: 400

Frames

You can use elements of a scene to provide an additional frame within the edges of the image. This could be a full frame, on all four sides of the image, or a partial frame, where only one, two, or three sides of the image are affected.

Potential framing elements include doorways, foliage, tree trunks, or even other people. Frames can either be an obvious element in their own right, or merely blurred parts of the image; they can also

be in the foreground or background of an image (although the former is more commonly seen, and easier to achieve in portrait photography).

Frames are used as a compositional device because they can add interest, context, depth, and balance to an image. For example, a shot of a subject in front of a plain background tells you very little about the place it was taken, and has only two elements—the subject and the negative

Above: The square wooden doors behind this trio of boys act as frames within the frame, giving a sense of place and a powerful composition. The low angle adds some blurred grass to the foreground, which provides an additional partial frame across the bottom of the shot.

Focal length: 120mm

Aperture: f/6.7

Shutter speed: 1/350 sec.

ISO: 800

space around them. In contrast, a shot of a subject framed by an ancient archway has added detail (interest), a greater sense of place (context), greater depth (particularly if the archway is closer to or further from the camera than the subject), and increased visual balance (particularly if the archway is centrally positioned).

When using frames in your image, consider what will complement the tone you want to convey. For example, photographing a cuddling couple through the leaves of nearby foliage gives the impression of an intimate moment captured, and the leaves and flowers in the foreground will add to the sense of romance.

You will also need to decide how much of the frame you want to be visible. This will depend on what is physically possible (sometimes the location will dictate), whether you want the frame to be a key part of the image or an edge detail, and where the frame is best positioned in order to lead the eye toward the main subject of the image.

If you want the frame within a frame to be blurred, you will need to consider your aperture settings and also the distances between the foreground element and your subject. The wider the aperture and the further apart the frame is from your subject, the more blurred it will become.

Right: The inclusion of the full doorway in this shot provides another example of a frame within a frame, with a humorous visual narrative added by the contrast between the small boy and the gigantic door.

Focal length: 95mm

Aperture: f/3.5

Shutter speed: 1/640 sec.

ISO: 500

Chapter 6
Posing

Arguably, portrait photographers have a lot more to think about than specialists in other image areas. Just like the majority of photographers, we want to flatter our subject, use atmospheric lighting, and create pleasing compositions; like landscape photographers, we often need to contend with the weather; and like wildlife photographers, we don't want to scare off nervous subjects or provoke dangerous ones.

We also need to build a quick rapport with a range of different personality types and ages so they trust and like us; we need to be able to notice and capture the essence of a person so that the shots we take resonate; and we need the ability to generate a range of images, often under pressure and in a short space of time.

Where other photographers mainly take shots of things as they are, portrait photographers pose their subjects, so they are shown at their best. A twist of the body to diminish a waistline, a curve made to look sexy but not plump, a hidden double chin, a sparkle in the eye—our subjects have egos that we need to appease, so the shots we take delight rather than disgust them.

That's a lot to ask for, but this chapter will show you how it can be done. It's the atmosphere you create that sets you up for success, and the smallest tweak to a pose that makes all the difference—master the details to create portraits that people love.

Right: Relaxed subjects who have trust and confidence in their photographer and are enjoying themselves will reward you with genuine smiles like these. Liking people and being able to get on with them are key skills in portraiture.

Focal length: 200mm

Aperture: f/4.5

Shutter speed: 1/800 sec.

ISO: 320

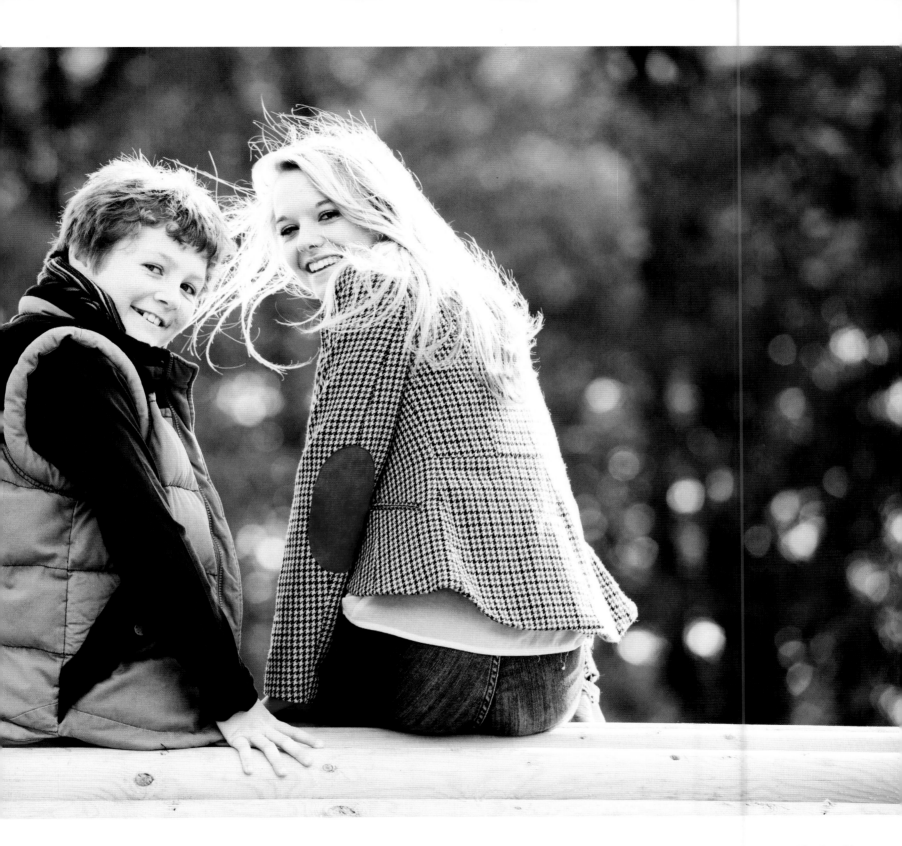

Interacting With Your Subject

For the majority of adults, seeing photographs of themselves has become a disappointing experience. Poor lighting (especially from automatic on-camera flash), a lack of knowledge about how to pose, and unflattering wide-angle focal lengths all regularly feature in amateur portraiture, leading people to believe that they are simply not "photogenic."

They may arrive for the photo session already dreading how they will look in the images, and there are often very specific parts of themselves that they dislike. Ask them how they feel about being photographed—and really listen to the answer. For example, a common issue is being overweight. If someone tells you that they hate photographs of themselves because they needed to go on a diet and they didn't, at least you can shoot creatively to minimize the appearance of their body size. Without that knowledge, you risk spending hours photographing someone only for them to take one look at the photos and tell you they hate how they look, when it's too late for you to do anything about it.

Once they have shared their concerns, reassure them that you know how to make them look their best and will be capturing flattering shots. If possible, guarantee each shoot, so your customer knows that if they don't get what they're after, they can come back for free. If your subject is distracted by their worries, you definitely won't get the images you need, so try and remove the worry before you begin.

Unless your subject has been professionally photographed recently, they are also likely to feel unprepared because they don't know what to expect. You can take away some of the fear of the unknown by explaining upfront what will happen, and explaining that you won't be asking them to do anything difficult. The simple act of telling them that you will be asking them to stand or sit in certain places, tweaking their posture slightly, asking them to look both into and away

from the lens, and asking them to interact with you for different expressions is all that's needed to help alleviate some of the unknown.

If you come across as nervous, your subject won't relax and trust you, or feel confident themselves. You need to guide them through the shoot, so build up your confidence by becoming an expert with your equipment and having a rough plan for the shoot, so you can keep the momentum going.

People want to avoid perceived pain, be it the discomfort of having a photograph taken, or the emotional pain of seeing images that don't flatter them. Your job is to reassure them that it won't "hurt" while the photos are taken, or when they see them, either.

Above: When this lady arrived at the studio and said, "I don't know why I'm here!" the photographer left his camera to one side, made some tea, and chatted for 40 minutes. Only then, once she had completely relaxed, was the first shot taken.

Focal length: 80mm

Aperture: f/8

Shutter speed: 1/180 sec.

ISO: 100

The Customer's Experience

When we look at a portrait of ourselves, or of someone we love, our view is naturally filtered through our feelings for the subject and the memories the picture conjures up. If the shoot is a miserable experience, then the final images will simply be a reminder of that misery. Even if you get the "perfect" shot, you will find you struggle to sell it afterward because of its associations.

That's why it's important to focus on creating an experience that is as enjoyable as possible, the whole time you are with a subject. When they see the images, the subject should remember how beautiful they are, how much fun the shoot was, and how much the photographer seemed to enjoy it too. If the subject is a child, your paying customer will be their parents, and you want them to walk away from the shoot excited to see the images, not relieved that the whole thing is over.

Right: This setup is just one light and a soft box, plus a gray paper background—just about as simple as it gets. The soft, Rembrandt lighting is very effective for this kind of image.

Focal length: 86mm

Aperture: f/11

Shutter speed: 1/250 sec.

ISO: 100

Added to this is the fact that people are more likely to spend money with people they like, so you can see why it's important to be likeable in the portraiture industry, especially if you are relying on making sales by selling prints after carrying out a shoot for a minimal fee. That's why you should start looking for something that you admire about your subject, as soon as you meet them, so you can set about capturing that aspect with genuine enthusiasm (even if they lack supermodel looks or an appealing personality).

Your subject/customer will pick up on your excitement and energy, and warm to you, as people tend to like others who show a fondness toward them. Their confidence will grow and they will be able to relax in front of the camera, aiding your ability to capture flattering portraits of them.

Whether your subject has kind eyes and an easy smile, gracefulness in every movement, or lively hair that dances with every turn of their head, find at least one thing to fall in love with, just for the duration of the shoot. Tell your subject how much you admire that "thing" about them, and when you take a shot that captures it well, tell them—they'll look out for it when they see the images. This will also distract them from actively seeking out negatives that they dislike about themselves!

Right: Good portrait photographers love people and know how to interact with all age groups to get the expressions they're looking for. Start by creating an atmosphere where everyone can relax, and it will be much easier to get natural reactions like this one.

Focal length: 200mm

Aperture: f/4

Shutter speed: 1/250 sec.

ISO: 280

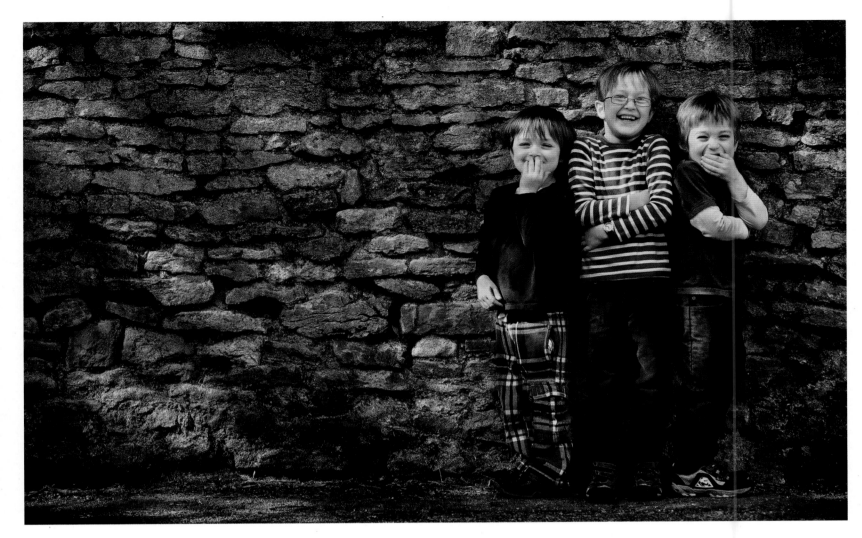

Before you Begin

Don't pick up your camera until you've put your subject at ease and found out what they hope to get from the shoot. Find out what kind of images appeal to them by encouraging them to bring pictures from magazines or web sites, and ask them what it is that they like about each particular shot: is it the expression, the simplicity, the detail, the pose, or something else? If they have had professional photographs taken before, ask them which ones they like, and why—this will give you an idea of which side of their face they prefer.

It's also important to ask what they hope to do with the portraits you take. Are they planning to post them on their social media profiles, put them in a display with existing photos, or create a single large print for the wall? The intended use could have a fundamental impact on the kind of image you need to capture, and the way in which it is cropped (see pages 94–95).

As you're interacting, subtly study their face and become aware of any characteristic movements—a lift of an eyebrow, a curl of a tentative smile, a tilt of the head, and so on. These microgestures are the ones to try and capture, so that when others look at the shot, they feel you have caught the subject's personality, not just their

Above: The original plan was for a moody shot of these boys in front of the stone wall, but as they couldn't stop giggling, their cheeky smiles were captured instead!

Focal length: 110mm

Aperture: f/5

Shutter speed: 1/200 sec.

ISO: 250

likeness. To do this you'll need to develop your rapport to a point where your subject drops their guard and reveals their true self.

Creating Expressions

Asking someone to say "cheese" doesn't generally result in a smiling portrait—more often you get a grimace. Instead, you'll need to verbally interact with your subjects in order to make them feel at ease and create genuine expressions.

Any long periods of silence will give the subject time to become self-conscious and start worrying about what they look like. Instead, play relaxing, upbeat background music if you're indoors and keep conversing with your subject to ensure they stay at ease wherever you shoot.

There are four main approaches to generating expressions and avoiding silence while shooting: these are reassurance and flattery; conversation; direct prompts; and gentle teasing. An average photo shoot will make use of all of them at different points to avoid repetition and predictability.

Reassurance & Flattery

When your subject looks good, tell them. If you've taken a great shot, say so. If you seem excited and enthusiastic about the images you're capturing, less-confident subjects will start to feel that they are not doing so bad after all. Get into the habit of making regular positive comments, such as "I love how the light is falling on your face here," "Keep doing what you're doing, it's perfect," and "Your hair looks amazing; this shot really shows it off."

Right: Asking your subject to "say cheese" will get a cringe at best. Find out as much as you can about your subject and use this as the basis for any interaction, so you can create genuine expressions, rather than forced ones.

Focal length: 100mm

Aperture: f/5.6

Shutter speed: 1/180 sec.

ISO: 50

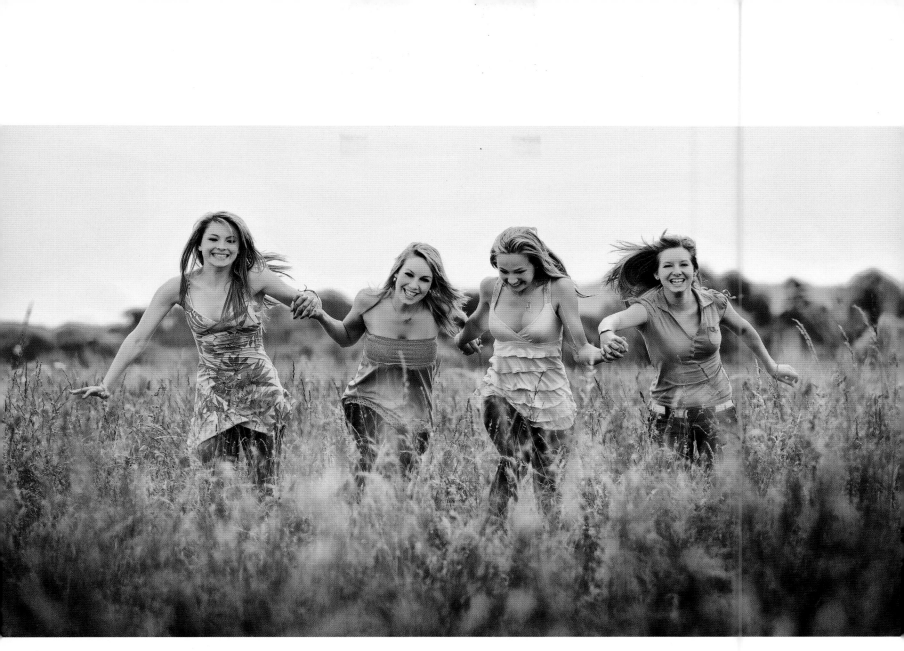

Conversation

This involves going beyond small talk to find out a little bit more about your subject so you can best capture their personality. For most people, their favorite subject is themselves, so ask what they do for a living, what they enjoy doing outside of work, and whether they watched last night's episode of the latest hit TV series—keep them talking and use the current topic to generate an expression where you can. For example, if you both watched the same comedy programme, use it as a prompt by asking them to give you a look like one of the main characters after they received bad news. After your subject has pulled the face, they are likely to laugh, giving you a genuine reaction to capture. In addition, it keeps your conversation fresh, as you won't be repeating the same prompts at every shoot.

Above: As the photographer, you need to guide your subjects through the shoot, prompting interactions, giving directions, and reassuring them that they look good so their confidence increases.

Focal length: 200mm

Aperture: f/5.6

Shutter speed: 1/1600 sec.

ISO: 500

Direct Prompts

Some prompts are straightforward instructions, while others may be intended to provoke a reaction. Serious ones could include "Look up toward the sky," "Part your lips slightly to show off your cheekbones," or "Turn your body slightly to your left," for example. Not every shot in your set should be of your subject smiling, so use direct prompts to convey instructions and get your subject looking in the direction you require. If your subject appears tense, ask them to tighten every muscle in their body, hold, and then relax, or to fill their cheeks with air and then blow slowly out. When you initially position a subject, telling them you're going to take a few test shots first and that they can just relax in that spot for a minute, can often work well.

Prompts that are intended to provoke a reaction include anything along the lines of "Give me your best supermodel pout/gangster snarl," "Look gorgeous," or "Give me a look like you've woken up and your husband has turned into a chocolate bar." Your subject may laugh straight away at the absurdity of the situation, or may play along and then laugh. Either way, have your camera pre-focused and ready to capture the shot.

For a similar effect with groups, try these: "Kiss the person nearest you," "Let's have some fake laughter, everyone shout out ha ha ha!" or "Look like you're in love with the person next to you." If you have one person who refuses to smile, instruct everyone except him or her to smile, ask everyone to pull their silliest face, or ask the group to all point toward the grumpiest person among them.

If the atmosphere is right and the rapport is there, try some illogical or completely unexpected prompts, for example by asking someone to "Lift your forehead up and lower your chin," or "Give me a look like you're a fish without a fin."

Gentle Teasing

Make others feel comfortable by being as down to earth as possible with some self-deprecating humour, and—after you've got to know your audience a little better, and if you think it's appropriate—by gently teasing your subject and anyone else in the room.

If you're photographing multiple subjects, light hearted jokes such as, "Shall we try a shot where you look like you like each other?" or "How about we make you look like a normal, happy family for this one?" After asking a couple or family to move in together as close as possible, react with mock surprise and say, "Whoa, not that close! It's not that kind of shoot!" or "Looks great, now make sure nobody farts!" Ask a group of subjects "Who here has got the strangest/loudest/worst laugh? Let's hear it!?"

The idea is to disarm your subject(s) and release any tension by making people laugh at themselves, giving you an opportunity to capture a true expression. Whether these interactions will hit the mark or not depends on the situation and the personalities involved, so practice "reading a room" until you can accurately gauge what is the right approach to take. Bear in mind that people are more likely to laugh along with jokes and comments from someone they find likeable, so work on building a rapport before teasing.

Right: Look to capture a range of expressions, not just smiles. The puddle in the foreground and the graffiti wall in the background help to create the moody, grungy feel of this shot.

Focal length: 98mm

Aperture: f/4

Shutter speed: 1/40 sec.

ISO: 320

Posing Guidelines

What is the look that you're trying to create in each shot? This will determine what type of pose to use. If you want your subject to appear relaxed, then ask them to sit or lean against something in the way they would normally, as if they were chatting to a friend. Providing an imaginary context can often help create a pose that looks natural.

If you want your subject to appear strong, stand them apart from objects and walls, to give them a feeling of strength and space. Ask them to angle their chin up for a more confrontational, confident look, which is popular in commercial shots that suggest a strong character.

Once your subject is in place, tidy up any stray limbs to improve the composition of the shot and consider hand placement (see page 129). Asking your subject to lean their torso slightly toward you will make them appear more involved, confrontational, and/or dynamic; leaning away from the camera implies relaxation, shyness, and/or defensiveness.

Before you begin, ask your subject which side of their face they prefer—many people have a strong preference, but wouldn't necessarily mention it. If your subject doesn't have a favorite, make sure you take images from both sides as faces are slightly asymmetric, so will have a subtly different appearance.

There are very specific technical placements for the head in traditional portrait photography, including the profile, three quarters, two thirds, and seven eighths head positions illustrated here. You could use these examples to learn them all, but in contemporary photography the position of the subject's head is often far less important than atmospheric lighting and a genuine expression.

In wider-angle shots, use your subject's body to create esthetically pleasing and dynamic shapes in the frame. A hand on a hip, for example, creates a triangle shape, but also draws attention to the subject's waistline, so is best for slimmer subjects.

Above: The profile position. The subject's head is at 90 degrees to the camera—here she has been asked to look to her left so the iris of her eye is visible.

Above: The three-quarters position. Starting from a profile position, the subject's head is turned toward the camera just enough that their nose falls within their cheek line.

Three-quarter Seated Pose

This is a popular pose that crops the bottom of the image frame into a seated subject's mid-thigh area. If the chair is visible in the shot, make sure that its color, condition, and any status implications are in line with the intentions of the shot. People naturally slump in chairs, so remind your subject to sit straight, particularly if you want to project a confident individual. Vary the position of the subject's arms to see what works best in the shot—they could be on the subject's lap, on the armrests of the chair, or near the subject's face, for example.

Placing Hands

People very rarely stand with both of their hands dangling by their sides, but once a camera is pointed at them, they often completely forget what they would naturally do with their hands.

Good hand placement is an essential part of ensuring that a pose looks natural, as loose arms just look unusual. The trick is to give at least one hand something to do, whether that's placing a thumb in a pocket, resting on the back of a chair, or playing with a loose tendril of long hair.

If you are photographing friends, families, or couples, get them touching in some shots—holding hands, with arms around each other's waists, and full-on hugs, for example. This also helps to bring their faces closer together.

Above: The two-thirds position. Starting from a profile position, the subject's head is turned two thirds of the way toward being straight on to the camera.

Above: The seven-eighths position. Starting from a profile position, the subject's head is turned seven eighths of the way toward being straight on to the camera.

Above: Face forward. The subject's face is angled directly toward the camera.

All images:

Focal length: Various

Aperture: f/8

Shutter speed: 1/180 sec.

ISO: 50

Making Adjustments

During the shoot, make sure you take time to check for anything that's out of place. Hiding a visible bra strap, straightening a collar, or damping down a stray hair before taking a shot will save you hours of time in postproduction.

Some portrait photographers are very "hands-on" when it comes to posing, physically moving a subject's arm into place or adjusting their hair. If this is your approach, make sure you always ask for permission before starting the shoot, as some people dislike being touched. In addition, you would be wise to never shoot alone; have a friend or family member nearby at all times to reduce the risk of any misunderstandings or false accusations of inappropriate behavior.

A safer approach is to *show* the subject how and where you want them to sit or stand, by taking up the pose yourself before moving out of the way. Then, to fine tune the pose as you prepare to take the shot, guide them into place with words and gestures to describe exactly what you're after.

Posing Women

There are some guidelines that relate specifically to posing women, which will help you achieve feminine images that flatter your subject and accentuate the curves of the female form. Conversely, if you are portraying a woman with characteristics that are considered stereotypically "male," you may want to intentionally avoid these types of poses in order to produce an image with a different narrative.

Positioning the Body

The well-known saying "the camera adds 10 pounds" is based on an element of truth: when a subject stands face-on to the lens, the pose exaggerates their width, making the body appear bulkier than it really is. Unless you are going for a confrontational pose, angle your subject so they are facing slightly to one side; a 45-degree angle shows the body at its slimmest.

The subject's face can then look in a number of directions—in line with the body at 45-degrees off-camera, toward the camera, a side-on profile, or looking slightly off-camera in the opposite direction, over their nearest shoulder. Poses that have the neck and shoulders angled in slightly different directions will make the subject appear more graceful, as will having the nearest shoulder tilted slightly higher than the far shoulder.

If standing, ask your subject to place their weight on their back foot, with the foot nearest the camera merely providing balance. If seated,

Right: The off-camera angle of the subject's body in this shot makes her appear slimmer. The position of her limbs appears natural, and her forward-leaning torso means she looks interested and alert.

Focal length: 75mm

Aperture: f/13

Shutter speed: 1/180 sec.

ISO: 280

crossing the subject's legs or ankles will provide a more feminine stance.

When the subject's face is angled less than 90 degrees to either side, ensure the nose doesn't break the cheek-line—if the end of the nose is within the outline of the subject's cheek, it will look a lot smaller than if it extends past it.

Above: Allowing the subject's nose to break through the line of the far cheek will make it appear significantly bigger. For a more flattering shot, ask your subject to turn their head a little more toward the camera, until the nose sits within the cheek-line.

Focal length: 70mm

Aperture: f/4

Shutter speed: 1/60 sec.

ISO: 800

Eye Direction

Your subject's eyes can be looking into the lens or off-camera. They can also be looking upward to open the eyes, or looking downward to show the subject's eyelashes and portray the subject as modest and/or deep in thought.

If your subject is looking down the lens, asking them to lower their chin by tilting their head forward will open up their eyes and reveal the whites beneath their irises. This can also imply submissiveness and flirtation, and is a look used by glamor magazines, so be sure to strike the right balance. In addition, dipping the chin beyond a certain point can put too much focus on the subject's forehead and make the eye gaze too harsh in appearance.

Above: The direction of the subject's gaze has a huge impact on the final image. In the first shot, the subject looks deep in thought, oblivious to the camera. In the second, she appears to be looking directly at the viewer, and is clearly aware of the camera. In the third, her downward gaze implies modesty or shyness.

All images:

Focal length: Various
Aperture: f/4
Shutter speed: 1/125 sec.
ISO: 400

Head Tilt

In everyday interactions, people naturally tilt their heads to one side to indicate that they are interested and listening. Asking a female subject to do this in some of the camera-facing shots will make her look more approachable. Before pressing the shutter-release button, ask your subject to tip her head subtly to one side and then to the other—one side usually appears a lot more natural, depending on how the subject's body is angled toward the camera.

Right: Compare this to the similar shot on the previous page. Here, the change in her eye direction and the slight tilt of her head, make the subject look as though she is more engaged with the viewer.

Focal length: 70mm
Aperture: f/4
Shutter speed: 1/60 sec.
ISO: 800

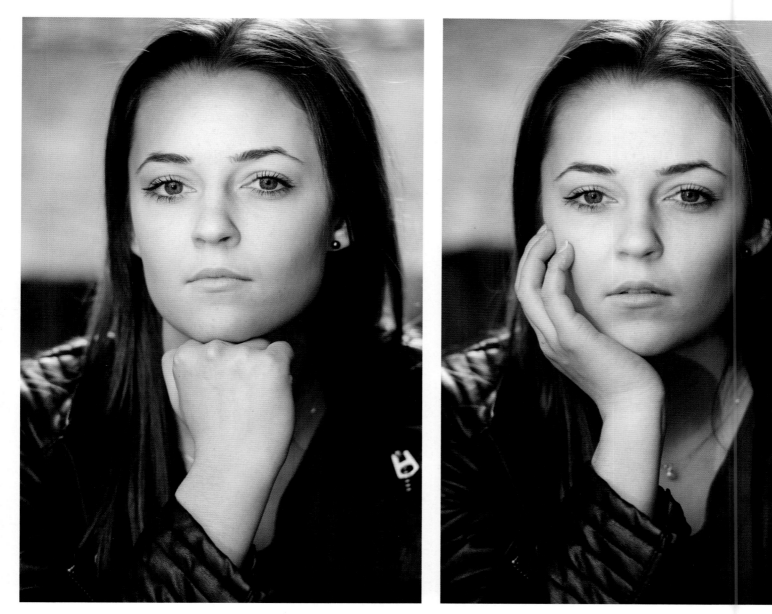

Hand Placement

When placing a woman's hands, the edge with the thumb is the least feminine looking, so angle the hand with the little finger closest to the camera where possible. Ensure at least one of the subject's hands is doing or holding something—with women this can include touching their hair or face, but ask the subject to do so in a way that feels natural to them, so the pose doesn't end up looking forced.

Above: The angle of a subject's hands determines how feminine they appear. Here, the wide, knuckled side of the hands in the first shot appears more masculine than the side view of the hand in the second image.

Both images:

Focal length: Various

Aperture: f/4

Shutter speed: 1/180 sec.

ISO: 280

Posing Men

When photographing men, you will often be looking for different things from the pose than you would when photographing a woman. This applies whether you are taking portraits for a customer that you hope will buy prints from you afterward, or whether you are creating an image for commercial purposes. Whereas we typically expect to see women appearing curvy and graceful, with men we tend to be looking for images that display strength, power, and confidence.

Body Shape

While the desired body shape for women is an hourglass, for men it's an inverse triangle, with broad shoulders and a narrow waist. To exaggerate a masculine body shape, keep the neck and shoulders square on to the camera to add bulk. Leaning slightly toward the camera will make the shoulders seem larger still, but ensure your subject relaxes his shoulders, otherwise he will look confrontational rather than confident!

Positioning your shot so your subject's shoulders are closer to the camera than his waist will make the latter appear slimmer, as will having the waist slightly turned away from the camera (so a narrower portion of it is in view).

Good posture will help too—remind your subject to stand up straight and clench his stomach muscles to improve the pose further.

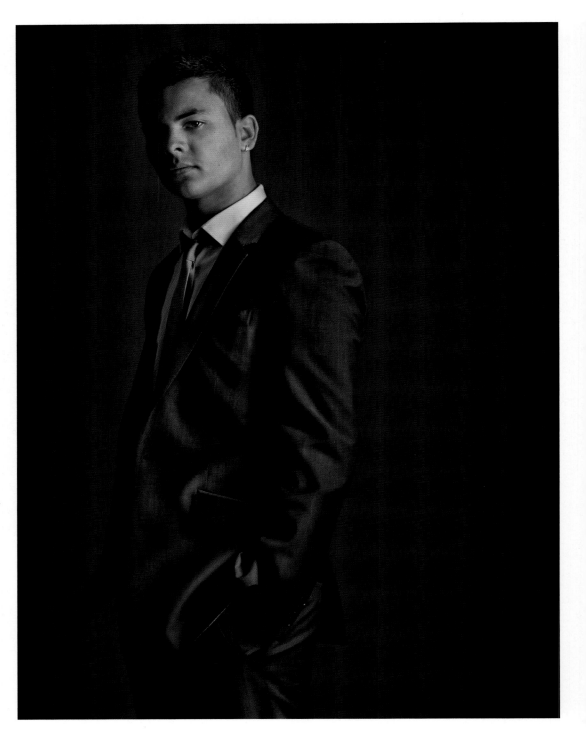

Right: Angling off-camera isn't as effective for a masculine shot, as men typically wish to appear broader. The best way to emphasize shoulder width is to photograph your subject face-on.

Focal length: 100mm

Aperture: f/8

Shutter speed: 1/100 sec.

ISO: 100

Standing Poses

Place the subject's feet shoulder width apart to give a more stable, confident pose. For a more relaxed version, lean your subject against a wall, crossing the leg nearest the wall in front of the other, with toes digging into the floor. Shoot from a low angle to imply power, or even arrogance.

Right: Posing your subject face-on to the camera will make his shoulders appear wider. Ensure your subject is standing tall and not slouching, so they appear confident as well.

Focal length: 140mm

Aperture: f/4

Shutter speed: 1/320 sec.

ISO: 800

Seated Poses

For a relaxed seated pose, ask your subject to lean back and bend one knee, resting the ankle of that leg on the knee of the opposite leg. For a more active pose, ask him to lean forward and rest his elbows on both thighs. The fingers could be interlaced or form loose fists, resting near the knees.

Eye Shape

Big eyes look less appealing on men than women, as they imply vulnerability and submission. Instead, ask your subject to lift and push out their chin a little by tilting their head back—this will accentuate their jaw line as well as decreasing the visible area of their eyeballs. See if your subject can master a half squint, where the lower lids of the eyes are lifted to hide more of the eyeball, implying mystery and mischievousness. Avoid shooting from too high a viewpoint with the subject looking down the lens, especially when close-up to your subject, as this will force him to widen his eyes.

Above: Asking a seated subject to lean forward slightly will make them look more actively engaged and alert, whereas leaning back appears more relaxed and at ease.

Focal length: 28mm
Aperture: f/4.8
Shutter speed: 1/60 sec.
ISO: 800

Above: Big eyes look feminine and are less appealing on shots of men. Here, the raised camera angle means that the subject is looking upward, opening his eyes up much more than if the shot was taken from a lower angle.

Focal length: 185mm
Aperture: f/4
Shutter speed: 1/125 sec.
ISO: 800

Above: Asking this subject to raise his chin and squint a little—as though the light was too bright—helped to avoid him looking "doe-eyed" when photographed from above.

Focal length: 200mm
Aperture: f/4
Shutter speed: 1/90 sec.
ISO: 280

Hand Placement

As with all subjects, men should be asked to do something with at least one of their hands. Placing them on their own hair or face can look too feminine, although fiddling with a tie or cufflink is acceptable. Other suggestions include slipping one or both thumbs or palms into trouser pockets, holding a prop such as a jacket, resting on a nearby surface, or standing with arms folded.

Above Left & Above: Having your subject's hands dangle by their sides can look unnatural—give them something to do by putting them in pockets or hooking thumbs through trouser belt loops, for example.

Both images:

Focal length: 85mm

Aperture: f/13

Shutter speed: 1/160 sec.

ISO: 100

Troubleshooting

The vast majority of portrait photographers don't spend their days photographing models, so at some point it's likely that you will need to work around some common physical problems in order to create flattering shots.

While a lot can be fixed after the fact, thanks to powerful postproduction software, it's still quicker, easier, and better to get as much right as possible in camera. This frees up your editing time for enhancing images, rather than fixing problems.

Blemished Skin

Lighting can create or remove the sense of depth, by way of shadows. Used cleverly, these can slim your subject and give your image a three-dimensional feel. However, if your subject has wrinkled or blemished skin, shadowy lighting can highlight these imperfections. Instead, flat, even, and diffused lighting will be more flattering. See pages 160–161 for advice on editing out blemishes during postproduction.

Blinking

Some subjects blink as frequently as every few seconds, resulting in a series of shots that more often than not have the subject's eyes partially (or fully) closed. Unless you check the preview screen for blinks constantly, you could end up moving to your next shot without realizing your subject looks sleepy or drunk in the one you've just taken.

Get into the habit of taking two shots every time you capture an image. Because they are milliseconds apart, the chances are that if your subject is blinking in one, their eyes will be open in the other. This will minimize the risk that you lose out on a great portrait due to a blink.

Taking two shots instantaneously is more difficult with studio lights, as they need a second to recharge their power for the next flash. In this situation, if you find that your subject continually blinks, ask them to close their eyes and then open them after you count down from three to one. Press the shutter-release button as the subject's eyes open fully.

Body Shapes

As you're getting to know your subject, note if they mention that they dislike their body shape. A common complaint is that they are overweight, in which case you can use low-key lighting, which will provide more shadows that can be used to hide and/or slim down parts of the body. Also make sensible clothing choices: for example, dark, long-sleeved tops help to hide large arms.

If the subject is part of a group, you can position them behind others, again to minimize the visible area of their body.

Shooting from above the subject's eye level and asking them to look up toward you will reduce a double chin, as will asking your subject to press their tongue against the roof of their mouth—although it's harder for them to relax and interact if they're constantly trying to remember to do this! Alternatively you can ask your subject to push their chin out. In a seated pose, hide the double chin by asking the subject to rest their head gently on their fist.

Glasses

Lights can reflect off the eye glasses worn by spectacled subjects, sometimes hiding their eyes completely. When you spot this, change the position of the lights, your subject's head, or angle the glasses by raising the arms a couple of millimeters above their normal position on the ears to resolve this.

Receding Hair

Harsher light sources can create "hotspots" on a bald subject's head, as the light reflects off their skin. Adjust your light source so it is lower in height and/or power to avoid this. If you are shooting using sunlight, use a diffuser or find a shaded area.

Shooting from a lower angle of view will reduce the amount of focus placed on the top of someone's head, but don't go too low, otherwise you'll end up capturing the contents of their nostrils in the frame and giving them a double chin.

Also, watch out for backlit ears, which glow red when lights are placed behind a subject who has little or no hair.

Uneven Eye Sizes

Facial features are asymmetric, so it's common for people to have slightly different eye sizes. In a portrait, this can become more obvious. Common wisdom is to keep the smallest eye nearest the camera, with the logic being that this will even out any small differences. However, this may result in both eyes looking the same size, despite one being further away from the camera, which looks incorrect to the viewer. Instead, if you notice this asymmetry in a subject you are about to photograph, simply ensure that the smallest eye is further away—it will naturally look as though the difference in size is due to the distance.

Groups

When they are being photographed with others, most people's natural inclination is to stand face on to the camera, side-by-side. However, this can end up with a photograph that looks like a police line-up: unflattering and unnatural looking! Instead, you want to minimize the gaps between your subjects, but without having people's eyes at the same level across the frame.

If you are able to get out and about, take a walk with your subject(s), using the environment you come across to position your subjects in a natural looking way.

In a studio environment, you can use steps, blocks, and dedicated posing tubs to seat people at different heights to create pleasing shapes and levels in the frame.

If people's faces are at different distances from the camera, and you want all of them to appear in focus, use a small aperture of around f/8 or f/11. If you still want the background to be blurred, simply move the couple or group further away from it.

Couples

The focus for couple shoots tends to be romantic poses, particularly if you are photographing a couple who are celebrating their engagement or their wedding day. The key to setting the mood is creating interaction between them, whether that's resting their foreheads against each other for a high-chemistry pose, holding hands as they walk and talk, or cuddling up together.

Right: Show interaction when photographing couples and groups, by asking them to touch in some way. The love between this couple is made evident by their matching stances and body contact.

Focal length: 155mm

Aperture: f/5.6

Shutter speed: 1/180 sec.

ISO: 1100

If one person is substantially taller than the other, seat them, ask them to lean toward the other, or use steps to even out the differences so there's a separation of about half a head's length between the pair's eyes.

In portraits of heterosexual couples, it tends to be the female that's predominant in most shots. However, if all your shots focus on the female, and afterward it turns out that she doesn't like her body shape, you'll struggle to make a sale. Therefore it's important to take some "safety shots," which are consistently flattering no matter what.

One example of this is to use steps: seat the man lower down, with the woman on a higher step behind him, leaning in to hug him so only her face and arms are visible. Take the shot from high up in order to define both jaw-lines. Another suggestion is to shoot with the man face-on to the camera with his hands in his pockets. Place the woman with her body facing toward him, hugging one of his arms.

When there is a conflict between positioning both subjects so the light is flattering, prioritize the lighting that falls on the woman. For wide-aperture shots, where you need both faces equidistant from the camera, ask the couple to imagine there is a pane of glass in front of them, and that you need them to have both their noses up against it.

However, while you want to minimize distances between the pair, ensure they aren't pressed so close together that their features are squashed up against each other!

Families & Larger Groups

Some of the best group portraits make it look as though the photographer just happened upon a group of people who are interacting.

Look for urban furniture that can help you position people at different levels in the frame—a set of steps in the city, a wooden fence along a country walk, or a bench in a park. In the bench example, you could have one person sitting on it facing forward, another sitting on it but with their feet up to one side and their back leaning against

the first subject, another on the floor in front of it, one standing behind, one perched on the armrest, and one perched on the backrest.

If any of the people in the group have indicated to you that they dislike having their photograph taken because they are body conscious, try to position them behind others, so only their face is visible.

With very large groups, visually break them into smaller subgroups, but bear in mind that the positioning of each one will imply status, with those smallest in the frame and furthest from the center perceived as less important. For corporate portrait photography, the sub-groups could be the teams within a department, with the overall leader toward the front center of the shot. With a family group, you could position mom or dad at the front, or the kids, or even the youngest, with the others slightly apart behind him or her.

Above: When photographing people with big height differences, think of ways to bring their faces closer together. In this shot, the parents are carrying the children, with added interaction created by the girl's arm, which visually links the two parents.

Focal length: 92mm

Aperture: f/4.8

Shutter speed: 1/180 sec.

ISO: 200

If you are photographing a family group with a wide spread of ages, choose an outdoor location where there's space for the children to move around and play in. When you find an area with great light, call everyone in for a group shot. Then pick off individuals and subgroups for smaller group shots the rest of the time. Place the eldest people in position first and then add the youngest —and most fidgety!—just before you are ready to take your shot.

If you need people looking toward the camera, you can either use verbal crowd control—shouting a countdown so that everyone knows you are about to take the shot—or by making yourself interesting enough that people are watching

what you will do or say next. Depending on the group size, you can interact on a more personal level, using gentle teasing or prompts to get the expressions you're after (see page 120–123).

If you are restricted to indoor locations, concentrate on creating shapes in the frame, whether that's three people positioned so their faces form a triangle (or inverse triangle), four people stepped up in height levels from one side to the other, or lots of shaped subgroups forming an overall larger group portrait.

Always take several shots, as the bigger the group, the more likely it is that someone will be blinking or glancing sideways.

Above: Group shots are more appealing and interesting when the individuals are all posed slightly differently. Here, angles to the camera, hand positions, and stance have all been varied to prevent the shot looking like a police line up!

Focal length: 58mm

Aperture: f/5.6

Shutter speed: 1/320 sec.

ISO: 200

Clothing & Accessories

The clothing your subject is wearing and any accessories they have on, hold, or are photographed with, all add to the narrative of the final portrait. Therefore, each addition should be carefully considered. Ask yourself if it adds to the image and if it is in line with your intentions.

Of course, if you are photographing paying customers, you may not get much of a say in how they turn up—indeed, you probably want them to wear whatever they feel best reflects their individuality. There are some general guidelines that you can provide in advance, though, so when they are viewing the shots at a later date they don't end up wishing that someone had worn something different.

Clothing Choices

When creating portraits of individuals, be aware that bold patterns and large logos on clothing can make the images date quickly, as fashions change. Plainer clothing choices will give the images a longer shelf life before they start to look "old."

For groups, it's more important that one person doesn't visually dominate the others. For example, if one person wears a bright red jumper while everyone else is dressed in pastel colors, the person in red will stand out from the rest. Neither do you want everyone to wear the exact same shade of denim jeans matched with white T-shirts, as was the fashion for portraits in the 1990s.

Ideally, ask everyone to wear complementary colors of the approximate same shade intensity, with clothing choices of similar levels of formality.

Right: The classic car and the subject's outfit combine to create a look that is reminiscent of the 1970s.

Focal length: 116mm

Aperture: f/4

Shutter speed: 1/250 sec.

ISO: 100

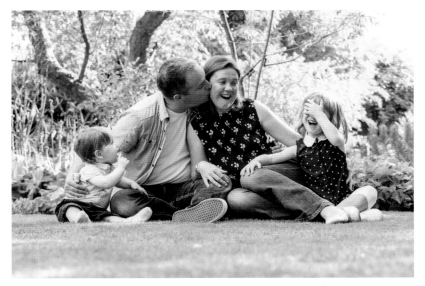

Accessories

Some accessories are the focal point of a shot—the reflections on dark sunglasses in a close-up, or the flirty gaze of an eye underneath a tipped hat in a crop shot, for example. Other times, they provide a secondary function—babies look cute in little hats, but they also hide bald heads and skulls misshapen from the birth process.

Some accessories may just add a splash of color in the background. For example, if you are creating a portrait that will be displayed in a room that has an orange feature wall, you may want to include the same color in the shot, so it really complements the setting.

In each case, capture some shots with and some without the accessory. That way, if you later decide that an object clashes with other elements in the frame, or distracts too much from the subject, you will have an alternative option.

Above Left: If possible, ask subjects in group shots to wear colors that work well together. This family has chosen blues and whites, creating a harmonious color scheme that doesn't detract from their interactions.

Focal length: 86mm

Aperture: f/8

Shutter speed: 1/350 sec.

ISO: 800

Above: Clothing is one of the ways people define and display their identities. Here, the fashion choices of the couple give a little more insight into their world and personalities than if they had worn more typical outfits.

Focal length: 165mm

Aperture: f/4

Shutter speed: 1/350 sec.

ISO: 140

Right: The accessories and subject are cleverly combined in this witty shot. Note how the muted color palette gives the portrait an arty feel, rather than a childish one.

Focal length: 70mm

Aperture: f/6.7

Shutter speed: 1/125 sec.

ISO: 70

Chapter 7
Working with Children

Working with children is about much more than making babies smile. First, parents need to feel relaxed, so their children relax as well. Then you'll need to overcome the wariness of shy children, otherwise they'll be hiding behind their parents' legs and crying out when parted from them.

Next it's about finding something likeable about every young subject you meet, to focus your attention and motivate you to push for one more amazing shot. If you don't get this right, your shots may be technically excellent, but they'll lack the emotion and creativity of your best work.

Then it's about understanding the abilities and motivations of subjects of different ages, so you can connect with them on their own terms and capture their latest stage of development.

This chapter contains a wealth of tips and techniques to help you get started with all the subject age groups you might encounter, from newborns, young babies, and toddlers right through to older children and teenagers.

Right: While parents will usually want to have pictures of their children looking happy, sometimes it's the more serious expressions that capture the true nature of their sons and daughters. This youngster was transfixed by the camera, enabling a shot with a gentle feel that shows off his big blue eyes.

Focal length: 140mm

Aperture: f/9.5

Shutter speed: 1/90 sec.

ISO: 140

From Kids to Teens

Parents see their children differently to anyone else, and it's this perception of their son or daughter that they want you to capture. The child needs to connect with you sufficiently so that their gaze into the camera lens carries visible emotion, as this is what the parents will react to when they see the final images.

To achieve this, there are two potential barriers to overcome: the child's *wariness* of you (especially if you are a complete stranger to them), and the parents' *worries*.

Overcoming Worries

A parent can have numerous fears about a photo shoot, including:

- What if my child refuses to smile?
- What if the weather ruins the photo shoot?
- What if I don't like any of the images?

While these things are on their mind, it's hard for parents to relax. Tense parents create an anxious atmosphere, and tend to "peck" at their children with negative comments ("Stop pulling that face," "Your hair is sticking up again," or—memorably—"We've paid a lot of money for this; don't ruin it"). Kids react to these types of comments by disengaging or misbehaving.

Start right away by reassuring the parents; if they're not happy with the final images, they can come back for another shoot, free of charge. Tell them that you'll be looking for specific things while you're taking each shot, so ask them to pass

Right: Before you start shooting, spend time finding out what the parents are hoping for from the photographs. If they don't have a clear idea in mind, show them some shots from similar shoots to try to find out what styles they like.

Focal length: 92mm

Aperture: f/5.6

Shutter speed: 1/45 sec.

ISO: 800

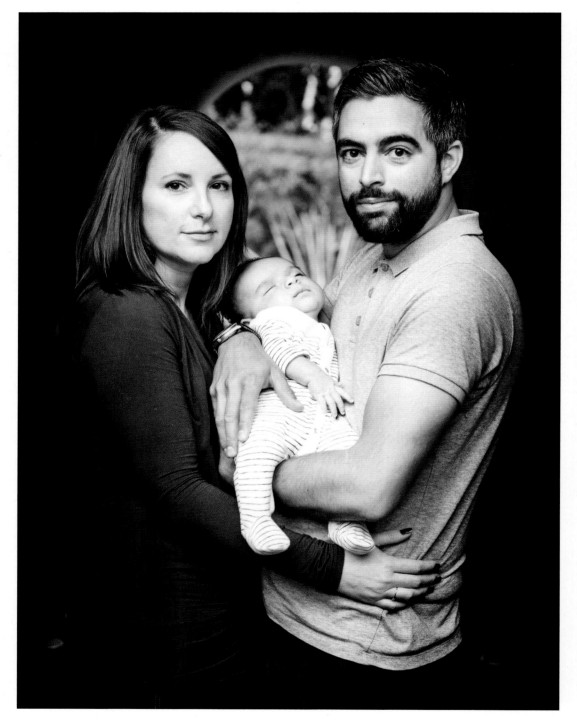

responsibility for worrying about the details to you—if you need them to step in and fix anything, you'll ask. They remain responsible for their children's safety, otherwise, you're in control!

Overcoming Wariness

Some children are quite comfortable meeting new people, while others are very shy. When families arrive to have their photo taken, make your first question one about refreshments. Time the shoot so there's no pressure to get started right away; that way, if there's a wary child, you can use this time to help break down barriers by finding out a little more about them. Equally, if the child walks up to you and says, "I've got my hat on. Can you take a photo of me?" don't miss the opportunity to interact with them and get some shots.

Each time you meet a child and their parents, actively tune in to the signals they are sending until you learn to read their body language and behavior, and adjust your plans for the shoot accordingly. The key is to adapt your approach each time to suit the individuals you are about to photograph.

Whether you spend time getting to know your subjects before getting your camera out, or as you start to photograph them, you won't be able to capture them at their best until you have some understanding of their personality (newborns are the exception here as they will—hopefully—sleep throughout the shoot).

Right: The door in the background provides a sense of scale for this portrait, while the boy's pose calls to mind a much older age group, creating a humorous contrast.

Focal length: 110mm

Aperture: f/4

Shutter speed: 1/160 sec.

ISO: 200

Just as importantly, as the parents are usually paying for your services, you need to understand fully what they hope to get out of the session in order to satisfy their requirements profitably.

Bribery & Threats

Avoid bribery and threats. Even from a young age, children are smart enough to know that if bribes are on offer or if threats are made, then that means one of two things: either mom and dad really want this (which puts the child in control) or it is going to be a really nasty experience (so they don't want to do it). Rather than trying to "push" an unwilling child to do something they don't want to do, try to understand what motivates and interests them, then aim to "pull" them through the shoot instead.

Looking for Likeability

As well as creating the right atmosphere, the ability to consistently capture stunning portraits of children is connected to an inner capacity to find something to like in even the most difficult child. It could be their pore-less skin, flame-red hair, wide-eyed curiosity, cheeky giggle, or just their childlike innocence. Whatever it is you focus on, seeking out at least one aspect of them that you find appealing will enable you to connect with him or her on that most basic level of likeability.

For the duration of the photo shoot you need to feel positive toward the child—if not, they will pick up on it, as will their parents. To understand the importance of this, imagine the opposite scenario. A sulky boy arrives with his parents and you instantly take a dislike to him. Everything he does from that point on—sticking out his lip, refusing to co-operate, being rude to his parents—further proves to you what a miserable child he is. How are you going to capture him at his best when you have already written him off? How will he react to your requests, when he can feel your disdain? How much will the parents spend on buying the portraits, when all the photos you took remind

them of the photographer who hated their child? No matter who you are presented with, there is almost always something to like about him or her. And if you don't like children in general, you probably shouldn't be photographing them...

Creating Interactions

The parents are relaxed and the atmosphere is positive; you have built a rapport with the child and everyone likes each other. So what now?

With the lighting and location taken into account, you can start to capture the kind of images that will really allow the child's character to shine. By instigating a series of interactions with him or her, you create opportunities for the

Above: Look for something to "fall in love with" for each subject and focus on capturing that element at its best. In this instance, the boy's big, curious eyes were irresistible.

Focal length: 190mm

Aperture: f/4

Shutter speed: 1/180 sec.

ISO: 100

child to show their personality while you are poised to press the shutter-release button.

There isn't an interactions checklist you can use for each child or situation you are likely to encounter. Some children will find it amusing to be chased around by a photographer, while others may find it intimidating, and this will have an effect on the types of shot you can get. If the shoot is taking place indoors (at home or in a studio), the energy levels will also need to be lower than outdoors, due to space limitations, which will again affect your photographs.

Children also develop at their own pace, so the age groupings that follow are just guidelines, with suggestions of the kind of activity that typically appeals to children at that age. Use this as a start point, and focus on fine tuning your ability to read children and their parents to work out what your next shot should be.

SAFEGUARDS

It's a sad fact of modern-day life that child portrait photographers are sometimes viewed with suspicion. Therefore, to protect both yourself and your subject, always gain explicit parental consent before photographing a child or teenager, and ensure that mom or dad are present throughout the shoot.

Left: Small children are always on the move, sometimes making it impossible to manually react to the lighting changes. One of the semi-auto shooting modes, such as Aperture Priority, can help you keep up, albeit with some loss of control over the exposure.

Focal length: 200mm

Aperture: f/2.8

Shutter speed: 1/500 sec.

ISO: 200

Above: This newborn was only a few days old when she was brought into the studio. This shot focuses on the bond between mother and baby.

Focal length: 200mm

Aperture: f/6.7

Shutter speed: 1/125 sec.

ISO: 50

Right: Including objects in portraits is a great way of providing a sense of scale, but safety must be your foremost consideration. Just out of the frame, several pairs of hands were ready to step in if this newborn had stirred!

Focal length: 78mm

Aperture: f/8

Shutter speed: 1/125 sec.

ISO: 50

Newborn babies (1–2 weeks)

Serene portraits of sleeping babies belie the behind-the-scenes effort that go into capturing them—expect to spend at least three to four hours on a newborn shoot to capture a good, varied set of images.

Of course, a baby has no understanding of your intentions when you lift the camera to your face, so your priority is to ensure that the basic needs of warmth, safety, and nutrition are met in order for a newborn to relax and drift off. To achieve the peaceful, naked, curled-up shots that continue to be popular with new parents, schedule the shoot for when the baby is between one and two weeks old. Any younger and they may not yet be settled and feeding properly; any older and they may resist being "posed" while asleep. Ask the parents when the baby is most settled—usually this is after a morning feed.

The temperature will need to be around 86°F (30°C) in order for the baby to be comfortable without clothes—if you're not sweating, it's probably not warm enough! The need for consistent warmth generally limits newborn shoots to indoor locations, so choose a bright room with plenty of natural light or a studio setup. Use the surface of a bed, flat cushions, or beanbags to create a soft, safe place to lay the baby. Cover the area in a piece of fabric large enough to fill the frame. Using fabrics with different colors and textures will add background interest and help to make your final set more diverse, but avoid anything patterned as this can be distracting.

Warm the area with a hot water bottle before placing the baby on it, otherwise he or she may be woken by the chill of the fabric. Patiently "tidy up" the pose by gently pressing each limb into place and holding it for a few seconds until you feel the baby relax. Experiment with the angle of the light, the background fabrics, and your own position to get maximum variety from the shoot. You could also capture the details—the baby's tiny hand, for example, adding in the parent's hand to give the image a sense of scale.

Babies (1–6 months)

Babies quickly become more responsive to their surroundings, and after a month or two you will be able to interact with them to make eye contact and start to earn their smiles. Their vision is still developing, so move your face close to theirs so they can see you. Their neck muscles won't yet be strong enough to support their head's weight, so you will still be very limited in the poses available to you: the baby can only be lying down—on their back, side, or stomach.

To achieve variety in the final set of images, you will need to compensate for the subject's physical limitations by regularly changing your own angle and the background.

Schedule the shoot around the baby's routine, asking his or her parents which time of day is best. As with newborns, use chunky, textured fabrics in a range of colors to spread out across the area where you intend to place the baby. Then, with the baby in place and the parents safely nearby, use songs, sound effects, and facial expressions to get a reaction from the baby. Use toys to get their attention, holding the toy as close to the camera lens as possible, so you get the baby looking toward you. In between smiles, capture the more serious expressions too, as these are when the baby's eyes are at their biggest.

Above: Use textured blankets to add interest to the background of baby portraits.

Focal length: 135mm

Aperture: f/2.8

Shutter speed: 1/50 sec.

ISO: 400

Babies (6–12 months)

Babies become able to support their own heads at around six months old, but aren't able to crawl until about eight months. The time in between is ideal for portraits, as the baby can sit unaided, but can't yet wander off. Again, to make your job easier, check with the parents regarding the best time of day to get the baby at his or her happiest.

Choose poses that show off the current stage of development, such as capturing the baby's first tooth or their first attempts to stand up. This will differentiate the shots from those taken when the baby was younger, and help to document the milestones. While some garishly colored toys can have a negative impact on the final image, old-fashioned wooden toys can work well; otherwise, don't include items in the frame unless they have special meaning, such as a much-loved blanket the baby sleeps with every night.

At this age, you can start to photograph babies outside more easily, providing additional options for variety in your images. Before you get started, ask the baby's parents what makes their baby smile—it could include tickling, singing, animal noises, gently blowing air, or pulling funny faces.

As with all ages, the subject's safety is a higher priority than getting the photograph. This is particularly important as the baby masters the art of rolling and crawling, as they will often move without any warning. It is therefore a good idea to shoot close to the floor to minimize any risk, and make sure that the parents are aware that *they* remain responsible for their baby at all times.

Right: A low step can provide a great place to place a baby or toddler, as it makes it easier to capture a low-angle shot. This youngster happily sat and interacted with his parents, enabling the photographer to focus on exposing the image for a sunny, vibrant feel.

Focal length: 86mm

Aperture: f/3.3

Shutter speed: 1/1500 sec.

ISO: 800

Toddlers (1–3 years)

Between one and three years old is the toddler phase—an age where kids just want to play. In order for them to be able to do this, they first need to not feel wary of you. When you first arrive, find out what the toddler enjoys doing, either by asking them directly, or via his or her parents if the toddler is feeling shy. Avid book reader? Offer to read one to them. Loves piecing together a puzzle? Spend 10 minutes helping them with one. Obsessed with fairies? Explore the garden together, looking for places where tiny magical creatures might hide.

Only then, when the toddler feels relaxed in your company, should you get your camera out. Break the shoot into five- or ten-minute games or activities, with low-intensity breathers between each one. Don't expect to stay high energy and get back-to-back smiles for hours at a time—if the mood is good for just one third of the time you're there, then you're doing well. It's worth explaining this to the parents beforehand, otherwise they can worry that you won't have "enough" good shots and start pressuring or trying to bribe the toddler to follow instructions. At this age, you'll have fleeting control at most.

Telling a toddler to smile tends to backfire, as this age group can't fake an emotion. Instead, you need to earn your smiles, by getting on their level and being playful, silly, energetic (in bursts), but always in charge still.

Where possible, choose a location with a lot of open space. Toddlers often run back and forth, giving you a chance to grab shots on their way back. They may be curious and approach you with questions or otherwise interact with you. Think of potential shots and get yourself in the right place to capture them.

You can rope in mom and dad to tease, tickle, and sing to the toddler, or pretend that you are chasing the parents or being chased by them. Try slapstick humor—the sillier you act, the better, as toddlers enjoy pantomime-style comedy! Challenge their knowledge—"What number comes after two? What noise does a duck make?"—and celebrate with claps and shouts when they get it right.

It's also worth capturing expressions other than smiles—some youngsters are more serious than others, so coming back with a whole stack of grinning portraits isn't necessarily going to reflect that toddler's personality. Use the moments when they are curiously exploring the world around them or studying a bug they've spotted to record their looks of wonder and concentration.

Timing is key for successful shoots with this age group. Find out when they normally take a nap and start your shoot a couple of hours beforehand, so you get a good chunk of time before they start to get grouchy. Reschedule if the toddler is ill, otherwise the whole shoot will become a fight and that's what the child's parents will remember when they look back at the images.

Above: This lovely old armchair was positioned in a corner with beautiful light, so the photographer asked the young subject to sit there in her fairy-like dress.

Focal length: 130mm

Aperture: f/4

Shutter speed: 1/100 sec.

ISO: 3200

Children (3–12 years)

When working with children, the photographer needs to balance the child's energy levels with the need to stay in control and get the shots required. If, on arrival, the child is very energetic and excitable, take on a calm persona to create a manageable atmosphere. If the child is very shy and quiet, focus on building a rapport before bringing some energy into the shoot later.

To build rapport, learn what the child's interests are and find a way to have a meaningful interaction around those interests. Maybe they love flowers—ask them to show you which ones are their favorite, and explain what it is they love about them. Having the child feel that you are "on their level"—that you care and are interested in them—will enable them to relax around you and enjoy themselves, giving you an opportunity to capture them at their best.

When they are ready, think of ways to engage their love of silliness. It's as important to become an entertainer as it is to be a competent photographer. You could develop an amusing walk or state that you have to hop every third step, or tell them you can't bear any words that have a certain letter in them—and then react with mock horror as they name every word they can think of that contains that letter!

Appeal to their imaginations, using the things available in your immediate environment. If the shoot involves a walk through the woods, tell the kids you're in the jungle and ask mom and dad to pretend to be a tiger, chasing the kids toward you (pre-focus or use continuous focus to ensure they are sharp in your shots). If there's a bench, call it a boat and tell the children you're a crocodile. The children will clamber onto the bench, allowing you to circle it, looking for the best light and angle for your shots. Still in role, pretend to "snap" your toothy jaws to keep the kids shrieking while you shoot away.

Create activities or games like these that the children will get involved in and use them as an opportunity to take photographs for five to ten minutes, then take your foot off the pedal and

allow everyone to calm down. The change of pace will give you a chance to capture a range of moods (children can look at their most angelic when their face is more serious) and will also help you to manage the shoot. It would be very difficult to maintain maximum levels of momentum throughout, so having gaps between each activity takes the pressure off you, gives you a chance to adjust the camera for any changes in the lighting, and allows you to prepare for the next activity. Equally, some children are naturally more gentle in nature, so the final set of photos should reflect this by having fewer energetic shots.

Children closer to the top end of the age range may want to be treated more like teenagers than children, which will require you to adapt your approach. Use your initial interactions with them as an opportunity to gauge their levels of maturity. If they enjoy magazines, music videos, and movies, it's likely that they will want to be photographed in a similar way to how their heroes are portrayed, so refer to the teens section opposite.

Above: This youngster was asked to wander down a picturesque alley near the photographers' studio. Capturing his lifted heel at this point in his stride was intentional, but having the boy's hand drifting along the grass was an unexpected—but welcome—bonus.

Focal length: 140mm

Aperture: f/4

Shutter speed: 1/800 sec.

ISO: 400

Teens (13+ years)

Teenagers can be inspiring to photograph—their bodies are at their physical peak, they tend to have bags of attitude, and can contribute a heck of a lot of creativity, as they often love photography in general. Unfortunately, however, they often turn up for a photo shoot simmering with resentment as their parents "made them" come and they don't particularly want to have photos taken with their not-so-cool mom and dad.

It can be a frustrating time for teens, because even at 15 years old they may already look 18, yet feel they are being treated like a kid. While the parents generally want smiling shots that make their son or daughter look their age, the teen may aspire to moodier shots in a similar style to the ones they've seen in music videos and magazines.

This means that while some families turn up excited to have their photo taken together, others arrive barely speaking. Your challenge is to make sure everyone leaves happy, so try and diffuse any rows by ensuring that all parts of the family get what they're hoping for from the shoot.

Teenagers may bring clothes that their parents don't approve of—explain to the parents that you're going to take a few shots with the teenager wearing those clothes because he or she likes them. Reassure mom and dad that this is how 15-year-olds dress and look, and that they shouldn't worry—this is an age where they are trying out different identities and finding which one fits. Ensure everyone knows in advance they will be able to change their clothes regularly, so they can bring a variety of different outfits to the shoot.

At the same time, try to strike a bargain with the teen—tell them there's a limit to how many shots you'll take with their parents, and that once those are out of the way you'll work together to capture some portraits that he or she will love. Ask them what kind of photos they think are cool, and refer to well-known adverts to get a better idea of what they've seen and liked. Ally with the teen a little, gently teasing their parents if it helps get a laugh.

When nothing else works, there's one last resort—recruit the teen as a "photographic assistant" for the duration of the shoot. Set a secondary camera on automatic mode and loan it to him or her on two conditions—they always keep the strap around their neck, and they agree to release the camera to take part in the occasional shot. When you want to get your camera settings "right," ask your assistant to stand where the light is, and take some "test" shots. Underexpose the first one deliberately and show it to your assistant, asking them if they think it's too dark. When they agree it is, correct your settings and re-take it—getting a shot of your assistant in the process. Then take photos of the other members of the family in the same spot to make the exercise appear authentic.

Bear in mind that self-confidence can plummet during the teenage years, so constantly reassure your subject throughout the shoot that they are doing everything right and that the photos are looking good. Above all, try and avoid any silence, as it is during these moments that self-doubt can come to the surface.

Above: Tune into the personality of the teenager, whether that's confident, confrontational, loud, and chatty, or shy and quiet, as was the case with this subject. This portrait captures the subject's vulnerability and beauty, but in a way that still looks "cool."

Focal length: 105mm

Aperture: f/2

Shutter speed: 1/60 sec.

ISO: 400

Chapter 8
Postproduction

There are purists who believe that no postproduction editing should be necessary for a great shot. For the majority of portrait photographers, however, using software to improve images is just part of the standard workflow. From whiter teeth, spot removal, and wrinkle reduction that flatter the subject, through to color tweaks, vignettes, and crop adjustments that improve the impact of a shot, postproduction is the final stage of the portrait process.

While it makes sense to get as much right in-camera as possible— it's quicker to wipe drool from a baby's mouth before shooting than it is to edit it out on every shot afterward, for example—start with the end in mind. Consider what exactly you need to capture, so you can create the final portrait that you have visualized. Without having a finished look and feel to aim for, it's all too easy to spend several hours "improving" an image until you end up with something that looks overly artificial and unbelievable.

There is an infinite amount of edits you can make to a shot; this chapter doesn't aim to show them all, but instead to demonstrate a solid workflow that covers a range of image improvements that might be made to a typical portrait.

Right: Postproduction offers myriad image-editing options, from the very subtle to the more overt. Sometimes the photographer's intention is to create a type of image that just isn't possible without significant postproduction enhancement. However, for the majority of portraits, the removal of minor flaws and small improvement tweaks form the basis of any editing.

Focal length: 100mm
Aperture: f/5.6
Shutter speed: 1/125 sec.
ISO: 100

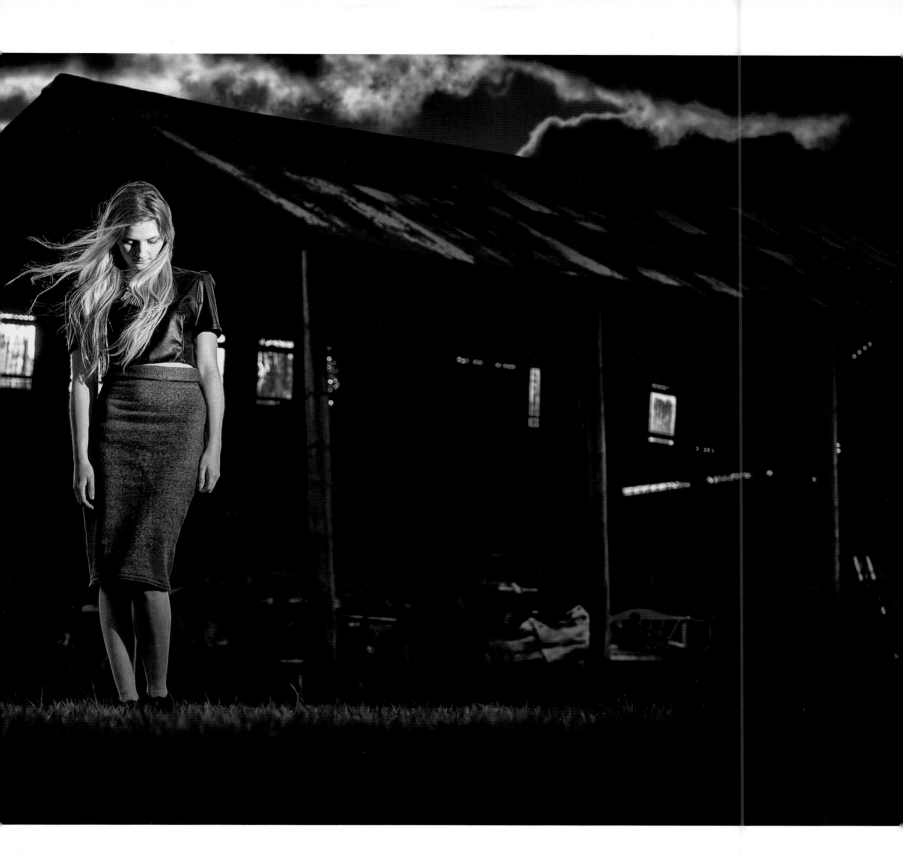

The Role of Postproduction

Postproduction is the second part of the creative process that produces the image envisioned by the photographer. However, it's easy to go too far. One of the hardest things about editing images is that there's no obvious end point—after spending hours zoomed into different areas of the image, pulling back to look at the whole once again may reveal that you've gone too far and the shot no longer looks realistic. To avoid this, consider how you want the final shot to look *before* you begin, so you have the end in mind. Generally, the aim is to gently enhance each portrait, keeping it believable, rather than drawing attention to the postproduction stage by overdoing the manipulation.

To help you get a sense of the look and feel you want to achieve through postproduction, spend time looking at the work of other people, collecting together examples you like. This is easily done using social media platforms such as Pinterest, which make finding and tagging inspirational photography easy. Then, start to consider how you can head toward a similar result with your own images. Look at online video tutorials, download some free software trials, and invest in books that focus on technical postproduction skills. These tips will help you get started:

- Screens display color differently to printed images, so calibrate your monitor before you begin otherwise you may find the color adjustments you've made look completely different once printed. Most Macs and PCs have free, built-in wizards that explain the color calibration process step-by-step and there are free or low-cost options available online as well. However, for the most precise calibration you will need to invest in some specialist calibration hardware. These small devices plug into a USB port and attach to your screen, with pre-loaded software that takes you through the process.

- Where possible, ensure any makeup is flawlessly applied before shooting, as this will save you hours of time trying to fix it later. Also be sure to remove snot, sleep dust, drool on babies, and any other marks before you start shooting.

- For best results, work on Raw files. Raw files contain all the image information, enabling you to make more decisions at the postproduction stage and retain maximum detail in extreme highlight and shadow areas.

- Get the exposure right in-camera. You will quickly find that postproduction is much easier and more convincing when the image colors and skin of your subject are light and bright before the file is edited, rather than dull and muddy.

- Apply different adjustments to different layers—use one layer for smoothing the skin, another for editing the eyes, and so on. This will allow you to go back and tweak each layer individually, and adjust how it interacts with your other layers.

- Save Photoshop files as .PSD files to retain all the layer information, or TIFF files to compress the layers without losing quality and detail.

- Apply the "two week" rule when editing out blemishes: if a mark wouldn't be there in two weeks' time, take it out. However, leave permanent features, such as moles, unless your subject specifically requests their removal, otherwise you risk causing offence.

- Use the golden ratio or rule of thirds overlays when cropping images to achieve the most visually pleasing compositions.

- Use "actions," which are combinations of postproduction adjustments packaged together to give a shot a specific look and feel.

Software

Adobe Photoshop is the most well-known editing software option, and is undoubtedly a powerful tool. It is expensive, though, and doesn't help you to manage your images, which is where Adobe Lightroom comes in.

Lightroom enables you to tag, store, and easily find thousands of photos, as well as make significant postproduction edits, including handling Raw files. Some professionals find that Lightroom meets all their postproduction needs, while others switch to Photoshop for fine tuning and more involved editing. Adobe currently offers free trials for both programs, so it's well worth experimenting before you make a decision.

It would be easy to believe Adobe products are your only option for postproduction, but there are alternatives. Top of the list is GIMP (GNU Image Manipulation Program), a free Mac- and Windows-compatible program that offers many of the same capabilities and features as Photoshop. There's also Aperture, made by Apple (specifically for Apple Macs), and the free-of-charge Paint. net, made by Microsoft for use with the Windows operating system.

You can also get automated postproduction software, in which you only need to click on different areas of the image to select where the subject's features are. The software then adjusts the image toward pre-set ideals—smooth skin, white teeth, bright eyes, and so on—giving you sliding bars to tweak the level of adjustment for each of the different fixes on offer. They are a quick and easy solution that can produce surprisingly good results, and many offer free trials.

However, just like using your camera on automatic mode, you'll be giving away creative control of the editing process, limiting your options, and producing what is essentially someone else's idea of what your portraits should look like.

Workflow Essentials

In this section, we'll walk through all of the steps between capturing the initial photograph and producing the final image you see at the end (page 169) from transferring the images, setting the underlying colors, and the final edit.

For this overview of the postproduction process we will walk through the way we do it here, which is using Adobe Lightroom and Adobe Photoshop (on a Mac). There are numerous applications that support the management and editing of images, but this is perhaps the most common combination.

1 Import your Images

The first thing you have to do is transfer your images from the camera's memory cards. There are numerous ways of getting your images onto your hard drive, but we use Adobe Lightroom (you could also just use the Windows Explorer or Mac Finder and drag the images off the cards).

One thing to remember at this point—at least if you use multiple cameras on a shoot—is that the file names won't necessarily reflect the order in which the images were captured.

Also, be sure to *copy* your files—don't just move them. If you can, copy them to multiple locations (an internal and external hard drive, for example). That way, should a hard drive fail, you have the image files safely stored elsewhere.

2 Add Images to Lightroom

Not everyone uses Lightroom—many photographers use Adobe Bridge, Capture One, Aperture (soon to be phased out), or the built-in file manager apps on Windows or Mac. There's no right or wrong—you have to pick whichever supports your way of working.

What *is* important is that you have some kind of method for keeping track of your images, so you know where to find them now, and where you will be able to find them in the future.

Above: At the import you can add metadata such as titles and keywords, but keep it simple to start with—you can always add more later!

During the import process, you can add metadata such as a title, caption, some keywords, and so on. These will be applied to all of the images you import, so it is best to keep it simple and just describe the shoot, the client, and maybe the location. You can add more detailed, shot-specific information at a later time.

Although it can seem a distraction, it is worth adding some basic metadata at this stage, as it gives you something to search for at a later date and, even if it's not specific to each shot, at least you can find the folder in your archives!

3 Rename your Images

Once you have your images in Lightroom, sort them by their capture time (so they are ordered chronologically) and then rename them.

When you rename files, it is a good idea to set up a naming convention that will enable you to track and locate any image at any time. In our studio, we use the following format:

YYMMDDZZZZ_XXXX

YYMMDD is the date the image was captured (note this can change mid-shoot if you work late nights at weddings!).

ZZZZ is a simple four-letter code to represent the shoot (in this example, the shoot was Bryony For Walkthrough so we used the letters BFWT). You could also use a single letter, but it's useful to have an extra clue about what the shoot was when someone emails a request for a file!

XXXX is an incremental counter starting at 0001. Always use four digits (including 0's at the start, where necessary) as it helps ensure the images are always displayed in the correct order, no matter which application opens them.

The images are then stored in folders that are also named using a **YYMMDDZZZZ_JobName** convention, so they will also be displayed in the correct order.

Above: A good file-naming format will make it easier to keep track of your images and relocate them if you need to.

4 Backup your Images

Hard drive failures are not a risk, they are a **CERTAINTY**. A recent study estimated that the average life of a hard drive is between three and six years, so the likelihood of failure is almost certain. With that in mind, you shouldn't edit or change your images—and certainly don't format your memory cards—until you have made a backup copy of the images.

For all of our commissioned work we **ALWAYS** have at least **TWO** copies of each image (even the cameras have dual memory slots just in case one card fails!). We use hard drives for our backups and keep a log of where every job is backed up to so we can find them easily at a later date.

5 Format your Cards

Once your backup is complete (and checked!), format your memory cards so they are ready to go for the next session. It's always worth doing this immediately and then repacking your cameras, as you never know when the next request for a session might occur!

6 Select the Images

Go through your images and select the ones you think you might need to use. We archive every image we've ever taken—we never delete anything—so we only need to select the images with a high likelihood of being selected by the client. We keep the rest anyway.

Once you have made your choices you can split them into two folders: Level 1 (keepers) and Level 2 (non-keepers).

This is a very simplistic way of categorizing your images, but it works. Alternatively, you could use flags, colors, or stars in Lightroom (or Bridge), but the limitation with this is that you cannot distinguish the selection if you're browsing the images in Explorer or Finder—with physical folders it's always possible to see which is which.

Above: Go through your images and select the ones you think you might want to use.

Above: Splitting your images into Level 1 (keepers) and Level 2 (non-keepers) allows you to browse between them more easily.

Above: By separating your images into physical folders (rather than using collections, stars, flags, labels, and so on) you can always see which shots are intended to be used and which have been archived "just in case." This is very useful when you're browsing images in your archive!

7 Set the Colors

The Raw file format is the most versatile format for images, as it will enable you to tune the color, exposure, white balance, and so on. We always work in the following order:
• White Balance
• Exposure
• Highlights/Shadows
• Whites/Blacks

As a general rule, we leave Lightroom's Clarity, Saturation, and Vibrancy sliders at zero during the raw conversion, as any detail tuning is performed in Photoshop later on.

If your images were shot at a high ISO setting, you may want to introduce a little noise reduction at this point, but keep it to a minimum, as a little grain in the image is usually much better that having a visibly over-processed image.

In terms of color, setting the skin tones to RGB values of around ~85% (red), ~75% (green), and ~65% (blue) produces a good starting point. Of course, these values vary depending on the skin tone of the person you're working on!

When setting the exposure, use the highlight and blacks warnings to help you. It's rare that you would want to let anything blow out in the highlights (unless you want a clean white background) and you would normally only expect blacks in areas of really deep shadow.

Once you're happy that the exposure and tonality of the image are correct, check and remove any dust spots. You are then ready to open your image in Photoshop for the final edits.

NOTE
You can copy dust spot corrections across all images using Lightroom's "Sync Settings" function. However, remember your model may have moved, so check the dust spot isn't now overlapping part of your subject.

Above: The Develop module in Lightroom (and the equivalent Camera Raw dialog in Photoshop) is incredibly versatile. This is where you would set the color, white balance, brightness, and so on.

Above: Once the colors are sorted, it's worth checking for dust spots. Clicking on the "Visualize Spots" check box in Lightroom makes finding any dust very straightforward (Photoshop's Camera Raw filter also has this feature).

Initial Crop

With this image, I had an idea of what I wanted to achieve when I took the shot, so I knew what I would be aiming for during postproduction. It's useful to pre-visualize the outcome in this way, as it saves a lot of time. However, you can never be 100% certain of the end result—while you're editing an image, other ideas will often come to the surface and you should feel free to explore them.

1 Nearly all of our final editing is done in Photoshop, although you can pretty much do everything you need directly in Lightroom. When I opened this image I decided I wanted a much squarer crop.

2 I always leave the background layer alone, so if I want to change the edit on the file I don't have to go and find the original Raw file (unless I want to change the original settings). You can duplicate a layer by selecting it in the Layers palette and choosing Layer > Duplicate from the top menu.

3 Although I wanted a square crop, that meant increasing the size of the image, rather than reducing it (as with a traditional crop). To achieve this, I set the Crop tool to a Ratio of 1x1 and created a crop that extended beyond the image.

4 To fill the blank space that was added around the edges, I used the Rectangular Marquee tool to select an area that I wanted to expand (being careful not to select any part of the subject), and then transformed the region using Edit > Free Transform. This was repeated on each side of the image to fill the now-square frame.

Removing Blemishes

Now we're going to remove any minor skin blemishes, taking care to leave any moles or birthmarks as they are—this is a portrait, not a fashion retouch.

If I'm doing high-end fashion retouching, I would use various techniques, particularly "Frequency Separation," which helps separate high-frequency areas (spots and scars, for example) from low-frequency areas (skin tone, shadow, and similar), making the retouching process much easier. However, for this portrait, we just need to use the Healing Brush.

1 In this walkthrough, we're going to do very basic retouching on the face—just removing a few spots, nothing more. Start by using one of the selection tools (I've used the Rectangular Marquee tool) to select the face area. Choose Layer > New > Layer via copy from the top menu bar to duplicate the area you've selected as a new layer.

2 Using the Healing Brush tool, carefully "paint over" any blemishes to remove them.

3 I like to use a soft brush—you can change the hardness of any brush in Photoshop by using the "{" key to make it softer and the "}" key to make it harder.

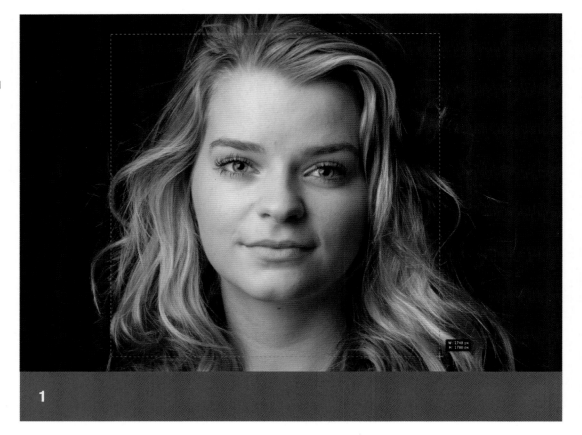

1

2

3

NOTE
Always rename your layers so you can tell what each one does later in the edit. This saves a lot of time later on!

Reducing Bags

Next, it's time to sort out the shadows under the eyes. As before, the aim is to keep the editing work looking natural, so we will *reduce* (not remove) the bags under our subject's eyes. If they are removed completely, the face can start to look very different.

Using a reflector or floor light in the studio would also eliminate these shadows at the time of shooting (and is why many ads for cosmetics have "clam shell" catchlights in the eyes.)

1 There is a natural shadow under the eyelid, but if someone is tired there is a second dark area lower down—this is the area we are going to reduce. Duplicate the previous blemish layer (Layer > New > Layer via copy) and give it a name.

2 Using the Patch tool, select the dark region beneath the eye, taking care not to include any eyelashes.

3 Drag the patch over a clean area of skin—this will intelligently fill the area using the clean area as a reference. Once this is done, reduce the layer's Opacity to make the edit appear natural. You'll need to set this depending on the image—if the effect is overdone it can leave the face looking unnatural.

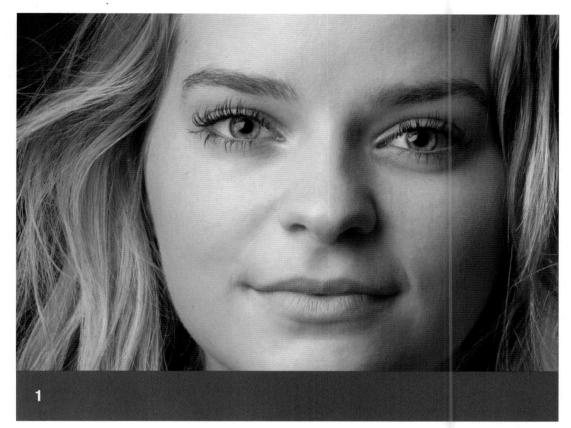

1

2

3

Sparkly Eyes

There are many ways to edit the eyes, but this is a very simple method that will quickly and consistently add sparkle.

1 Use the Freehand Lasso tool to select a region around the eyes and eyebrows, and then choose Layer > New > Layer via copy to place them on their own layer.

2 Convert the layer to a Smart Object by choosing Layer > Smart Objects > Convert to Smart Object from the main menu, or (as here) by selecting Convert to Smart Object from the dropdown menu in the Layers panel.

3 Choose Filter > Sharpen > Unsharp Mask. In the filter dialog set a large Radius and low Threshold, and then adjust the Amount to enhance the contrast in the eyes.

4 Having applied the Unsharp Mask filter, add a layer mask that hides the effect you've just created (Layer > Layer Mask > Hide All). This creates a black mask, and anything on the layer where the mask is black won't show (which, by default, is everything).

5 Using a soft brush, and with the foreground "paint" color set to white, paint in the areas where you want the sharpening to be visible—effectively removing the mask to allow the sparkly eyes to show through. If you make a mistake, switch the foreground color to black and paint the mask back in.

Reducing Skin Shine

Masks can be used in conjunction with Curves to selectively reduce the highlights on your subject's skin, making it appear "smoother" and less shiny.

1 To do this, we're going to use an Image Calculation (Image > Calculations). In the Image Calculations dialog, select Merged in both of the Source dropdown menus. Select the blue channel in each and then set the blending mode to Multiply. This will pick up the blue channel and multiply it with itself, making everything except the highlights very dark!

Select New Channel from the Result dropdown menu to create a new channel with the result of the calculation in it.

2 The resulting mask will be fairly dark, but it needs to be darker, so do the same thing again. This time, however, multiply the resulting Alpha 1 channel with the blue channel again. This will create a very dark mask that only exposes the brightest parts of the skin (and the eyes), with smooth gradations across the mask.

3 Open the Channels panel to view the new channel (in this instance, the channel is named Alpha 2). Hold down the Cmd/Alt key and click on the channel to create a selection from the channel. Click back on the RGB channel to return to the normal view.

4 Create a Curves adjustment layer (Layer > New Adjustment Layer > Curves). When you do this with an active selection it automatically creates the corresponding mask for the layer.

Adjust the curve to bring down the skin highlights slightly. Remember, the only part of the image that will be affected by this are the parts where the corresponding mask is light in color.

1

2

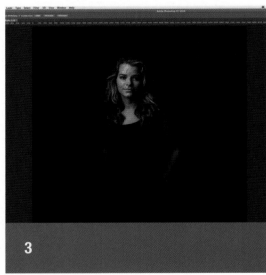

3

4

NOTE
You will need to paint out the mask on any areas (such as the eyes) where you don't want the adjustment to be applied.

Vignette & Noise

Adding a Vignette

Vignetting is the darkening of the corners of an image, which can be used creatively to hep focus attention on a centrally placed subject. Photoshop offers myriad ways of adding a vignette, including Curves, Lens Correction Filter, and Levels, but here we are using an Exposure adjustment layer.

1 Create an Exposure adjustment layer (Layer > New Adjustment Layer > Exposure) and adjust the Gamma slider until the level of the vignette looks right. Note that it will cover the whole image at this point.
 Select the Brush tool and choose a large, soft brush. Set a low Opacity and knock back the center of the Exposure layer's mask, revealing the lighter image beneath.

Adding Noise

If you're editing an 8-bit image with gentle graduations, you may find that you start to see banding in your image—this often occurs in dark backgrounds, especially if you add a gentle vignette. When this happens, adding a small amount of noise can improve the smoothness of the image.

1 With the top layer in your image selected in the Layers panel, press Ctrl + Shift + Cmd/ Alt + E to "Stamp Visible." This creates a new layer from all the visible layers in the image. Convert this new layer into a Smart Object and add a little noise using Filter > Noise > Add Noise…

Background Textures

Adding a background texture isn't something you will always do—some people prefer a really clean background instead. However, if you do want to add texture, here's how it's done. You can, of course, go out and shoot your own library of textures, but I'm using a displacement map of a plastered wall (with cracks and all!) that came in a set of commercial textures we bought for modeling 3D room setups.

1 Drag the texture image from your desktop (or whatever folder it is in on your hard drive) on top of your photograph. This will automatically make it a smart object that you can pull and push around without degrading it in any way.

2 Scale the texture to fit the photograph using Image > Transform > Scale. If you hold the Shift key down while you drag the scaling "handles," the texture will retain its original aspect ratio.

3 Once it has been resized, set the texture layer's Mode to Soft Light and reduce the Opacity to blend it with your photograph (the precise Opacity value will depend on the texture you are using and what you're trying to achieve with it).

4 Add a mask to the layer (Layer > Layer Mask > Reveal All) and paint out the areas where you don't want the texture to show (usually your subject). If you want to see where you're masking, press the "\" key—this will show you what is known as a "Rubylith." The red areas indicate where the mask is, so these are the areas where the texture won't show.

3

4

Black & White

There are numerous black-and-white conversion tools out there, ranging from those that are built into image-editing software to standalone, dedicated programs.

Silver Efex Pro 2 (owned by Google) is one of the most well known and well regarded dedicated options. It works as either a standalone program or a plugin for Photoshop/Lightroom, and offers plenty of control over the conversion process. It also features an array of classic black-and-white film type effects, as well as various tones, frames, vignettes, and so on.

1 Although you can use a Black & White adjustment layer in Photoshop, Silver Efex Pro 2 makes it a whole lot easier to produce great-looking black-and-white conversions.

2 Silver Efex Pro 2 has a range of toning options, but this image was tinted using a Color Balance adjustment layer in Photoshop (Layer > New Adjustment Layer > Color Balance), setting the Midtones to Red: 23, Green: 11, Blue: 1. This gives a lovely warmth to the photo.

Opposite: The final image.
Focal length: 92mm
Aperture: f/13
Shutter speed: 1/180 sec.
ISO: 280

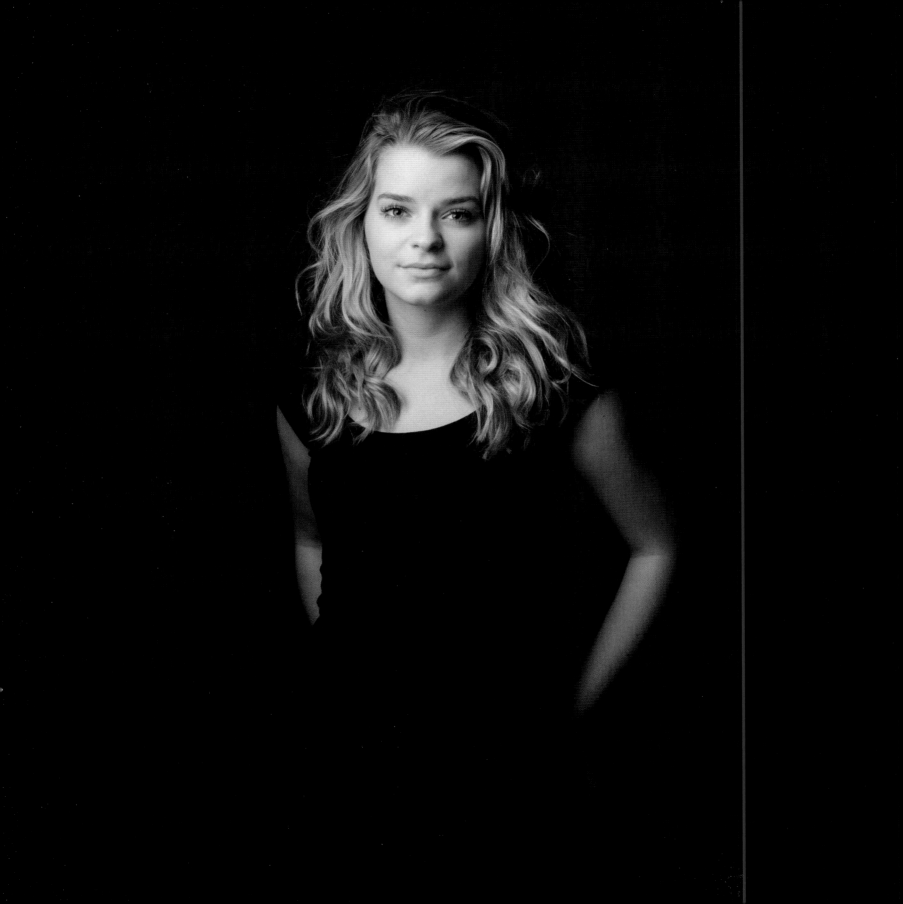

Glossary

AEL (Automatic Exposure Lock) A camera button that locks the current exposure settings until the shutter-release button is pressed, allowing you to recompose a scene before taking the shot.

Angle of view The extent of a scene that a lens can take in, measured in degrees (also referred to as "field of view"). A zoom lens has a variable angle of view, while a prime lens' viewing angle is fixed.

Aperture The hole in the lens through which light passes to reach the camera's sensor. The size of the aperture is measured in f/stops, and can be manually changed when the camera is in Aperture Priority or Manual mode.

Bracketing A method of taking multiple images of the same scene, but changing the exposure slightly each time. This provides more postproduction options, such as a choice of different exposure settings, and the ability to blend two or more shots to create a high dynamic range image. Bracketing can be done manually by using exposure compensation; by changing the aperture, shutter speed, or ISO; or by using the camera's Automatic Exposure Bracketing (AEB) function.

Camera shake Blurring of an image caused by the photographer's movements while the exposure is being recorded. Typically caused by using a slow shutter speed when handholding the camera, and exaggerated by telephoto focal lengths. Can be countered by using a faster shutter speed; image stabilization (if the camera or lens has this built in); mounting the camera on a tripod; or resting it on another support.

Catchlights White shapes in the subject's eyes caused by the reflection of the lights, without which eyes look dull and lifeless. For best effect, position your lights and angle your subject so these appear in the 10 or 2 o'clock position.

Center-weighted metering A metering mode in which the camera makes exposure setting decisions with a heavy bias toward the reading at the center of the frame.

Contrast The range of tones from light to dark in an image. A high-contrast image has extremes of highlight and shadow areas, while a low-contrast image has similar tones throughout.

Depth of field The area of the image which is in sharp focus. Using a wide aperture results in a shallow depth of field, which is great for creating portraits with soft, out-of-focus backgrounds.

Distortion A lens fault that causes straight lines in a scene to curve in a photograph, either curving outward from the center (barrel distortion), curving inward toward the center (pincushion distortion), or a mixture of both (moustache distortion).

DSLR (Digital Single Lens Reflex) A camera that uses an internal mirror to reflect the scene from the lens up to the photographer's eye. During the instant that the exposure is made, this mirror flips up out of the way just as the shutter opens, allowing light to reach the image sensor.

Dynamic range The extremes of contrast that a camera is able to record accurately in a single exposure, without having clipped highlights or shadow areas where very light or dark tones are shown as pure white or black with all detail lost.

Evaluative metering A metering mode in which the camera takes reflected light readings from multiple points across the image frame.

Exposure The act of light reaching the camera's image sensor, as determined by the aperture, shutter speed, and ISO settings.

Exposure compensation A quick and easy way of increasing or decreasing the amount of light contributing toward the exposure.

Exposure triangle The three camera settings that determine how much light contributes to an exposure—aperture, shutter speed, and ISO.

Exposure value (EV) The combinations of aperture and shutter speed that allow the same total amount of light to reach the sensor. For instance, a slow shutter speed combined with a narrow aperture can produce the same EV as a fast shutter speed and a wide aperture. This doesn't mean the same image will be produced, however, as changing the shutter speed will affect how motion is recorded, while changing the aperture will affect the depth of field.

Fill-in flash Artificial light that is not the main light source. Can be used to lighten shadow areas in order to reduce contrast and reveal more detail.

Focal length The distance from the optical center of a lens to the focal plane, measured in millimeters. A focal length of less than 50mm is considered "wide angle," as it delivers a wider angle of view than the human eye, while lenses with a focal length longer than 50mm are known as "telephoto" lenses, as they magnify the scene more than it would normally appear to the eye. The focal length of a prime lens is fixed, while that of a zoom lens can be changed within an available range.

f/stop (or f/number) Denotes the size of the aperture, with lower f/stops (such as f/1.4 or f/2.8) indicating a wider aperture and higher f/stops (such as f/16 or f/22) denoting a smaller aperture. The number is a fraction, based on the ratio of the lens' focal length to the diameter of the aperture.

Histogram A graph displaying the number of pixels at each level of brightness in an image. If the graph

is fairly evenly spread, this indicates a wide range of tones in an image; if the graph is concentrated in one area of the graph, there is a narrow range of tones. If the graph is stacked at either of the edges, this indicates that detail has been lost in the highlights, shadows, or both.

Hotshoe A metal mount on top of the camera that can both hold and communicate with external flash equipment, enabling synchronization between the exposure being recorded and the flash being fired.

Image sensor The camera element containing millions of photosites that capture light from a scene before it is converted into an electronic signal. The two most common types of sensor are CCD (Charge-Coupled Device) and CMOS (Complementary Metal-Oxide Semi-conductor).

Incident light reading A meter reading based on the light falling on the subject, as opposed to a reflected light reading, which records the amount of light bounced off a subject. Incident light readings are the more accurate of the two, as reflected light readings can be fooled by very light or dark tones, resulting in the image being under- or overexposed respectively. Handheld light meters offer the ability to measure both incident and reflected light.

ISO A measure of the image sensor's sensitivity to light, with a low ISO (such as ISO 100) indicating low sensitivity and a high ISO (such as ISO 1600) high sensitivity. ISO is an abbreviation of International Organisation for Standardisation, the group that set the standardized measures.

JPEG An image file format that uses compression algorithms to vastly reduce the size of image files. However, the compression causes a loss of detail and quality each time the file is saved. The name comes from the Joint Photographic Experts Group who created the format.

Megapixel One megapixel is equal to one million pixels.

Memory card The removable file storage device that holds the image data.

Metering The camera's internal system for determining exposure settings, based on the amount of light reflected from the scene.

MILC Short for Mirrorless Interchangeable Lens Camera. This type of camera doesn't have an internal mirror to reflect the scene up from the lens to the photographer's eye, as happens in a DSLR. Instead, a live image is streamed from the image sensor to the LCD screen on the back of the camera or an electronic eye-level viewfinder.

Noise Non-image-forming artifacts caused by high sensitivity settings and/or long exposures. Can be seen as colored speckles (chroma noise) or an underlying coarse texture (luminosity noise).

Overexposed An incorrect exposure resulting in an image that is overly bright. Highlight areas may be recorded as pure white, with no detail, and shadow areas may be unnaturally light in tone.

Pixel A contraction of "picture element," the smallest piece of data in a digital photograph.

Raw An image file format that contains all the original image data, without compression or loss of quality or detail. Different makes of camera have different types of Raw file, and all require processing in editing software such as Adobe Photoshop in order to be saved in a file format that can be easily shared and opened.

Red-eye reduction A feature that fires a pre-flash prior to the shutter being released. This shrinks the pupil size of subjects in order to reduce the occurrence of red eye, where the flash reflects off the back of the retina, making the pupil appear red in color rather than black.

Reflected light reading A meter reading based on the light reflected from a subject, as opposed to a incident light reading, which records the amount of light falling on a subject. In-camera metering systems rely on reflected light to decide the exposure settings.

Remote switch A device that activates the shutter remotely, reducing the risk of camera shake and enabling the photographer to be away from the camera at the moment the shot is taken.

RGB (Red, Green, Blue) The three base colors that combine in different amounts to form all colors (including white) on digital devices.

Rule of thirds A composition guideline that states images will be most compelling when key elements are placed at one third or two thirds from the sides of the frame, both horizontally and/or vertically.

Spot metering A metering mode in which the camera decides the exposure settings based on reflected light from a very small area. This is usually the center of the frame, but some cameras allow you to link it to the active focus point.

TIFF (Tagged Image File Format) An image file format which doesn't result in the loss of detail and quality, and which can be easily shared and opened without further processing.

Underexposed An incorrect exposure resulting in an image that is too dark. Shadow areas may be recorded as pure black, with no detail, and highlight areas may be unnaturally dark in tone.

Viewfinder The eyepiece of the camera, through which you look in order to frame your image.

White balance Camera control that enables you to match the color temperature of different light sources to alleviate any color casts.

Useful Web Sites

Authors

Paul Wilkinson www.paulwilkinsonphotography.co.uk
Sarah Plater www.sarah-plater.co.uk

General

Digital Photography Review www.dpreview.com

Photographic Equipment

Bowens Lighting www.bowens.co.uk
Canon www.canon.com
Elinchrom Lighting www.elinchrom.com
Fujifilm www.fujifilm.com
Nikon www.nikon.com
Olympus www.cameras.olympus.com
Panasonic www.panasonic.com
Ricoh/Pentax www.ricoh-imaging.com
Sigma www.sigma-global.com
Sony www.sony.com
Tamron www.tamron.com
Tokina www.tokinalens.com

Photography Publications

Ammonite Press www.ammonitepress.com
Black & White Photography Magazine www.blackandwhitephotographymag.co.uk
Outdoor Photography Magazine www.outdoorphotographymagazine.co.uk

Printing

Epson www.epson.com
Harman www.harman-inkjet.com
HP www8.hp.com
Ilford www.ilford.com
Kodak www.kodak.com
Lexmark www.lexmark.com
Marrutt www.marrutt.com

Software & Actions

Adobe www.adobe.com
Corel www.corel.com
GIMP www.gimp.org
Greater Than Gatsby www.greaterthangatsby.com
Google Nik Efex www.google.com/nikcollection
MCP Actions www.mcpactions.com
Topaze Plugins www.topazlabs.com

Index

Acknowledgments

Paul Wilkinson

This book is dedicated to everyone who has had faith in me over the years—most notably my beautiful wife, Sarah, who works tirelessly running the show at the studio (and at home!) and my mum and dad who instilled in me the confidence to have a go at anything! Thank you to our kids, Harriet and Jake (both of whom feature in this book), and to Michelle and Megan in the studio who, along with Sarah, have spent months working through image selections and model release forms. Finally, a huge thank you to Sarah Plater for asking me to get involved in this book; photography has been my passion (and profession) for a very long time and it has been a real thrill to be able to put some of that down on paper!

Sarah Plater

Dedicated to my husband, Jon Wellstead, and my nephew, Ryan Yarnell. With thanks to Lisa Bowen, Joyce and Doug Wellstead, and my mum and dad for their support over the last 18 months. A special thank you to everyone who has bought, read, and/or reviewed *Foundation Course: Portrait Photography* and now *Mastering Portrait Photography*—you are the professional photographers, creative artists, and visual journalists of tomorrow.

AMMONITE
PRESS

To place an order, or request a catalog, contact:
Ammonite Press
AE Publications Ltd, 166 High Street, Lewes, East Sussex, BN7 1XU, United Kingdom
Tel: +44 (0)1273 488006
www.ammonitepress.com